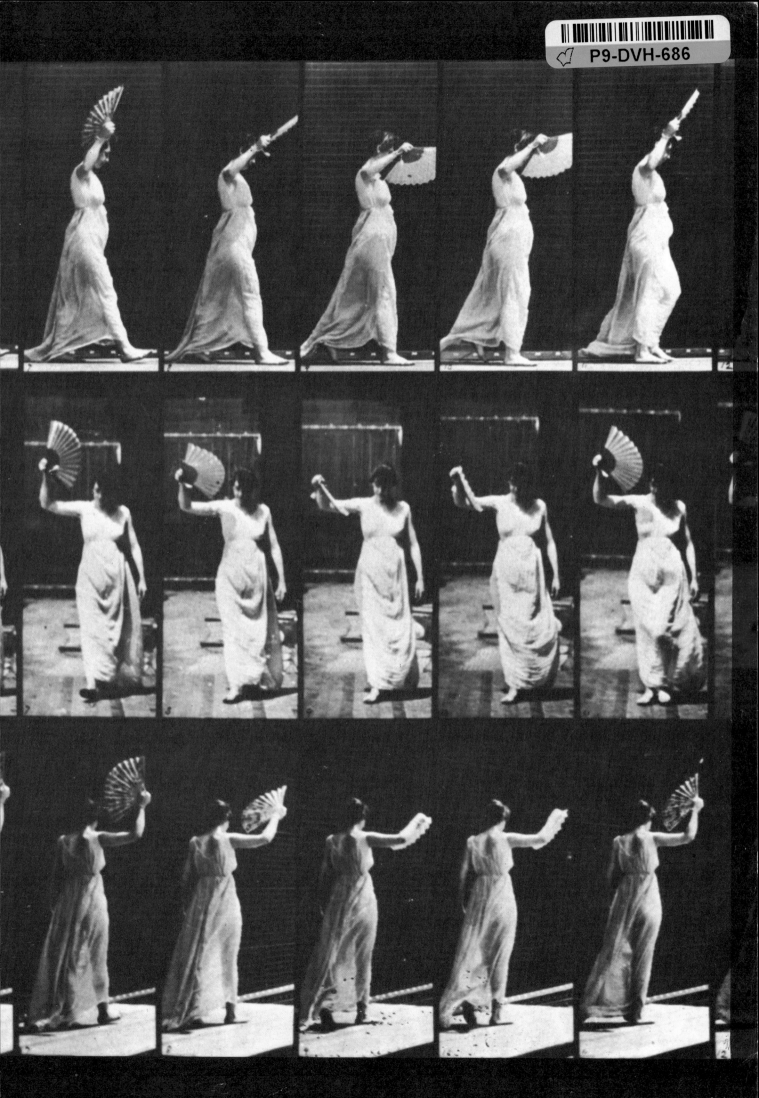

History of Photography

History of Photography

Techniques and Equipment

Camfield and Deirdre Wills

Exeter Books

NEW YORK

This book is dedicated to all those
photographers, scientists and experimenters
for whose contributions to HISTORY OF PHOTOGRAPHY
we have been unable to find space.

Published by The Hamlyn Publishing Group Limited
London · New York · Sydney · Toronto
Astronaut House, Feltham, Middlesex, England.

Copyright © The Hamlyn Publishing Group Limited 1980
First published in U.S.A. 1980
By Exeter Books
Distributed by Bookthrift Inc.
New York, New York.

ISBN 0-89673-040-9
Library of Congress Catalog No. 79-57282

Printed and bound in Spain
by Graficromo, S. A. – Córdoba

Contents

An early Victorian hand-painted
lantern slide.

The Technical Evolution

The Photographic Process

Since the very beginnings of human existence people have recorded their activities and environment by art. Photography is a process which originally fulfilled two needs: firstly, it was a form of mechanical recording independent of an individual's ability to draw accurately, and secondly, it provided a method of making any number of prints from the original negative quickly and easily. It was to become the most widely used technique ever devised for producing small quantities of continuous tone pictures.

The cities of London and Westminster, accurately copied from the table of the camera obscura at the Royal Observatory, Greenwich.

The earliest known aid to sketching was the camera obscura, essentially a light-tight box with a pinhole or lens at the front and a ground glass screen at the back. When pointed at a scene an image of this appeared on the screen at the back which could then be traced directly onto ground glass or a piece of thin paper laid on top of it.

Although thought to have been known since the early days of Chinese civilization and used by the tenth-century Arabian philosopher Alhazen to view eclipses of the sun, the first detailed description of it was made in the fifteenth century by Leonardo da Vinci in his notebooks. Shortly afterwards Giovanni Battista della Porta described the use of a lens replacing the pinhole in his book *Natural Magic* published in Naples in 1558.

The first significant advances towards the recording of the images produced with the camera obscura by chemical means arose from the experiments carried out in the early eighteenth century by Johann Heinrich Schulze, a professor of anatomy at the University of Altdorf in Germany. He made a study of the manner in which some metallic compounds, notably those of silver, possessed the property of darkening when exposed to light. In 1777 Karl Wilhelm Scheele, a Swedish pharmacist, demonstrated that this effect was most pronounced when the light rays emanated from the violet end of the visible spectrum.

The camera obscura had been

used by Josiah Wedgwood in the eighteenth century for sketching designs for the decoration of pottery at his works at Etruria in Staffordshire. His fourth son, Thomas Wedgwood, an uncle of the naturalist Charles Darwin, commenced in the early 1790s a series of experiments with the object of recording by chemical means the images produced by the camera obscura. Working from the earlier experiments of Schulze and Scheele he was able to produce a series of images, on paper and on leather, of inanimate objects. The process was described by his friend Humphrey Davy, the noted chemist, in a paper which was published in *The Journal of The Royal Institution* (Vol. 1, No. 9, 22 June 1802, p. 170) under the title 'An account of a method of copying paintings upon glass and of making profiles by the agency of light upon nitrate of silver. Invented by T. Wedgwood Esq. with observations by H. Davy'. Although Wedgwood had formulated a method of recording images, neither he nor Davy was able to suggest a method of stabilizing them to prevent further darkening upon exposure to light.

The credit for producing the first permanent images created by the action of light must be accorded to a Frenchman, Joseph Nicéphore Niépce. In the early nineteenth century, when he was middle aged, he became interested in lithography and began to experiment with the aim of establishing a method of producing designs directly upon the litho stone by the action of light, rather than by the laborious method of drawing by hand then in use. Around 1815 he experimented using paper he sensitized to the action of light with a mixture of chalk, silver nitrate and salt but, like Wedgwood, he was unable to fix the images which he formed, and he turned his attention to other substances.

By 1827 he had succeeded in fixing an image formed in a camera obscura. The method was based upon his discovery that a coating made by dissolving a quantity of an asphalt-like substance, bitumen of Judea, in a suitable solvent possessed the property of hardening when exposed to light. After exposure the plate was washed with oil of lavender so that the unhardened areas were dissolved leaving a permanent image. Unfortunately the process was unsatisfactory for normal photography as the exposure time required was about 8 hours.

In 1826 Niépce was introduced to Louis Jacques Mandé Daguerre by the Parisian optician, Chevalier. Two years later they formed a partnership but Niépce died in 1833 before much progress had been made. Although his son Isidore continued the partnership it was Daguerre who was the dominant figure, and on 7 January 1839 a formal announcement of the discovery of the 'daguerreotype' process was made by François Arago, Secretary of the French Academy of Sciences.

The daguerreotype

The daguerreotype had little in common with Niépce's bitumen plates, or heliographs as they had become to be known. The base material upon which the images were made was a highly polished sheet of silver-plated copper or, in rare instances, a sheet of polished silver. For this reason they became known as 'mirrors with a memory'. The plates were sensitized by exposing the silvered surface to the vapour formed from heating solid iodine crystals in a fuming box, thus forming silver iodide on their surfaces. They were then loaded into the

Left The earliest permanent photograph by Nicéphore Niépce (1827). Although it is very indistinct the roof of a building can be seen in the foreground.

Opposite Extracts from a catalogue (c. 1850) of daguerreotype equipment.

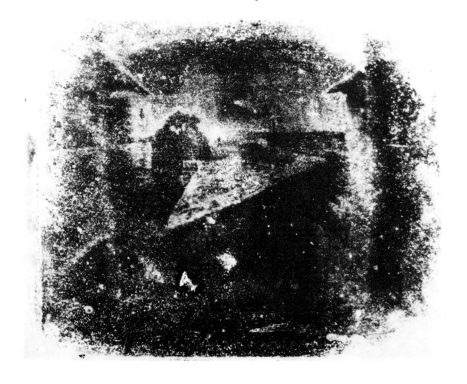

MISCELLANEOUS APPARATUS.

Mercury Boxes for small sized Cameras, with iron or porcelain cistern, shifting legs, frame for plates, &c. 15s. and	£1	1	0	
Ditto ditto, best construction, with cast iron cistern, sliding front and legs, glass window for viewing the development of the picture, and three frames for plates £1 4s., £1 10s., and	2	2	0	
Improved mercury box, with sliding metal frame and rod, with one set of frames	2	2	0	
Ditto, with two ditto	3	3	0	
Ditto, with three ditto	4	4	0	
Mercurial thermometers for boxes	0	7	6	
Earthenware washing tray and stand	0	3	6	
Ditto, small size	0	1	6	
Washing trays in copper and glass, from	0	2	6	
Glass spirit lamps 2s., 3s., 4s., and	0	5	0	
Ditto graduated measures ... 1s. 6d., 2s., 2s. 6d., and	0	3	6	
Ditto mortars and pestles, from	0	2	6	
Ditto stirring rods	0	0	3	

SETS OF DAGUERREOTYPE APPARATUS.

No. 10.—Estimate for a complete Daguerreotype Apparatus, suitable for the professional photographist, consisting of a large-sized camera and compound lens for large views, portraits, and groups; small size camera, with large aperture and short focus combination of lenses, for taking portraits up to 4 inches by 3 inches in dull weather; polishing lathe, with series of circular buffs; three hand buffs; set of metal plate holders and supports; heating stand; large bromine and iodine apparatus and set of frames; set of plate boxes to hold two dozen each; table stand for camera on rollers; adjusting chair, with head rest; adjusting head rest, with heavy iron foot for full-length portraits, &c.; large mercury box for the different sized plates; lantern, with yellow glass shade; metal still and worm tub for obtaining distilled water; a large and small gilding stand; stoneware barrel and cock for holding distilled water; porcelain dishes; filtering stand; funnels and filtering paper; spirit lamps; set of daguerreotype colours and brushes, and flexible India-rubber bottle; glass measures; two painted back grounds, &c., &c., with a full supply of all the necessary chemicals, polishing materials, &c., complete, £110.

IMPROVED IODIZING AND BROMINE APPARATUS.

Consisting of two stout glass pans, enclosed in mahogany or walnut wood case, with spring bottoms and air-tight glass covers. Two mirrors are placed on one side, for viewing the plate while being prepared, and on the other two apertures for the admission of light. The great advantage of this form of apparatus for preparing plates consists in the facility and certainty with which the sensitive coatings are applied,—

No. 1.—For plates from 8½ in. by 6½ in. downwards	7	7	0
No. 2.—For plates from 6 in. by 5 in. downwards, £3 10s. to	4	4	0
No. 3.—For plates from 4 in. by 3 in. downwards	2	10	0

DAGUERREOTYPE PLATES.

ENGLISH MANUFACTURE.

Size.	Third quality.	Second quality.	Best.	
2½ in. by 2 in.	...£0 10 0	...£0 11 0	...£0 12 0	per doz.
2¾ in. by 3¼ in.	... 0 18 0	... 1 0 0	... 1 0 0	,,
4 in. by 3 in.	... 1 7 0	... 1 8 0	... 1 8 0	,,

FRENCH MANUFACTURE.

	No. 40.		Electro-plated.	
2½ in. by 2 in.	£0 5 0	...£0 5 6	...£0 6 6	,,
2¾ in. by 3¼ in.	... 0 6 0	... 0 8 0	... 0 9 6	,,
4 in. by 3 in.	... 0 10 0	... 0 11 6	... 0 12 6	,,

MOROCCO CASES AND FRAMES.

Fig. 31.	Fig. 32.	Fig. 33.

Morocco leather cases, lined with velvet, and fitted with gilt mats and glasses, for finished pictures (Fig. 31.)

		Best.	Second Quality.
No. 1. for plates 2½ in. by 2 in. ... per doz.	£0 15 0	£0 12 0	
No. 2. ,, 3¼ in. by 2¾ in. ... ,,	1 4 0	1 1 0	
No. 3. ,, 4 in. by 3 in. ... ,,	1 16 0	1 13 0	
No. 4. ,, 4¼ in. by 3¼ in. ... ,,	2 2 0	1 16 0	

Morocco frames, with suspension ring, mats, and glasses for plates. (Fig. 32.)

No. 1 size, 2½ in. by 2 in. per doz.	0	9	0
No. 2 size, 3¼ in. by 2¾ in. ,,	0	15	0
No. 3 size, 4 in. by 3 in. ,,	0	18	0
No. 4 size, 4¼ in. by 3¼ in. ,,	1	1	0

Gilt metal mats, either square, oval, or domeform, of best quality :—

No. 1 size, 2½ in. by 2 in., outside measure ... per doz.	0	2	0
No. 2 size, 3¾ in. by 2¾ in. ,, ... ,,	0	2	9
No. 3 size, 4 in. by 3 in. ,, ... ,,	0	5	0
No. 4 size, 4¼ in. by 3¼ in. ,, ... ,,	0	5	6

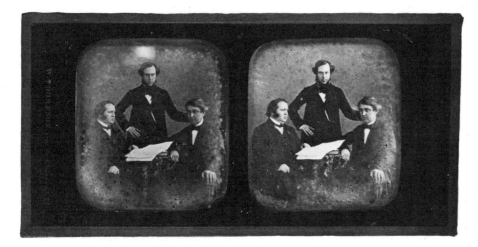

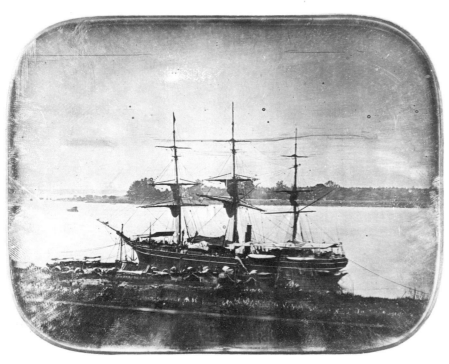

camera and an exposure was made. The original whole-plate size images required an exposure time of between 10 minutes and 1 hour, depending upon the brightness of the light. The image so formed was 'developed' by suspending it in a box above a dish of mercury which was heated by a small spirit lamp. The vapour released formed, in conjunction with the exposed silver iodide, an amalgam after which the plate was treated with a solution of salt which dissolved any of the silver iodide which had not been employed in producing the image. The result was a picture in which the highlights were represented by the light-toned amalgam of silver and

mercury and the shadows by the polished silver, the plate having to be held in such a way that they reflected some dark surface. Obviously the viewing angle and conditions were critical if the picture was to be viewed at its best.

Each image was unique in itself and copies could only be obtained by making a daguerreotype copy of the original image. The images in the originals were reversed left to right, often noticeable by wedding rings appearing on the right hand instead of the left or by the position of buttons on clothing. When it was thought necessary to have 'right way round pictures' these could be obtained by placing a prism or mirror

in front of the camera lens. The process was remarkable because of its ability to record detail clearly and with an excellent range of tones.

After the announcement of the discovery of the process, negotiations were entered into with the French Government which culminated in August 1839 in an agreement by which the Government agreed to pay pensions of 6,000 and 4,000 francs per annum to Daguerre and Isidore Niépce respectively in return for a full disclosure of the process. The partners agreed and the process was disclosed to the Government, who in turn made it freely available throughout the world—except in England where a

patent agent, Miles Berry, had applied for and been granted a British patent (No. 1839-8194) on 14 August 1839. This was just five days before the historic announcement made by François Arago in the afternoon of 19 August 1839 at a joint meeting of the Academy of Sciences and the Academy of Arts held in the Palace of the Institute. Daguerre was not present; he was said to have a throat infection.

The fact that the process was patented in England acted as a powerful deterrent to its commercial exploitation, and explains why so many early English daguerreotypes do not bear the name of the photographer, many of whom practised the process without obtaining a licence.

Although the daguerreotype was the first photographic process to be publicly announced, it cannot be said that it was the forerunner of photography as we know it today. That distinction must be accorded to the negative/positive process developed by William Henry Fox Talbot, an English gentleman living at Lacock Abbey in Wiltshire.

The photogenic drawing and the calotype

In 1833, whilst on his honeymoon at Lake Como in Italy, Fox Talbot used a camera lucida as an aid to sketching. Dissatisfied with the results he first considered reverting to the use of a camera obscura which he had used earlier with no better result, but eventually he decided to experiment with producing a chemical process of recording images. On his return to his country estate at Lacock he began the series of experiments that culminated in the invention of the photographic process as we know it today: the production of a negative image of the subject and a method of making any number of positive prints from it.

The concept of light-sensitive paper had been established by Wedgwood, but it was Fox Talbot who solved the final problem of

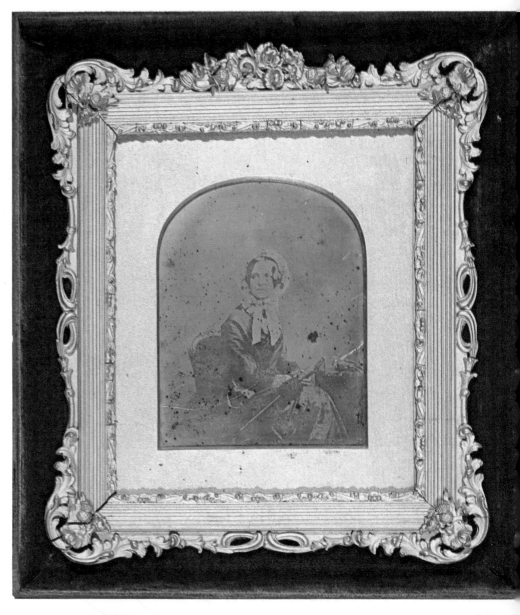

Above Daguerreotype in an ornate gilt frame (c. 1850).

Left L. J. M. Daguerre (1787-1851). Reproduced from a woodburytype made by The Woodburytype Permanent Photographic Printing Company from a daguerreotype taken in 1846 by J. E. Mayall.

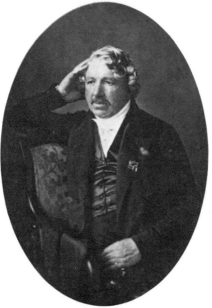

fixing the image by using a strong solution of salt. His first experiments involved sensitizing sheets of ordinary writing paper by first treating them with a solution of common salt followed by one of silver nitrate. Thus a light-sensitive compound—silver chloride—was formed within the fibres of the paper which darkened when exposed to the action of light. He placed thin objects such as pieces of lace, leaves or paper printed on one side in contact with the sensitized paper and exposed them to bright sunlight. When the sensitized paper had darkened sufficiently he fixed the image so formed in a solution of common salt, stabilizing it enough to be viewed in normal light without any further darkening taking place.

By 1835 Fox Talbot was producing these negative images in small wooden cameras, said to have been made for him by the estate carpenter at Lacock, Joseph Foden. The best known of these negatives is the one depicting the lattice window in the South Gallery at Lacock Abbey, which is thought to be the earliest surviving photographic negative. The original is in the Photographic Collection of the Science Museum at South Kensington, London. Soon afterwards he was able to obtain positive prints by contact printing the negatives onto similar sheets of sensitized paper. He called the process 'photogenic drawing', and on hearing of the work of Daguerre in France he hurriedly arranged for an announcement of his own experiments and for the display of examples at a meeting of the Royal Institution in January 1839.

In September 1840 Fox Talbot, acting on a suggestion made by his friend Reade, made the all-important discovery that sheets of photogenic drawing paper which had been given a brief exposure, insufficient to produce a visible image, possessed a latent image. By using a solution of gallic acid he developed this into a visible one. It was, of course, a negative, but positive prints could be made by

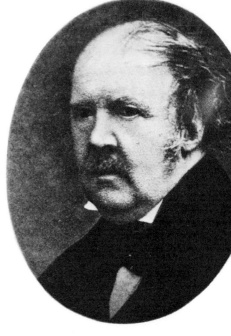

Right William Henry Fox Talbot (1800-77).

Below Photogenic drawing of lace by W. H. Fox Talbot (*c*. 1839). *Lacock Abbey Collection.*

Below right Photogenic drawing of leaves by W. H. Fox Talbot (*c*. 1839).

Bottom *The Ladder* by W. H. Fox Talbot (1844). A calotype taken of his employees at Lacock Abbey. *Lacock Abbey Collection.*

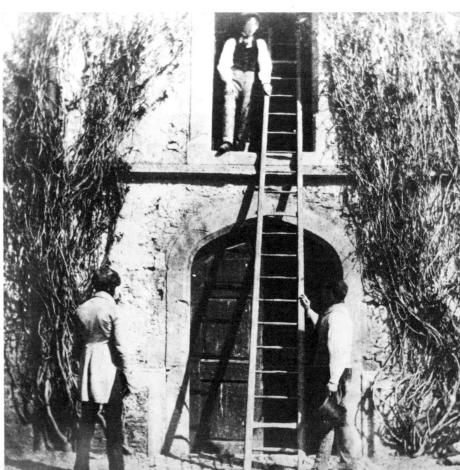

contact printing using sheets of the original photogenic drawing paper. He called the process the calotype but at the time it became popularly known as the 'Talbotype' or 'sun picture'. It is a mistake to refer to positive prints made in this way as calotypes, since they are almost invariably salt paper prints, i.e. prints made on photogenic drawing paper, from calotype negatives.

The process was described in a paper presented at a meeting of The Royal Society held on 10 June 1841, which summarized the patent (No. 8,842) granted to him on 8 February of the same year. Briefly, a sheet of good quality writing paper was brushed on one side with a solution of silver nitrate, then dried and dipped into a bath of potassium iodide. These two chemicals interacted to form silver iodide within the fibres of the paper, but since it contained an excess of potassium iodide it was comparatively insensitive to light and could be stored for future use. Shortly before use it was sensitized by floating it upon a solution of silver nitrate, acetic acid and gallic acid which Talbot called his 'gallo-nitrate of silver solution'.

Commenting upon the extreme sensitivity of the resulting material, Fox Talbot said that in very bright sunlight an exposure time of 1 minute at f/16 in the camera was sometimes sufficient. The latent image was then developed by immersion in a solution of gallo-nitrate of silver. It was fixed in a solution of potassium bromide, later to be superseded by sodium thiosulphate (hypo).

Since both the daguerreotype and the calotype processes were protected by patents in England, their commercial exploitation was slow compared with other countries. The cost, both of equipment and materials, was high. The daguerreotype was a unique image affording high standards of definition, brilliance and tonal quality. The calotype, because of the fibrous nature of the paper used for both the negative and the salt paper positive print, had a softer, less sharp appearance. The photography of living subject matter was difficult in either process because of the long exposure times needed.

Although Fox Talbot's process was inferior insofar as the technical quality of the final image was concerned, it had the overwhelming advantage of being reproducible, for

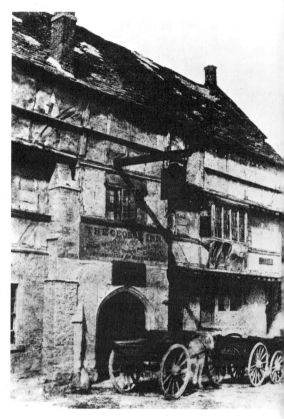

Below Modern print from a calotype negative. *The George Parker History of Photography Collection.*

Left Portrait group taken with the calotype process by W. H. Fox Talbot at the entrance to the cloisters of Lacock Abbey (c. 1845). *Lacock Abbey Collection.*

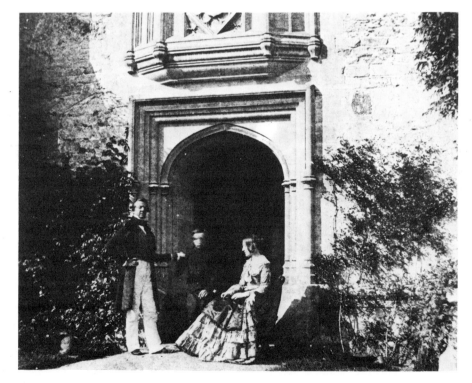

17

any number of positive prints could be made from the original negative.

The need for a negative/positive process which avoided the problems associated with the use of paper negatives and of sensitizers contained within the fibres of the paper was all too obvious to the photographers and scientists of the period. The solutions were to be provided by two individuals: Louis-Désiré Blanquart-Evrard, a clothing merchant from Lille in France, and Frederick Scott Archer, the orphan son of a butcher from Bishop's Stortford in England.

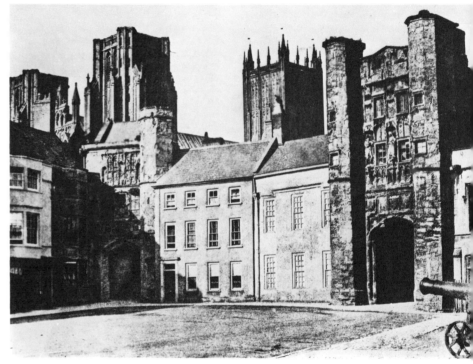

Below and Right Print from a calotype negative of Wells, Somerset together with a modern photograph from a similar viewpoint. *The George Parker History of Photography Collection.*

Right *Street View in Cairo* by Francis Frith (1858). The original is a gold-toned albumen print 20 × 16 inches.

Opposite top A collodion positive on glass (ambrotype) with an elaborately decorated surround.

Opposite bottom *The Nene at Wisbech* by Samuel Smith (probably taken in September 1861). Smith took up the calotype process around 1852 and took a large number of topographical photographs of the area around Wisbech. (See Millward & Coe *Victorian Landscape—the Work of Samuel Smith* Ward Lock, London, 1974). *The Kodak Museum, Harrow, Middlesex.*

The albumen print and the wet collodion process

An amateur calotypist and experimenter, Louis-Désiré Blanquart-Evrard answered the need for a printing process capable of competing with the ability of the daguerreotype process to record fine detail. In 1847 Niépce St Victor had experimented with glass plates coated with albumen (egg-white) as a support for the light-sensitive compounds for negative work. However, the exposure times required were too long for it to be acceptable, In 1848, following publication of the details of this process, Blanquart-Evrard coated thin, smooth paper with egg white before sensitizing. The result was a smooth, semi-glossy surfaced paper capable of retaining all the quality contained in the original negative. The details were communicated to the Academy of Sciences on 27 May 1850 and the process remained in general use until about 1890. It has been recorded that at the time the Albumenizing Company of Dresden in Germany, one of the largest manufacturers of albumenized paper, used upwards of 20 million fresh eggs per annum. Some of the yolks, which had no photographic use, were sold to cake makers but many had to be disposed of as waste.

The advantage of glass as a supporting base for negatives had been realized from the earliest days of photography. The practical difficulty was providing a transparent substratum coating which would adhere to the glass and at the same time act as a support for the light-sensitive salts. Sir John Herschel had made the world's first photograph on glass as early as 1839, but the preparation of the plate required many hours work and, in consequence, the process was an impractical one.

Frederick Scott Archer was a sculptor who had become a founder member of The Calotype Club in 1847. Archer utilized the recently discovered collodion as the sub-

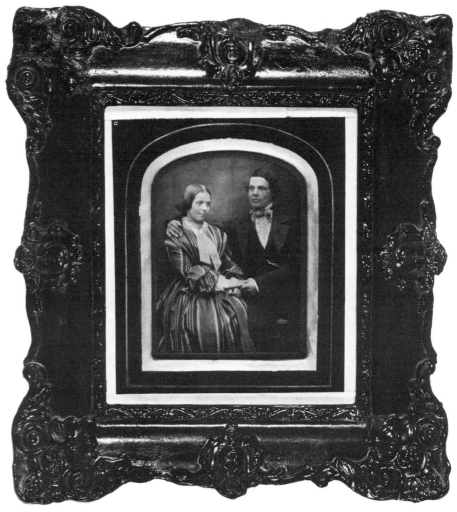

stratum coating. The method which he suggested, and which was published in *The Chemist* in March 1851, was to pour a small quantity of collodion, to which had been added potassium iodide, onto a clean sheet of glass. An even coating was obtained by tilting the plate. When the ether, which was the solvent in the collodion solution, had almost evaporated, the plate was treated in a solution of silver nitrate. The now light-sensitive material was then loaded into the darkslide and the exposure made while the negative was still moist. Once left to dry it lost its sensitivity. Arguably the most important single contribution to the development of the photographic process since its invention, the wet collodion process possessed the advantages of shorter exposure times than either the calotype or the daguerreotype and the use of a transparent base material which did

not interfere with the recording of fine detail and delicate tones.

Archer made no attempt to capitalize on his invention, apart from the small amount that he received from the publication of his book *The Collodion Process on Glass* in 1852. He died penniless five years later, living just long enough to see his process revolutionize photography.

Shortly after the announcement of the wet collodion process, it was noticed that if negatives which had insufficient density for normal printing were placed upon a black background the image appeared as a positive. Working in conjunction with Peter W. Fry, a fellow member and also the founder of The Calotype Club, Archer developed a technique which enabled this effect to be used commercially. By adding a small amount of nitric acid to the developing solution and under-

exposing and under-developing the negative, a suitable image could be obtained. The new process was widely used in portrait establishments in place of the daguerreotype. In England they were known as collodion positives on glass, but the American term for them, ambrotypes, became their popular name. Usually they were displayed in small cases such as those used for daguerreotypes or in frames for hanging. The common method of providing the black background was to apply a coating of black varnish paint to the back of the glass. Black velvet or black sheets of paper or, less frequently, deep red, blue or black glass were used for the same purpose.

The necessity to make the exposure while the emulsion was still damp created great difficulties for topographical photographers who had to take a portable darkroom or

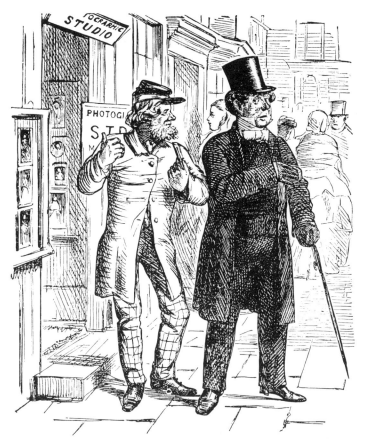

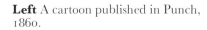

THE LATEST PHOTOGRAPHIC DODGE.

ARTIST-PHOTOGRAPHIC (to Clerical Old Gentleman). *"Here y'are, Sir; C'rrect Likeness warranted at this Establishment, Sir; Frame and Glass included, and Brandy and Water always on the Table!"*

Left A cartoon published in Punch, 1860.

Below Frederick Scott Archer (1813-57).

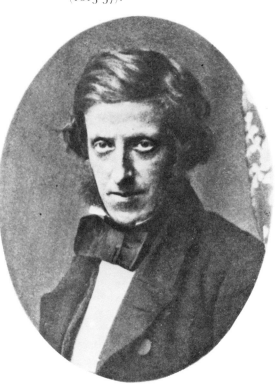

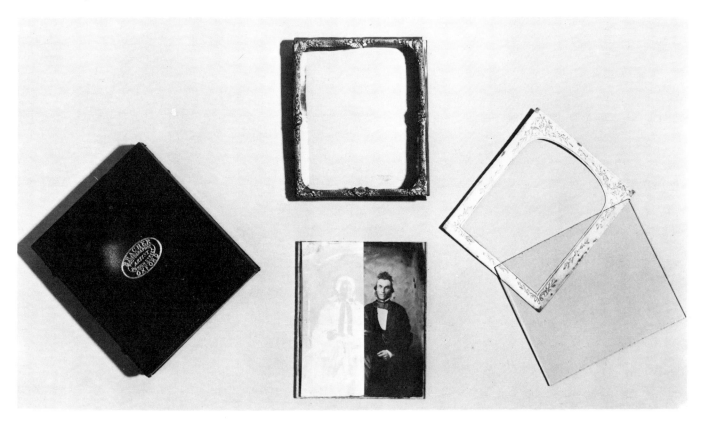

tent with them on their travels, and many scientists and experimenters directed their activities towards the production of a satisfactory dry collodion plate.

The first experiments were directed towards treating the plates with a substance which inhibited the plate from drying out. For this purpose a variety of substances were suggested, among them beer, tea, honey, coffee, raspberry syrup and extracts of rice, raisins and tapioca. A modification suggested by J. M. Taupenot, a French chemist, in 1855 enjoyed greater popularity than any others. He suggested that the sensitivity of the collodion could be extended by coating the plate with a film of iodized albumen. The plate was then dried and could be kept in this state for a week or so. A brief immersion in a silver nitrate bath was all that was required before it was exposed. The major disadvantage was that the plates required a rather longer exposure than the conventional wet collodion plates. Nonetheless it was used by such well-known photographers as James Mudd of Manchester and the architectural photographer Robert Mac-Pherson, who worked in Rome.

The first truly dry collodion plates were devised by Dr Hill Norris of Birmingham who was granted a patent for his process in 1856. He suggested that the prepared plates be coated with a solution of gum arabic or gelatine. They were then dried and could be packed in boxes for sale. Their speed was about half that of ordinary wet collodion plates, and a factory for their manufacture was established by Norris at Yardley, a suburb of Birmingham. They achieved a considerable popularity in a very short time, and were soon on sale on both sides of the Atlantic. In 1860 he introduced an improved version having twice the speed, and these were used by, among others, Francis Bedford, one of the most distinguished topographical photographers of the period who paid the sum of £2 per dozen for 12 × 10 inch plates.

Major C. Russell was another who suggested various modifications to the wet collodion process but none of them had any lasting success. He made a most important discovery though, that of the alkaline developer which has to take the place of the traditional acid developer and is still in universal use today.

An entirely different approach to the problem was made by two young members of the Liverpool Amateur Photographic Association. B. J. Sayce and W. B. Bolton, who was later to become Editor of the *British Journal of Photography*, worked from the precept 'prepare the sensitive silver salt within the collodion itself'. Sayce was only 27 and Bolton a mere 16 when their process was published in the *British Journal of Photography* on 9 September 1864.

By adding silver nitrate to a collodion emulsion containing cadmium bromide, they prepared a sensitive emulsion based on silver bromide rather than silver iodide,

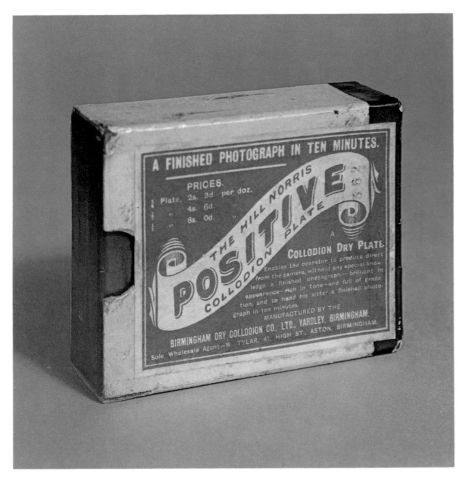

A FINISHED PHOTOGRAPH IN TEN MINUTES.

PRICES.
¼ Plate, 2s. 3d. per doz.
 4s. 6d.
 8s. 0d.

THE HILL NORRIS
POSITIVE
COLLODION DRY PLATE

A
COLLODION DRY PLATE

Enables the operator to produce direct
from the camera, without any special know-
ledge, a finished photograph—brilliant in
appearance—rich in tone—and full of grada-
tion, and to hand his sitter a finished photo-
graph in ten minutes.

MANUFACTURED BY THE
BIRMINGHAM DRY COLLODION CO. LTD., YARDLEY, BIRMINGHAM.
Sole Wholesale Agent—W. TYLAR, 41, HIGH ST., ASTON, BIRMINGHAM.

Opposite top An albumen print studio portrait of Miss Ellen Lusted (*c.* 1880).

Opposite bottom Smartt's portable darkroom tent showing the frame before being covered (*c.* 1870).

Left An original box of Hill Norris dry collodion plates.

with the silver bromide held in suspension within the emulsion. They also adopted the alkaline developer suggested by Russell.

Dr Richard Leach Maddox was responsible for the first successful 'gelatine dry plate'. His suggestions, which were published in the *British Journal of Photography* on 8 September 1871, attracted little attention at the time. It was a London photographer, John Burgess, who decided to attempt to improve the process and to undertake its commercial exploitation. In 1873 he marketed a ready-prepared gelatine emulsion for photographers to coat onto their own plates. It was slower than the wet collodion emulsions and did not become the commercial success that Burgess had hoped. In the following year Richard Kennett marketed a gelatine-based emulsion in pellicle form. The pellicles were dissolved in water and the emulsion then coated onto glass plates by the user. A year later he advertised that he could supply ready-coated plates. The

process of manufacture involved drying the emulsion by heat and this increased the speed.

Charles Bennett realized that it was the application of heat that was important, and devised a 'ripening process' of manufacture, details of which were published in the *British Journal of Photography* on 29 March 1878. The process was developed commercially by Wratten & Wainwright of Croydon, S. Fry of Kingston and Mawson & Swan of Newcastle, all of whom marketed gelatino-silver dry plates.

Their emulsions, basically similar to those in use today, were, however, only 'blue sensitive', but Hermann Wilhelm Vogel, a German professor of photochemistry in Berlin, discovered late in 1873 that treating collodion emulsion plates with certain aniline dyes made them sensitive to the colours absorbed by the dyes. This discovery led directly to the fully colour-sensitive materials of today. The early experiments extended the sensitivity from blue to

blue and green and these were called orthochromatic plates. Later this was further extended to include orange and red, and the first completely panchromatic plates were manufactured by Wratten & Wainwright in 1906.

Since the introduction of Archer's wet collodion process, glass had been the traditional base on which emulsions had been coated. It had two disadvantages: it was inflexible and it broke easily. A flexible roll of sensitive material had many advantages, the most important of which were flexibility, lightness and compactness. Early in the 1880s George Eastman, the American founder of the Kodak organization, introduced a paper negative material which was made transparent by waxing or oiling after processing. At first it was available as cut sheets, but in 1885 W. H. Walker designed a roll-film holder for Eastman which took a roll of the paper negative material sufficient for 24 exposures. This could be fitted to a conventional plate

23

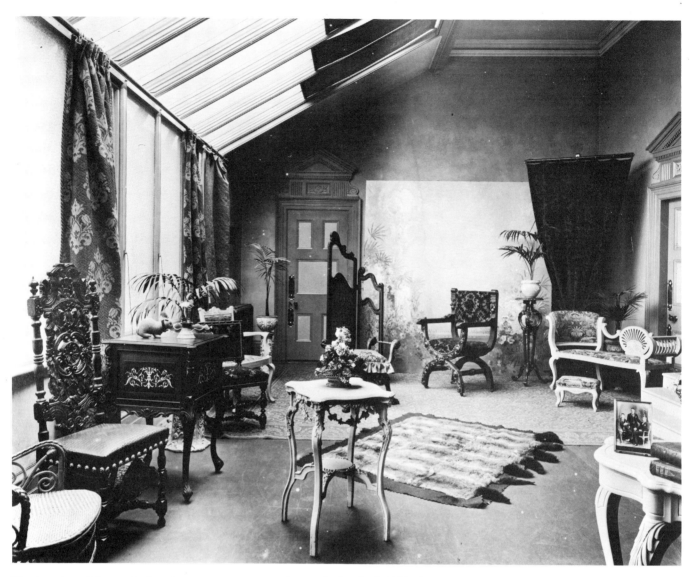

The interior of the professional portrait studio of Walter Baker at 159 Moseley Road, Birmingham at about the beginning of the twentieth century.

camera instead of a darkslide. Some ten years earlier L. Warnecke had introduced a roll-film holder using a length of sensitized paper sufficient for 100 exposures, and as early as 1855 A. J. Melhuish and J. B. Spencer had devised a holder for rolls of calotype paper, but neither had achieved any degree of popularity.

Following the introduction of a transparent stripping film given the name 'American film', Eastman called for a transparent, flexible and tough base on which to coat his emulsions. One of his chemists, Henry Reichenbach, developed the synthetic material 'celluloid' which had been invented by Alexander Parkes of Birmingham in 1861. A refined version of this material was introduced in 1889 for the new generation of Kodak roll-film cam-

eras and was, of course, the fore-runner of roll film as we know it today.

The cellulose nitrate based film was highly inflammable, a factor which was to influence the design of cinema projectors, and as it was not dimensionally stable it was unsuit-able for some scientific and photo-mechanical applications. The first of these objections was overcome by the use of cellulose acetate from the 1930s and the second with the introduction of polyester-based materials in the 1960s.

Paper prints

Reference has already been made to the albumen print process intro-duced by Blanquart-Evrard which remained in general use from the

1850s to the 1890s. The transition to gelatine-based emulsions took place during the 1880s, although gelatine had been used earlier for some of the permanent print processes which are dealt with in another chapter.

The first significant contribution was made by Peter Mawdsley, the founder and General Manager of The Liverpool Dry Plate and Photographic Printing Company, who in 1873 produced a silver bromide emulsion for print making. Mawdsley contributed an article on gelatino-bromide plates and papers to *The Year Book of Photography* of 1874 and in the same publication his firm advertised a gelatino-bromide paper which was said to be suitable for negative making, contact printing or enlarging. However, it was not until the 1880s that the commercial production of silver bromide and silver chloride printing papers was undertaken in quantity by such firms as Mawson & Swan at Newcastle-upon-Tyne, and Morgan & Company, both of whom advertised bromide printing papers.

By the beginning of the twentieth century the variety of printing papers available and the number of firms producing them was considerable, as the following summary compiled from some of the advertisements in the *British Journal of Photography Almanac* for 1905 shows:

Silver Halide Print-out Papers
Commonly known as P.O.P. these emulsions are characterized by not requiring to be developed. The negative and a sheet of the paper were placed in contact in a printing frame and exposed to a light source of high intensity such as sunlight. When the print was sufficiently dark, it was toned to improve the colour and fixed.

Available as either gelatino-chloride or collodio-chloride papers.

Silver Halide Developing-out Papers
Available as either silver chloride or silver bromide emulsions. The former were slow (requiring a long exposure), could be handled in any subdued light and were generally used for contact printing. The latter were much faster, needed to be handled in a darkroom illuminated with an appropriate safelight, and were used mainly for making enlargements.

Both types were available in a variety of surfaces from glossy to 'carbon matte' and with surface textures from smooth to rough.

Almost all forms were available from the following firms:

Cadett & Neall, Limited, Greville Works, Ashtead, Surrey.

Elliot & Sons, Limited, Park Road, Barnet, Hertfordshire.

Thomas Illingworth & Company Limited, The Photo Works, Willesden Junction, London.

Ilford Limited, Ilford, London

Kodak Limited, Harrow Works, Wealdstone, Harrow, Middlesex.

Kosmos Photographics Limited, Letchworth, Hertfordshire.

Leto Photo Materials Company Limited, 9, Rangoon Street, London.

Marion & Company Limited, 22 & 23, Soho Square, London.

Morgan & Kidd, Kew Foot Road, Richmond, Surrey.

Wellington & Ward, Elstree, Hertfordshire.

The permanent processes

The major problem which confronted the early photographers and inventors was the comparatively short life of many of the prints that they produced. The importance of adequate fixing and washing was not entirely appreciated, and the nature of the albumen print process was such that neither of these operations could be carried out to archival standards. In consequence both photographers and chemists worked with a common aim; that of producing an image which was as permanent as the glass or paper upon which it was based.

It was known that the images formed by light-sensitive silver salts were essentially fugitive in a long-term sense, and so attempts were made to use other metallic compounds or to convert the silver-based images into a more stable form.

Of the earliest attempts, one of the more successful was suggested by Mongo Ponton, a Scotsman who was Secretary of the Bank of Scotland. On 29 May 1839 he delivered a paper to the Society of Arts for Scotland, of which he was then Vice-President, on the subject of 'A cheap and simple method of preparing paper for photogenic drawing in which the use of any salt of silver is dispensed with'. The process was based upon his discovery that 'when paper was immersed in the bichromat of potash alone, it was powerfully and rapidly acted upon by the sun's rays'. Again in his own words 'the result exceeded my expectations'. If an object was placed on a sheet of paper treated in this way, the parts exposed to light changed colour to a deep orange in proportion to the intensity of the light. Stabilization was achieved by immersion in water when those salts unaffected by the action of light dissolved out of the paper. He drew particular attention to the cheapness of the process. For an outlay of £1, 4 oz of silver nitrate or 128 oz of potassium bichromate could be purchased. A full account of the meeting was published in the *Magazine of Science* dated 6 July 1839.

In 1852 William Fox Talbot was granted a patent based upon his observations that a light-sensitive substance could be prepared by mixing solutions of potassium bichromate and gelatine. Exposure to light hardened the bichromated gelatine whereas those parts unaffec-

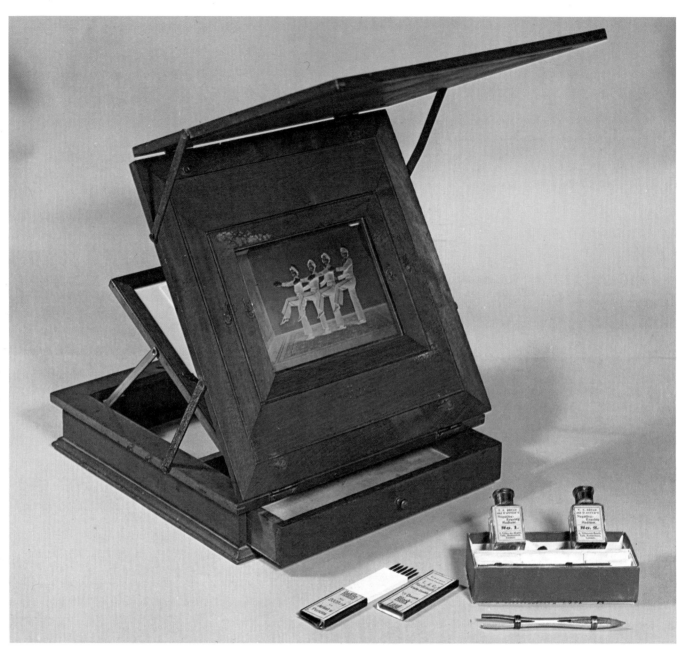

A late Victorian retouching desk together with retouching materials.

ted by light remained unhardened and could be dissolved in warm water.

In 1855, Alphonse Louis Poitevin, a Frenchman, was granted a patent for an ink printing process based on the use of the relief surface as the printing plate.

It was this principle that was adopted by Walter Bentley Woodbury for his woodburytype process, and by Joseph Wilson Swan for his carbon printing process. Woodbury was granted a patent (No. 2338, 1864) for the process which is arguably the most beautiful reproduction process for photographs ever devised.

A relief image in gelatine was prepared by contact printing the original negative onto a sheet of bichromated gelatine. This matrix was then placed on the surface of a sheet of lead, usually about a quarter of an inch thick, and the sandwich placed in an hydraulic press under a pressure of about 5 tons per square inch. The result was a reversed image of the matrix in relief in the lead which was then used as a mould to produce the final image.

A solution of gelatine incorporating a pigment of the desired colour was prepared, and while still warm and fluid this was poured onto the lead mould which had previously been placed in a small hand press; a piece of paper was placed on top of it and the press was closed. The excess pigmented gelatine was squeezed out at the sides. When the gelatine had set the press was opened and the piece of paper, now bearing the

coloured gelatine image in which the dark shadow areas were represented by a thick section of coloured gelatine and the highlight areas by a thin section, was removed. The print was then trimmed and mounted. If a transparency was required a piece of glass was substituted for the paper. The cost of the preparation of the mould and the complexity of the equipment required made the process unsuitable for single prints or short runs of prints. It was used extensively for book illustration during the period 1870-1890 but the invention of three photo-mechanical printing processes—the collotype of Ernest Edwards in 1870, the photogravure process of Karl Klic in 1879 and finally the introduction of the ruled half-tone screen by Max Levy, based upon a suggestion made by his brother Louis in 1886—inevitably led to its decline.

The first carbon prints were produced in 1858 by John Pouncy. He used gum and hot gelatine as the vehicle of suspension for the pigment, but did not make a complete disclosure of his method because Poitevin's patent was still valid. In the early 1860s Joseph Wilson Swan, a partner with John Mawson in the firm of Mawson & Swan of Newcastle-upon-Tyne, started to experiment using a pigment in a solution of gelatine, and was granted a patent on 29 February 1864.

A brief description of the process appears in Cassell's *Cyclopedia of Photography* edited by Bernard Jones and published in 1911.

'It depends for its working on the fact that gelatine, to which has been added a suitable proportion of an alkaline bichromate, becomes insoluble when exposed to light, but retains its solubility if kept in the dark. A sheet of paper is coated with a mixture of gela-

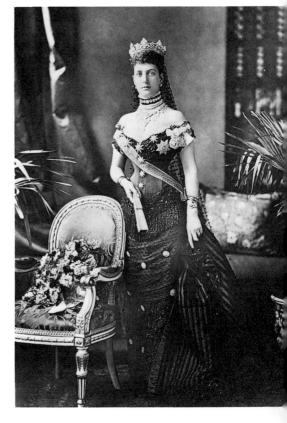

Below Her Royal Highness Princess Alexandra of Wales from a woodburytype by Waterlow & Sons. She was a very enthusiastic photographer and with other members of the Royal Family attended lessons at the London Stereoscopic School of Photography during the 1880s.

Left A fine hand-coloured carbon print on a sheet of opal glass (*c.* 1880).

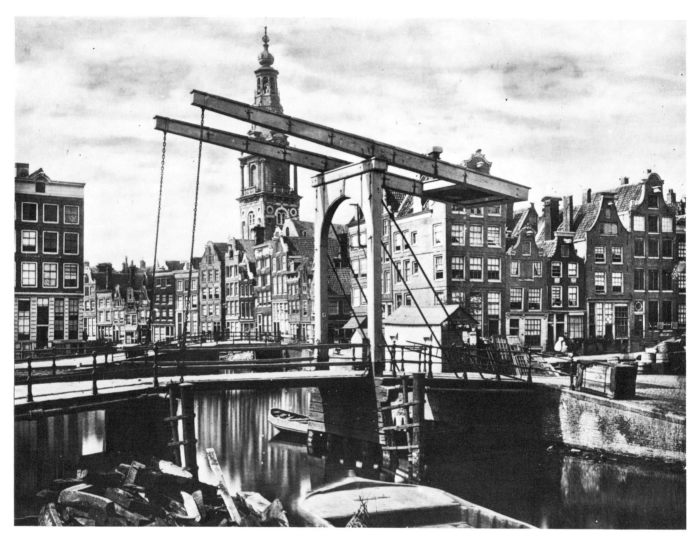

tine, colouring matter and potassium bichromate, and then exposed to daylight under a negative. The proportions of the gelatine film that are protected by the high-lights or dense parts of the negative retain their solubility, while those that receive the full force of the light through the shadow portions become insoluble. Parts exposed under the intermediate tones become partially soluble. By treating the film with hot water, the soluble portions are washed away while the insoluble parts remain and form the picture. Any colouring matter may be employed, and consequently a picture may be produced in any desired colour.'

To allow the warm water to act on the unhardened parts which are, of course, on the underside of the image, this must be stripped off the original support and laid 'upside down' on another support. If the image is left like that the result will be a laterally reversed picture. If it is necessary for the picture to be the right way round then it must be transferred once again to the final support.

Either of these supports could be of almost any material. The commonest were paper and clear glass depending on whether the image was required for viewing by reflected or transmitted light. Some very fine pictures were obtained by making the transfer onto opal glass, artificial or real ivory or pottery or porcelain, and such images were often hand coloured.

Since the final image in the case of both the woodburytype and the carbon print consists of a suspension of pigment in gelatine, both are completely permanent and a number of the leading pictorial workers, of whom we might mention Craig Annan, Edward J. Steichen and Alexander Keighley, used the prints for their exhibition.

The alternative approach to the production of permanent prints by the use of metallic salts other than silver was being investigated by a number of experimenters. One of the results of these experiments was the granting of a patent to William Willis in 1873 for a printing process using platinum. Difficulties associated with its commercial production delayed its introduction until the establishment of the Platinotype Company in 1879. Unfortunately it was a costly process and after the dramatic increase in the price of platinum immediately before the Great War its sales rapidly dropped.

It was arguably the finest and most satisfying of all the printing processes available to the photographer which could be used to make single prints. It was used almost exclusively by the English architectural photographer Frederick H. Evans and also by Baron de Meyer for his portraits.

George Eastman and roll film

The influence and direction given to photography by the amateur is remarkable and George Eastman, who was born at Waterville, New York on 12 July 1854 and who died by his own hand on 14 March 1932, was an outstanding example.

The paraphenalia of early photography was extremely cumbersome. Massive tripods were needed to support the large cameras during long exposures. The chemicals had to be on hand for immediate use. The crates of glass plates were heavy. Photographers working in remote places employed teams of porters, as did Samuel Bourne in the foothills of the Himalayas, or converted wagons as did Fenton in the Crimea, or used an adapted boat as did Frith on his journeys up the Nile.

The advent of the dry plate did much to 'lighten the load' but what the amateur photographer and the professional explorer alike required was lightweight equipment which required a minimum of technical knowledge to operate. It was George Eastman, businessman and entrepreneur, who was to provide the answer.

Born three years after the introduction of the collodion wet plate process, fatherless at the age of eight, George, his mother and two sisters were forced to live in somewhat reduced circumstances. Mrs Eastman took in lodgers and the children undertook any odd casual jobs that they were able to obtain.

He left school when barely 12 to start work as an errand boy with an insurance company. At the age of 20 he became a bookkeeper with the Rochester Savings Bank and was able to take over financial responsibility for the family. Soon afterwards he became interested in photography and having little artistic flair concerned himself with the technical aspects of his new hobby.

Initially his main interest was with the making of dry plates and gelatine emulsions. Eastman carried out his own experiments based on the publication in the *British Journal of Photography* on 29 March 1878 of a description of the work of Charles Bennett. He soon formulated a method of making reliable and consistent plates and turned his inventive mind to methods of mass production and marketing. Within a year he had designed a plate-coating machine and came to England to patent it in July 1878. Returning to America he set up a factory and arranged with the photographic supply house of E. & A. Anthony for them to market his plates. Difficulties were experienced with plates losing their sensitivity during storage and many complaints were received from customers. Eastman replaced all the defective material, but was unable to resolve his production problems.

In 1882 in company with Colonel Strong, his partner in The Eastman Dry Plate Company, he returned to England and visited the Mawson & Swan plate factory at Newcastle-upon-Tyne, where he was given every assistance in solving his problems. Business increased and in 1884 the firm became a corporation with Colonel Strong as President and George Eastman as Treasurer.

Pursuing his ambition to 'lighten the load' he succeeded in coating a gelatine emulsion onto thin paper which was made translucent after processing by using wax or castor oil. He marketed this material in standard sheet sizes in 1884. The next step was almost inevitable. A camera manufacturer, William H. Walker, joined the Company in the same year. Eastman suggested the possibility of producing the paper negative material in roll form. Walker designed a holder which

Above A platinotype print by Whitlock's of Birmingham of Mrs A. M. Griffiths, of 'Thornbury', Edgbaston, Birmingham taken in 1902.

Opposite *Amsterdam* by Adolphe Braun (1811-77). An example of the topographical work of this outstanding French photographer.

Right *Evening at Buttermere* by G. L. Hawkins, F.R.P.S. A bromoil transfer. *The Kodak Museum, Harrow, Middlesex.*

Bottom A bromoil portrait by Arnold E. Brookes, F.R.P.S.

could be attached to the back of most plate cameras in place of the standard darkslide. Although not the first roll holder using paper negative material it was the first successful one.

Later in the same year Eastman introduced his 'American film'. This was a roll of paper which was first coated with a solution of unhardened gelatine so that it could subsequently be dissolved away using warm water in the later part of the process, followed by a layer of collodion upon which the gelatine emulsion was then coated. After exposure and during the processing sequence the soluble gelatine layer was softened by the application of warm water and the light-sensitive emulsion floated off the paper base. The emulsion, now bearing the negative image was then transferred to a suitable transparent base such as glass for printing.

In November 1886 a patent was granted to Eastman and F. M. Cossett for a box camera having an internal film holder which was interchangeable with a conventional darkslide. The mechanism was complicated and in consequence the cost of production was high and very few were sold. Brian Coe, the Curator of the Kodak Museum at Harrow,

records in his book *The Birth of Photography* that in 1888 Eastman sold a job lot of 40 of them to a dealer and ceased production.

Almost immediately he marketed the first roll film camera, adopted the trade name 'Kodak', introduced the slogan 'You press the button, we do the rest' and in the following year, 1889, introduced the first roll film coated directly onto a transparent base. This had been developed by his chemist Reichenbach using celluloid as a base.

It was this application of celluloid that was to revolutionize photography and open the way to the design of cameras for making 'movies'.

The Numbers 1 and 2 Kodak took circular pictures, $2\frac{1}{2}$ inches and $3\frac{1}{2}$ inches in diameter respectively. In 1890 the Numbers 3 and 4 were produced for quarter plate and 5×4 inch size pictures. A Number 4 with a capacity of 250 exposures was the camera which Admiral Peary took with him on his Polar expedition.

George Eastman had achieved his primary objective. He had simplified the photographic process and made available to everyone.

Eastman's greatest strengths were his ability to select and attract to his organization individuals of the highest calibre long before their full potential became apparent and his strong sense of independence which manifested itself in his policies of buying patent rights rather than paying royalties.

The control processes and their inventors

The basis of all the control processes is that the final image is composed of a substance which is not light-sensitive and which was not used in the formation of the original image on which the picture is based.

Like most of the permanent processes that have already been considered, they are derivatives of the experiments with bichromated gelatine undertaken by Mongo Ponton and Alphonse Louis Poitevin. They differ essentially in that the original negative becomes no more than a preliminary sketch for the creative manipulation that takes place during the printing process. Each finished print is truly an original picture, since it is almost impossible to ensure that the controls exercised during its making are precisely duplicated in any further prints. The controls available to the photographer include choice of base paper colour, choice of image colour or colours, modification of density and contrast by controlling the quantity of pigment used either overall or locally, and even the surface texture which could be varied by the control of the amount of medium used in the pigment and by choice of the type of bristle or hair used in the brushes.

The finished pictures, particularly those which used oil based pigments, often bore more than a superficial likeness to oil paintings or etchings. The acknowledged masters of the pigment processes were certainly artists in every sense of that word and some of them demonstrated their artistic abilities in other more conventional forms of artistic expression.

The earliest of the control processes was the carbon print, a brief description of which was given in the section on the permanent processes. The mass production of carbon pigment tissues in a wide range of colours was commenced in 1868 by The Autotype Company and continued until the 1940s. Their advertisement in the 1910 *British Journal of Photography Almanac* lists 37 colours at prices of between 6/6d and 8/- ($32\frac{1}{2}$-40p) per roll, each 12 ft long and 30 inches wide.

The process required a negative of the same size as the desired size of the finished print. Briefly it was a contact printing process permitting neither enlargement nor reduction directly. It was, of course, possible to make a positive by contact and then from that to make a new negative of the required size by projection printing. This was cumbersome, costly, particularly if a large print was required, and often led to some loss of resolution and undesirable changes in density and contrast. The only advantage of such a technique was that retouching was much easier on the larger sized negatives.

Derived from it was the 'ozobrome' process of Thomas Manly which was introduced in 1905. He was working from an observation by Howard Farmer that bichromated gelatine could be rendered insoluble. A normal print was made on bromide paper to the required size and this was then placed in contact with a sheet of sensitized carbon tissue, exposed and then processed as for a normal carbon print. The process was developed on a commercial basis by The Autotype Company under the trade name 'carbro' (CARBON-BROMIDE), and was practised until the Company withdrew the sale of carbon tissues in the 1940s.

In 1904, G. E. H. Rawlins introduced the first of the oil processes for pictorial photographers. A sheet of gelatine-coated paper was sensitized using a solution of potassium bichromate, and a contact print, using a negative of the same size as the required final print, was made by exposure to daylight. The negative had to be of rather higher contrast

Three pictures taken with a Number 1 roll-film Kodak camera.

and density than was desirable for normal printing. The exposure caused a hardening of the gelatine in proportion to the gradations of the original negative. Stabilization was achieved by washing out the potassium bichromate with water. It was essentially a carbon print but without any pigment. The print was then placed in a tray containing very tepid water. The water was absorbed by the gelatine in inverse proportion to the degree of hardening that had taken place. The image was then formed by applying a rather stiff oil-based pigment to the surface with a stiff brush using a 'dabbing' action. Because oil and water are not compatible the pigment adhered to the surface in inverse proportion to the amount of water that had been absorbed. The shadows which had been hardened the most absorbed little or no water and consequently 'took' the ink freely. The highlights, which had remained unhardened, protected by the high densities of the negative during exposure, absorbed the water freely and therefore repelled the ink. Manipulation of the temperature of the water bath, of the viscosity of the ink and of the brush technique enabled modifications of both contrast and density to be effected.

In 1907 E. J. Wall and C. Welbourne Piper suggested and developed techniques for extending the process to enlargements. The image on a normal bromide print was bleached in a solution which at the same time hardened the gelatine in proportion to the density of the silver image. The print was then inked in the same way as an oil print. The new process was called 'bromoil' (BROMIDE-OIL). If desired, the pigment image could be transferred to any other suitable support by placing a sheet of the new paper on top of the pigmented picture, before the ink dried out, and passing the sandwich between a pair of rollers or a lithographic roller press, when the ink image was transferred to the new support. The original print could then be re-inked

and used again. Such prints were known as bromoil transfers. Because the final image in these processes was a pigment one applied by a brush it had a resemblance to more traditional art processes.

The gum-bichromate process derived from the experiments of Alphonse Louis Poitevin and John Pouncy during the 1850s and 1860s have already been mentioned under the section on the permanent processes. It was revived and improved by Robert Demachy during the period 1894-97. His father, Charles Adolphe, was the founder of the highly successful French bank which bore the family name. Robert himself had no interest in a banking career but its success enabled him to pursue his artistic interests. He was not only one of the finest of all pictorial photographers, he was a thoughtful, if somewhat controversial writer and speaker on the subject.

The gum-bichromate process, like most of the control processes, was based on the use of potassium bichromate but this time in association with gum and not gelatine. A suitable coloured pigment was mixed with a solution of gum and potassium bichromate and then applied to a sheet of paper like a water colour wash and allowed to dry. The print was made by contact using daylight as the light source and the unhardened unexposed areas were then washed away by soaking in water. Some control could be obtained by varying the temperature of the water.

In order to obtain half tones it was necessary to make multiple printings and the photographer could achieve the required densities either by a series of similar coatings of gum and bichromate, allowing the print to dry between each successive exposure and coating and varying the time of each exposure, or by variation of the amount of bichromate in the solution or by using successive coatings of different thickness. Colour could be introduced by the use of a different

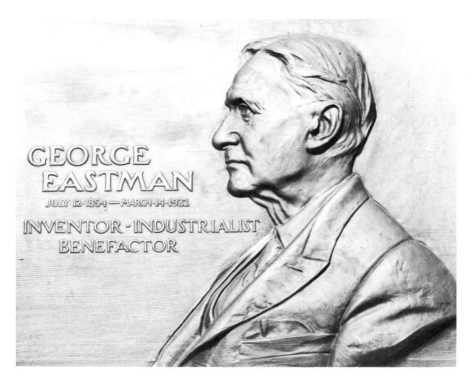

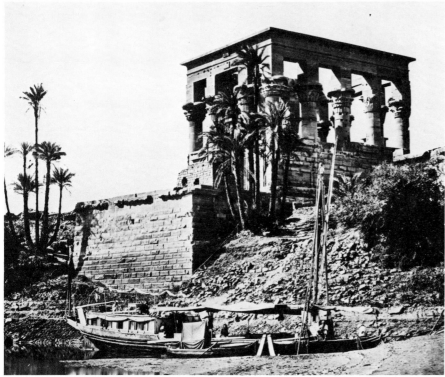

Above *The Hypaethral Temple—Philae* by Francis Frith (1858). The boat in the foreground was used by Frith as a travelling darkroom on his journey to the upper reaches of the Nile.

Top A plaque commemorating the achievements of George Eastman. *Kodak Museum, Harrow, Middlesex.*

coloured pigment for each printing.

The size of gum bichromate prints is limited by the size of the negative and consequently most are of modest dimensions, but large prints can be made either directly from a large original negative or from an enlarged negative made by projection.

Photography in colour

From the earliest days of the daguerreotype and the calotype photographers had dreamed of being able to produce pictures in full colour rather than in just tones of grey, or monochrome as we call them now. Before advancements in emulsion technology made a reality of these dreams it was not unusual for the better class of photographic establishment to offer a colouring service to their clients.

Daguerreotypes and prints made from calotype negatives were often hand coloured, but in our experience many more of the former have survived and their colouring was, in general, of a much higher standard both technically and artistically.

Paper prints were usually coloured using diluted watercolour paints. Because of the fragile nature of the image on the daguerreotype plate a different technique had to be used. The various colours, in dry form, were ground together with some gum arabic into a very fine powder. This powder was then dusted onto the plate and fixed in position usually by breathing upon it. A number of manufacturers produced colouring outfits and many of the early textbooks included directions for hand colouring.

In some cases the image was not coloured but gold paint or gold leaf was applied to various parts of the picture such as jewellery, gilt embossing on books, brass fitments on furniture and even on microscopes and telescopes. Images that have been treated in this way are often described as being 'heightened in gold'.

The introduction of Blanquart-Evrard's albumen printing paper

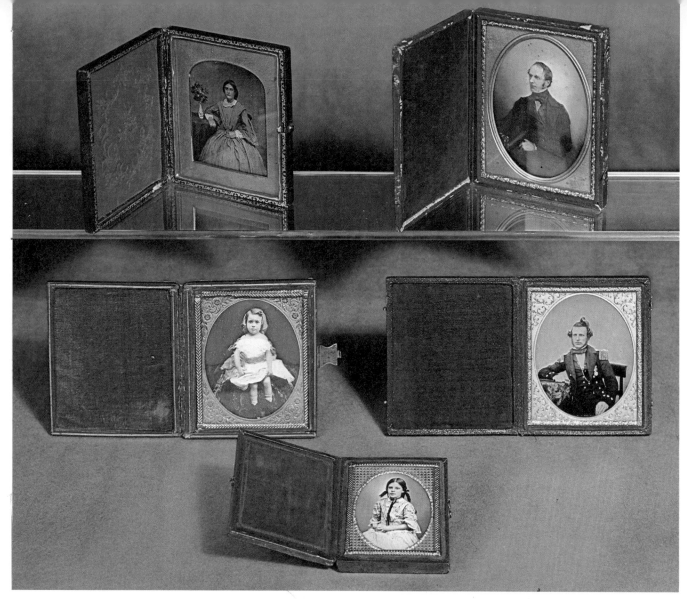

and the collodion positive on glass (commonly known as the ambrotype) derived from Scott Archer's wet collodion process, made little difference other than modifications in the pigments and their method of application.

Although the carbon process could be used to make prints of almost any single colour and was ultimately adapted to produce full colour images, what was required was a marriage of the 'photographic process' and the 'trichromatic theory of colour vision'.

There are two distinct concepts of colour reproduction by the photographic process: additive and subtractive. A brief description of the principles of each method should enable the reader to follow the historical development of colour processes with greater interest.

Both systems rely on the initial breakdown of the scene into three basic component colours: blue, green and red. Dr Thomas Young elaborated the original observations of Sir Isaac Newton in his paper delivered at a meeting of The Royal Society in 1801 into what is now generally known as the 'trichomatic theory of colour vision'. This demonstrates that all colours are a mixture in some degree of the three so-called primary colours: blue, green and red. If a set of three photographs of a subject are taken on a material which is sensitive to these colours through three filters, each of which transmits or passes only one of the colours, each of the resulting black and white (monochrome) negatives will have recorded the colour component of the original scene represented by the colour of the filter through which it was taken. Three such negatives are usually referred to as a separation set, since they separate the colours of

Examples of hand-coloured collodion positives on glass (c. 1860).

which the original scene was formed. Briefly the original scene will have been broken down into its three component colours.

Monochrome images are then prepared from each negative on a transparent material. These of course will be positives. It is at this stage that the additive and subtractive theories diverge. The former adopts the concept that by adding together beams of light of the three primary colours, white light is formed. The latter adopts the opposing concept of starting with a beam of white light and subtracting from it those colours that are not needed to form the colours of the original scene.

Any filter passes (i.e. transmits) its own colour and absorbs (i.e. does not transmit) its opposite colour.

Primary colours	*Complementary colours*
Blue	Yellow
Green	Magenta
Red	Cyan

The first practical demonstration of the additive concept as applied to photography took place on 17 May 1861. James Clerk Maxwell described in detail the experiments which he had begun in 1855. In the course of the lecture he used three magic lanterns to project positive images made from the three blue, green and red separation negatives of a piece of tartan material. These had been prepared for him by Thomas Sutton. Sutton, Editor of *Photographic News*, had compiled the first dictionary of photography in 1858 and had designed a number of cameras and lenses.

When the three images were projected through filters, similar to those used to take the original negatives onto a screen, and superimposed they combined to produce a colour picture of the original tartan. Although far from being a perfect reproduction of the original the demonstration showed that the principle was a valid one, and that for optical purposes the primary colours were blue, green and red and not blue, yellow and red which were the primary colours of the painter.

Although the truth of the demonstration was accepted at the time the validity of it was questioned in modern times. The photographic emulsions available at the time were sensitive only to blue light, so theoretically the plates exposed in the camera through the green and red filters should have had no image on them. In fact it was not until 1906 that emulsions sensitive to the whole of the visible spectrum (i.e. panchromatic) became commercially available.

The explanation of this paradox was provided in 1961 by Ralph M. Evans of the Kodak Research Laboratory in the United States. He showed that the red liquid filter used by Sutton, which was a solution of sulphocyanide of iron in water, transmitted some ultraviolet radiation as well as the visible red and that by coincidence the red dyes in the tartan material also reflected ultraviolet radiation. Therefore, an image of the red component part of the tartan was recorded on a plate that was insensitive to red. The green image was obtained by using a dilute solution of copper chloride in water as the filter and this transmits a small percentage of blue light; it was this blue light that was recorded on the plate.

The subtractive concept takes as its starting point a beam of white light and by means of filters subtracts from the beam those colours that are not required.

Each of the complementary colours absorbs (i.e. subtracts) its opposite primary colour, and transmits the other two.

Complementary Colour	*Transmits*		*Absorbs (Subtracts)*
Yellow	Green, Red	= Yellow	Blue
Magenta	Blue, Red	= Magenta	Green
Cyan	Blue, Green	= Cyan	Red

A little experimentation with some of the cellophane wrappings from sweets held in front of any white light should be convincing of the truth of the concept, whilst the more serious minded might obtain a set of complementary filters for the same purpose.

The principles of the subtractive concept were the subject of a patent granted to Louis Ducos du Hauron, one of the most remarkable of all photographic inventors and experimenters. Born at Langon, near Bordeaux in France, he was responsible for a number of inventions which were ahead of his own time. Fully colour-sensitive emulsions had not been produced at the time so the concept of subtractive colour synthesis as a means of producing a colour photograph had to lie dormant from the date of du Hauron's

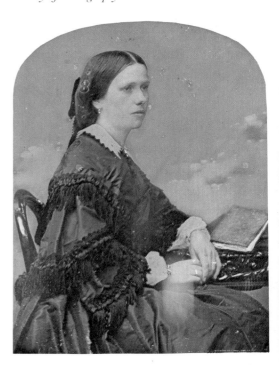

A fine hand-coloured daguerreotype portrait (*c.* 1850). *The George Parker History of Photography Collection.*

patent in 1868. The details were published in 1869 in a book, the first of a number to be written by him on the subject, entitled *Les Couleurs en Photographie; Solution du Probleme*.

All but a few of the early practical colour processes adopted the additive concept. It was an American, Frederick Eugene Ives, who adapted Maxwell's demonstration to a commercial product. By 1892 he had developed his colour camera and viewer, marketed under the name 'Kromskop', for single pictures and by the end of the century had designed a stereoscopic version. The production of the three separation negatives was accomplished quite successfully despite the fact that full panchromatic sensitivity was still to be achieved. By 1884 Vogel had extended the colour-sensitivity of emulsions through green to orange and this sufficed for the separation sets needed for the Ives' Kromskop.

Monochrome diapositives were made from the original separation sets and placed in the viewer which enabled them to be viewed superimposed one on another through filters similar to those used on the camera. The aim of most of the experimenters was to avoid the cumbersome nature of such a system which required a special viewer and three diapositives on glass.

Ducos du Hauron suggested in *Les Couleurs en Photographie* that a full colour picture could be printed if the filters used to produce the separation sets were in the form of a series of microscopically small blue, red and yellow dots, or lines, drawn onto a glass screen. This screen would then be placed in contact with the sensitive plate in the camera and was bound up in register with a positive on glass made from the resulting negative. The result would not have been entirely satisfactory because of his choice of yellow as one of the colours instead of the theoretically correct green.

Provided that the lines or dots were sufficiently small for them not to be capable of being viewed as individual units by an observer there was no reason why a satisfactory picture should not be obtained. Professor John Joly of Dublin commenced experimenting in around 1890 and presented a paper on the subject at the Dublin Royal Society in June 1896. He had developed a machine which ruled a series of parallel lines, each about 0.1 mm wide, across a glass plate. Using coloured dyes mixed with a gum to produce a series of lines, which touched each other but did not overlap, across the plate in the repetitive order of orange, blue-green and blue, he produced a suitable screen.

An orthochromatic plate was exposed with one of these screens in contact with it, the exposure being made through the screen onto the plate. After processing, the negative was contact printed to make a positive transparency on glass which was then bound in register with a

A set of colour separation positive images for the Ives Kromskop viewer.

similar screen ruled with red, green and blue/violet lines. It is essential that the register is exact otherwise there will be colour fringing.

A very similar process was devised by James W. McDonough of Chicago and patented in 1896. Originally the ruling was coarser than Joly's but when it was commercially introduced a standard of 300 lines per inch had been achieved compared with the 250 lines per inch of Joly's process. Neither process was a commercial success, mainly because of the difficulties of mass production of the screens.

In 1892 McDonough had registered a patent for a process which used as the filter screen a piece of glass which was given a thin coating of a tacky substance like gum arabic. A quantity of blue, red and green pellets of shellac was ground to form a very fine powder and intimately mixed. This random mixture was then scattered onto the tacky surface of the glass plate and varnished. So far as we are aware this method was not marketed at the time.

During 1904 Auguste Lumière and his brother Louis, who were born at Besançon in eastern France, announced that they were experimenting with a very similar process using a random mixture of dyed potato starch grains with the interstices between the grains filled in with powdered charcoal.

The photographic emulsion was then coated on top of the prepared screen and an exposure made through the glass and screen. A system of reversal processing was adopted which avoided the problems of registration. Early in 1907 the plates were available for sale to the general public and became an instant success. Examples were accepted for display at major photographic exhibitions and received many awards. Ultimately the Progress Medal of the Royal Photographic Society was awarded to the brothers in 1909.

Between 1907 and 1909 a number of processes were suggested by various experimenters. Of these the three most important were the 'Omnicolore' marketed by Jougla & Cie., the 'Thames colour plate' marketed by a firm of that name, and the 'Diopticolore' produced by Louis Dufay.

The Thames plate incorporated a screen composed of a series of red and green circles each about 0.05 mm in diameter with the interstices coloured blue. The other two both utilized systems of ruled lines.

The Diopticolore was the first of a series of ruled screen systems introduced by Louis Dufay which continued to be marketed until the early 1950s. It was introduced in 1909 as the 'Dioptichrome' plate, in 1932 as Dufaycolor cine film and finally in 1935 in a roll film form.

The last of the additive colour screen processes to be advertised was a revamped version of the Finlay colour screen plate first marketed in the late 1920s. Promoted in its new form by Johnson's of Hendon in 1953 it was only on sale for a comparatively short time.

The basic principles of the subtractive concept had been stated by Ducos du Hauron. He pointed out that the problem could be summarized in the following terms:

i) 'The design and manufacture of camera equipment which would produce the three negatives comprising the separation set by a single exposure. Unless this was achieved the photographer was restricted to inanimate or static subjects.'

ii) 'The formulation of methods of making the separation positives in the three complementary colours and superimposing them in a single integral pack.'

Whereas the additive screen plate processes using a screen which was integral with the emulsion needed but a single exposure to produce the image, the subtractive process needed three separate negatives each of which recorded one of the three (blue, green or red) colour components of the subject. Unless the subject matter was completely static all three had to be taken at the same moment. It was equally important that they be taken from the same viewpoint and by the same lens. Even the slight displacement of the lenses in a stereoscopic camera constitute two separate viewpoints making it impossible to obtain exact superimposition. The answer was the so-called 'one-shot camera' in which the image produced through a single lens was analyzed into the three component colours within the body of the camera and recorded on three separate plates. This was usually achieved by a beam splitting device in the form of either semi-transparent mirrors or a prism which directed the image into three distinct paths to the three negatives via blue, green and red filters; one of which was placed in each path. Some of these cameras are discussed in more detail later in this book in the section which deals with special purpose cameras.

The problems associated with the production of the positives and their superimposition concerned methods of controlling the processing of each of the images so that both their densities and contrasts as well as the spectral absorptions of the dyes used to produce the complementary positive images were all compatible.

Almost all the early subtractive colour print processes are based upon the characteristics of a bichromated gelatine film such as was used for Swan's carbon process to which reference was made in the section on permanent processes. By making a set of three positive transparencies on carbon tissues coloured cyan, magenta and yellow and then mounting these in register on a suitable support a picture in full colour was obtained. However, this depended on having original negatives of the same size as the required print. In 1905 Thomas Manly introduced his ozobrome process, the commercial version of which was the Autotype Company's carbro process. Some 15 years previously Howard Farmer, the lecturer in charge of

Opposite top The Aptus ferrotype camera made by Moore & Company of Liverpool was very popular with the seaside and fairground photographers during the 1930s. It had a diaphragm shutter mounted in front of an f/4.5 lens which was set in a helical mount.

Right A carbon process cabinet portrait by Frank Meadow Sutcliffe.

Below The Mikut 'one shot' colour separation camera introduced in 1936.

Opposite bottom An Agfacontour process print by W.J. Chignell (1976).

Frank M. Sutcliffe Whitby in Yorkshire.

photographic studies at The Polytechnic of London had noticed that a bichromated gelatine film could be hardened not only by exposure to light but also in a process in which the potassium bichromate is reduced to chromium salts. It is the chromium salt which is responsible for hardening the gelatine. Manly utilized this attribute to avoid the necessity of having an original negative of the same size as the final print. By making a print either by contact or enlargement to the required size and then rolling it into intimate contact with a sheet of carbon tissue the tissue was hardened in those places where it was in contact with the silver image. The depth of penetration of the hardening was proportional to the density of the silver image. When the two were parted the tissue was processed as a conventional carbon print would have been. Prints in full colour could be obtained by making bromide prints from a separation set and then proceeding as for a carbon colour print.

Although other processes based upon somewhat similar principles were proposed the 'tri-chrome carbro' process was predominant and the prints produced during the 1930s under the trade name of Vivex are amongst the finest and certainly the most permanent of all photographic colour prints.

'How much easier the process would be were it possible to make the separation set on one plate.' This is a quotation from an old photographic notebook the writer of which probably never lived to see his dream come true. Certainly Ducos du Hauron, the most far-seeing of all Victorian experimenters did not live to see his patent of 1895 for an integral tripack emulsion blossom forth in 1935 as Kodachrome. The principle was used for a number of processes between 1915 and 1930 but none of them were very successful. However, two American professional musicians Leopold D. Mannes and Leopold Godowsky, who had experimented in photo-

graphy since their school-days together at the Riverdale School in New York, initiated the research which led to the first successful subtractive integral tripack colour reversal film—Kodachrome—in 1935. In 1965 they were jointly awarded the Progress Medal of The Royal Photographic Society.

Although the basic idea was a simple one, the technological difficulties were considerable: coat onto a film base three light-sensitive emulsions one on top of each other, each one to record one of the colour components of the original scene; reversal process these to positive images; dye them in the complementary colours and then bleach out the original silver image. The technical problems were to make the three emulsions sufficiently thin to avoid optical sectioning when the transparencies were projected to prevent migration of chemicals and dyes between the various layers and to ensure compatibility of density, contrast and film speed between the three.

In its final version the order of the layers was:
1. Protective layer.
2. Blue-sensitive photographic emulsion.
3. Yellow filter (to absorb blue light).
4. Blue and green-sensitive photographic emulsion.
5. Gelatine anti-migratory layer.
6. Blue and red-sensitive photographic emulsion.
7. Base.

Since all photographic emulsions possess a basic blue sensitivity it was necessary to introduce a yellow filter (minus blue) so that the layers beneath recorded only the green and red colour components of the subject.

The original material had the colour forming couplers incorporated in the processing solutions and because of the complexity of the technology had to be processed by the manufacturer or by a special laboratory. Materials of this type are

known as non-substantive emulsions. Later materials such as Kodak's Ektachrome introduced in 1946 had the colour couplers incorporated within the emulsion layers and are known as substantive emulsions. Materials of this type may be processed by the user.

An alternative approach was proposed by an Hungarian chemist, Dr Bela Gaspar and appeared in its original form under the name Gasparcolor in 1934 as a positive material for making colour release prints from three separation negatives for the motion picture industry. The British film *Trade Tattoo* released in 1936 was produced by this process.

Instead of producing the coloured images in each layer during processing Gaspar incorporated layers of the three complementary dyes (cyan, magenta and yellow) within the tripack emulsion. The final full colour image was formed by destruction of the dye in those areas in which it was not required to form the final image. It was, in consequence, known as 'the dye destruction or silver dye bleach process'. The present day Cibachrome process is based on the same principle.

The tripack materials that we have so far considered have been concerned with the production of transparencies and although materials have been produced within the last decade for the making of prints from transparencies the majority of colour prints are made from colour

negatives produced on a tripack material.

The film that is used to produce colour prints is essentially similar to the reversal material used for making positive transparencies. It is the processing technology that differs. Instead of introducing a reversal stage to produce positive images in each of the three emulsion layers, the images are retained in their negative form and in their complementary colours of cyan, magenta and yellow. The majority of colour negative materials incorporate an overall orange coloured mask the purpose of which is to correct the deficiencies of the magenta and cyan dyes. The magenta dye which should absorb only the green also absorbs some blue-violet. The cyan dye which should absorb only red also absorbs to some extent both blue and green. Fortunately the yellow dye is much more efficient and absorbs very little other than blue-violet. The cumulative effect is that the reds and yellows are too bright and the greens and blue-greens are too dark. By incorporating a selective overall orange mask compensation is achieved and a good quality print can be produced.

The colour negative is printed onto paper which is coated with a similar tripack emulsion. Dr W. T. Hanson of the Kodak Research Laboratories was responsible for much of the original research.

The first colour negative film available to the general public was the second generation Kodacolor first marketed in America in 1942. It is necessary to distinguish it in this way because the name had been used for a lenticular 16 mm cine colour transparency film based on the patents of two Frenchmen, R. Berthon and A. Keller-Dorian, and marketed by Kodak between 1928 and 1937.

Instant pictures

The earliest of what might be called the instant picture dates from the wet collodion era. Adolphe Alexandre Martin delivered a paper to The French Académie des Sciences in 1853 in which he described a variant of the collodion positive on glass process (the ambrotype). Instead of backing a suitable negative image with black paper, velvet or varnish he suggested that the emulsion should be coated directly onto a thin sheet of tin plate or iron. It was this association that gave them their traditional name of 'ferrotypes', although later they were popularly known as 'tintypes'. During 1856 patents were obtained in England by William Kloen of Birmingham and Daniel Jones of Liverpool and in America by Hannibal Smith of Ohio. In the following year the American patent rights were purchased by Peter Neff who gave the name 'melainotype' to the process.

They have always been considered as having very poor quality and in general were a 'cheap' product. This reputation was not really deserved and was more a comment on those who practised the process than it was on the process itself. The majority of the images were 3×2 inches or smaller, although examples as large as 12×10 inches were produced. Travelling photographers often used the process at fairs, race meetings and at the seaside. At first they used a conventional camera and a small portable barrow style darkroom but soon after the turn of the century a number of 'take-u-quick' cameras were being manufactured. The metal plates were contained in a magazine and were processed in tanks beneath the camera.

Because the fixing and washing were usually of a perfunctory manner the images soon faded, although those taken in studios have often survived in good condition, provided that they have not been exposed to dampness which causes rust to form and the collodion emulsion to 'bubble' on the surface of the metal. One of the oldest photographic wholesale houses Jonathan Fallowfield Limited, of London who started trading in 1856

Below An Agfacontour process experimental portrait by W. J. Chignell (1975).

Opposite A bas-relief print by J. T. Suffield, A.R.P.S. (1944).

S. WOLSTENHOLME
CLAREMONT PARK
BLACKPOOL.

ISAAC WILDE'S
LONDON GEM STUDIO
just below the South Pier, BLACKPOOL.

ANGLO AMERICAN
PHOTO' COMP.Y

80? NEW STREET,
BIRMINGHAM.

ISAAC WILDE
BLACKPOOL.

Examples of Victorian tintypes on *carte-de-visite* style mounts.

were still advertising both cameras and materials for the process in their 1939 catalogue.

The concept of 'instant-print' photography was, like colour photography before it, a dream indulged in by photographers for decades before it became a reality. The Aptus ferrotype cameras led the way into the 1930s but their pictures in no way resembled the paper prints produced by normal photography. In the early 1930s a number of designs were produced; some were commercially marketed but they were not entirely satisfactory. Brian Coe in his book *Cameras* refers to the Maton camera introduced in 1930 which produced sepia toned positives in about 10 minutes. Hugh Cecil the London portraitist designed a twin lens camera which took two pictures at a time, one of which was then immediately reversal processed so that the client could see a proof before leaving the studio. A review of it appears in *The British Journal of Photography Almanac* for 1932. In 1936 the Photo-See camera was introduced in America which claimed to produce a positive print in 5 minutes but involved the use of a number of aqueous based solutions and certainly this did not appeal to the general public.

In the years immediately before the Second World War the research laboratories of both Agfa in Germany and Gevaert in Belgium were experimenting with diffusion-transfer systems of high contrast for document copying involving no halftones. Dr Edward H. Land, a well known American scientist, who had already developed the synthetic polarizing material 'Polaroid', took up the idea and set up a research team to investigate the possibility of producing a continuous tone material which could be processed by diffusion-transfer principles within the camera body. In 1947 he achieved his goal and in November 1948 the first Polaroid Land instant picture camera, the Model 95, was placed on sale in America. Research continued and in 1952 a professional

43

model was launched. In 1959 a film with an ASA rating of 3,000 was made available. In 1963 a fully transistorized shutter version of the basic camera was marketed as the Model 100. In the same year Polacolor film was marketed which produced a print in full colour in less than 1 minute compared with the 20 or so seconds required for black and white prints.

In 1976 Kodak entered the instant picture market with cameras which incorporated automatic exposure control and in the following year they introduced a model which had a built in coupled rangefinder.

Meanwhile the latest product of the Polaroid Corporation is an 'instant-print' cine camera with projection facilities in a separate unit similar to a medium sized television.

The Camera

Almost inevitably camera design and manufacture has evolved as the direct consequence of innovations in the optics and chemistry of the photographic process. The basic concept of a light-tight box, with a lens or pinhole and some form of capping device at the front and a means of holding the light-sensitive material at the back has remained unchanged since the invention of the process.

The short focal length and small apertures of the early lenses meant that there was little if any need for a focussing system and as the earliest negative materials required an exposure time of minutes rather than the present day fractions of a second a cap on the lens was the only form of shutter needed. Indeed a photographer in Sussex in the 1860s used a top hat for that very purpose.

The earliest cameras were made of wood in the traditional style of the camera obscura and were manufactured by opticians or instrument makers, although Fox Talbot's 'mousetraps', as his wife called

them, are said to have been made for him by Joseph Foden, the estate carpenter at Lacock. Prominent amongst the early makers were Giroux and Lerebours in France and Ross and Ottewill in England. The longer focal length lenses used in these cameras required some form of focussing and this was achieved by having the front and back sections in the form of two boxes sliding one within the other.

A notable exception to these ideas was the Voigtlander all metal camera of 1841 which had a Petzval lens having a relative aperture of f/3.6 and an integral rack and pinion mount.

The first folding camera was constructed by Charles Chevalier in 1840. The sides consisted of two panels hinged horizontally and once the front and rear panels had been removed the body could be folded flat to occupy very little space. The design was subsequently used by other manufacturers including Ottewill and Horne & Thornthwaite.

The announcement of Scott Archer's wet collodion process in 1851 was the first major technological advance to influence camera design. The need to make the exposure whilst the emulsion was still moist required modifications to the arrangements for holding the negative material. Darkslides were fitted with draining channels and the plates were held in position by short wires positioned across the corners of the slides. The greater use of the camera for architectural photography highlighted some of the disadvantages of the rigid box form style of construction. The rise, fall and cross front movements were limited in such cameras to a sliding movement of the lens panel. Movements in the negative plane, 'back movements' as they were to become known, were non-existent. The solution was the adoption of flexible bellows between the front and back uprights. Such an arrangement permitted a degree of flexibility hitherto impossible. However, cameras which embodied bellows were not in

Left A de Vere 'Devon' 5 × 4 inch format monorail camera. Cameras of this type are now the general purpose instrument of the commercial and industrial photographer.

Opposite The 'Toyo View', a modern Japanese 5 × 4 inch format monorail construction camera.

Below Examples of the changes in layout and style of the front page of *The British Journal of Photography* between 1854 and 1979. *The British Journal of Photography.*

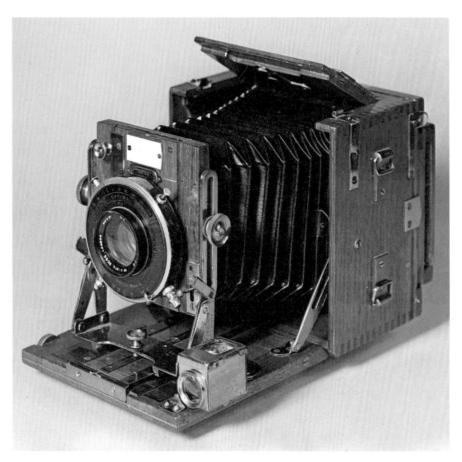

Left An example of a tropical model quarter plate Sanderson 'hand and stand' camera.

Below A Shew lightweight folding plate camera of the late 1890s.

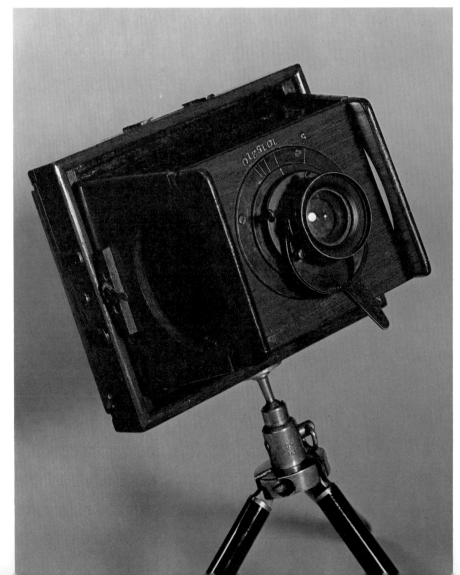

general manufacture until the late 1850s, presumably because both the manufacturers and the photographers thought that the flexibility of the bellows construction was insufficiently rigid and could easily be effected by gusts of wind during the long exposure times which were then prevalent.

The introduction of the leather or cloth bellows enabled the camera makers to make provision for an extended range of focussing movement, to accommodate lenses of varying focal length and to provide the additional distance between the lens panel and the darkslide which was needed for close up photography, such as copying. Most simple cameras were described as 'single extension' models. Those with longer bellows were known as 'double extension' or even 'triple extension' models. These terms were related to the focal length of the lens which was generally equivalent to the diagonal of the negative used in the camera. Thus a half-plate (negative size $6\frac{1}{2} \times 4\frac{3}{4}$ inches) camera

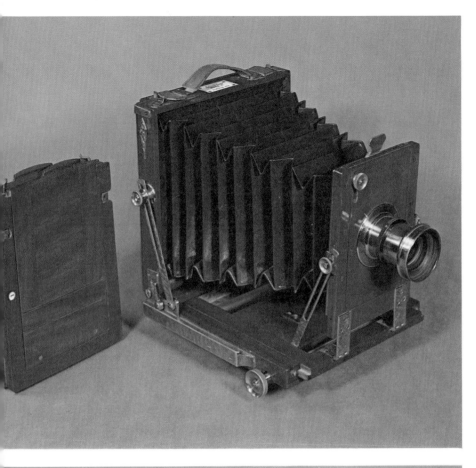

Above *The British Journal Photographic Almanac* for 1867 and 1914, which was the largest issue published with 1496 pages.

Top A half plate field camera made by Henry Park.

would have a normal lens of about 8 inch focal length and a bellows extension of up to 12 inches if it were a single extension model. A double extension model would have an extension of about 16 to 20 inches and a triple about 24 to 30 inches.

The earliest form of mechanical focussing employed one single threaded rod anchored to a nut fixed in the base of the supporting standard to which the lens was attached. The other end of the rod ran through a threaded bush at the back of the camera and usually had a folding handle or knob attached to it. It was superseded by the rack and pinion system which is still in use today as the fine focussing mechanism on most monorail technical cameras. One advantage was that independent racks could be fitted to both front and back standards and this was the usual practice on triple extension models. At first cameras were fitted with square bellows but these severely limited the range of movement possible and, although they were in general retained on large studio portrait and process cameras, they were supplanted on the general purpose field cameras by a form of tapered bellows.

The earliest monorail cameras appeared during the 1850s but they were regarded at the time as no more than curiosities. This was because of the inflexible and cumbersome style of such a design and the technical problems associated with maintaining a sufficient degree of stability of the standards when these were mounted on a single rail. Both the standards and the rail were constructed in wood.

The best of the brass and mahogany cameras of the nineteenth century are magnificent examples of the art of the cabinet maker. Examples made by George Hare, Henry Park and Louis Gandolfi are amongst those which are most prized by collectors. During the early years of the twentieth century improvements in emulsion technology and the introduction of anastigmatic lenses created a demand for technical

47

cameras designed to use smaller negatives. The demand was met by the creation of a form of camera which became known as 'the hand and stand'. As the name implies it was designed to be used either as a hand camera, for which purpose it was fitted with a form of direct vision viewfinder usually of the reflector type, and also as a stand camera for architectural or similar work. For the latter purpose, movements such as rising and falling front, drop baseboard, wide angle racks and swing fronts were desirable. Several designs were marketed but three were to become predominant: the Sanderson, which became the best known universally popular camera of the first 30 years of the twentieth century; the Sinclair Una, the most popular of the more expensive hand made instruments; and the Watson Alpha de Luxe.

It was usual for these cameras to be covered in black leather, but it was still possible to buy so-called 'tropical models' made of polished mahogany or teak with brass bound joints. It is models of that style which are the most attractive to collectors. In the *British Journal of Photography Almanac* for 1927 Sinclairs announced a model constructed in duralumin which they named the Traveller Una.

A very large number of folding plate cameras of either wood or metal construction, with the exterior of the body covered in a thin leather or leatherette material, appeared during the 1920s and of these the Newman & Guardia Sibyl and the Goerz Tenax are representative.

Considering that many of the early experimenters, Fox Talbot and Thomas Wedgwood amongst them, used reflex type camera obscuras, it is surprising that satisfactory designs for reflex cameras did not appear until the 1860s. Thomas Sutton designed a single lens reflex camera whilst he was lecturer on photography at King's College, University of London during 1860, and was granted a patent for it in the following year. Arrangements were

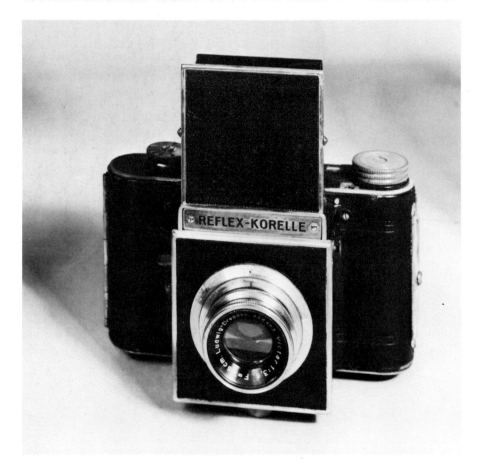

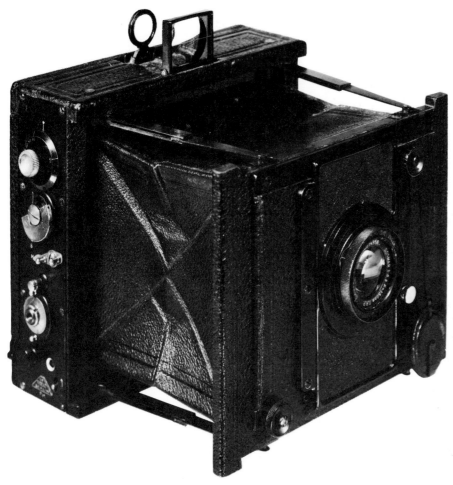

Opposite bottom The Reflex Korelle $2\frac{1}{4}$ inch square format roll-film camera by Kochman. First introduced in 1933.

Opposite top One of the more unusual of the Exakta single lens reflex roll-film cameras—the $2\frac{1}{4}$ inch square format model which was introduced in 1938.

Left A quarter plate strut type focal plane press camera by C. P. Goerz fitted with a Dogmar f/4.5 lens.

made for its manufacture by the firms of J. H. Dallmeyer and Thomas Ross. In practise the design had few advantages compared with conventional cameras and since not many were manufactured examples of them are now eagerly sought by collectors.

During the 1880s interest in the design revived and in the last decade of the century cameras of this type were marketed by a number of makers. Towards the end of the century magazine plate and roll film versions had made their appearance.

The popularity of the single lens reflex was to be fully established in the years before the outbreak of the First World War with the introduction of superb classic designs: the Graflex, manufactured by Folmer & Schwing who became a part of the Kodak organization in 1905; The Soho, made by Kershaw's of Leeds for Marion & Company; The Minex and Videx cameras pro-duced by Adams & Company; and the Newman & Guardia Reflex.

The introduction of the 35 mm miniature camera during the 1930s with its advantages of small size, low weight, portability and wide aperture lenses at first directed attention away from the heavier and more cumbersome reflex cameras. The challenge was soon taken up by the designers who produced a new generation of small compact reflex cameras using roll or 35 mm film stock.

A number of transitional designs appeared during the 1920s. The first of these was the Paff roll-film box reflex camera, introduced by Ihagee in 1921 which was the forerunner of the Exacta family of miniature reflex cameras introduced by them 12 years later. Then the Ensign roll-film 120 reflex was marketed in 1924 and in 1928 the all metal Mentor compur shuttered reflex first appeared.

During 1933 two cameras were introduced which were to have a considerable impact upon future developments. The first was the Ihagee vest pocket roll-film single lens reflex camera—the Exacta. It was followed two years later by a 35 mm film version and in 1938 by a $2\frac{1}{4}$ inch square model. The other was the $2\frac{1}{4}$ inch square Reflex Korelle made by Kochman. In 1935 Curt Bentzin marketed a very fine $2\frac{1}{4}$ inch reflex camera: the Primaflex. Immediately after the Second World War, in 1948, the original version of the Hasselblad—the 1600F—appeared and was soon accepted as the ultimate in reflex design. It was fitted with a focal plane shutter and an interchangeable 120 roll-film magazine. A modified version, the 1000F, was marketed in 1952. In 1957 the focal plane shutter was abandoned in favour of a compur between-lens shutter and the camera has remained in this basic form.

The most significant of all the post-war developments was the introduction of the 35 mm pentaprism

single lens reflex design. The first of these cameras to be marketed was the Contax 'S' introduced in 1949 and the design was soon adopted by most of the other manufacturers. Very few 35 mm precision cameras are manufactured today which are not derived from this design concept. The conventional reflex and rangefinder systems appear to have declined in popularity and to have been abandoned by the manufacturers.

It will be a surprise to many that the twin lens camera dates from the early 1860s. One of the earliest designs dated 1864, by Andre Disderi, the Parisian portraitist of *carte-de-visite* fame, was for a twin lens stereoscopic camera. It was, however, not a reflex but a straight through design. One of the earliest of the twin lens reflex cameras was designed by Thomas Bolas and marketed in 1881; it employed a prism viewing system and could therefore be said to be also the forerunner of the pentaprism system. The 1890s witnessed the introduction of a number of twin lens cameras, notably: the Yale, manufactured by Adams (1898); the Ross Divided Reflex (1890); the Artist, marketed by the London Stereoscopic Company in 1899; and The Newman & Guardia twin lens reflex of 1895. Such cameras were very heavy and cumbersome and had few advantages over a single lens camera. Never very popular, they were completely out of favour by 1912.

Franke & Heidecke and Voigtlander in Germany, who had both been concerned in the manufacture of miniature stereoscopic cameras, produced designs for precision, metal-bodied, twin lens reflex cameras in the late 1920s and early 1930s. The Rolleiflex was introduced in 1928 and Voigtlander marketed their 'Superb', replacing the somewhat simpler 'Brilliant', in 1933. All had the same negative format—$2\frac{1}{4}$ inch square. They achieved an immediate popularity. In 1935 the Fothflex, a German twin lens reflex having a similar format,

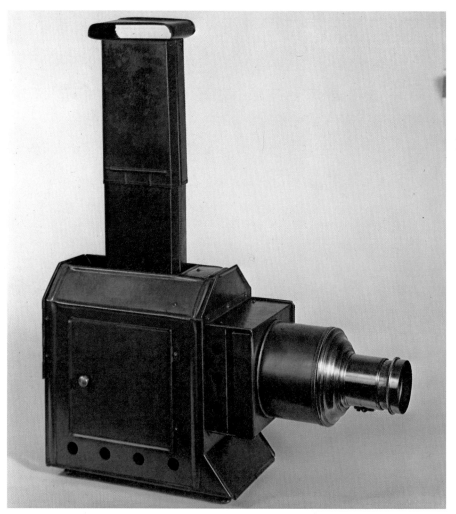

appeared. It was of particular interest for it was one of the few such cameras to have a focal plane shutter. In the same year Carl Zeiss introduced the Contaflex, a 35 mm twin lens reflex of remarkably advanced design. It can claim, quite justifiably, to be the most sophisticated camera of its type to have been made. Interchangeable lenses, built-in exposure meter, focal plane shutter, an albadatype direct vision finder built into the focussing hood and the viewing screen incorporating a magnifier were some of its features. Amongst the standard lenses available for it were a 5 cm f/1.5 Sonnar and a 150 mm f/4 Sonnar.

During the 1950s many of the leading manufacturers added twin lens reflexes to their ranges but in the late 1960s and early 70s there was a decline in their popularity, many people preferring the new style instant return mirror, single lens

reflexes fitted with pentaprism viewing systems.

The introduction of the roll film by George Eastman to which I have already made reference revolutionized camera design. Although figures have never been seen to support the statement it would not be surprising to learn that Kodak's output of roll-film cameras eclipsed that of all other manufacturers.

Eastman's roll film, when it was first introduced, was looked upon as something for the utmost novice as was Land's Polaroid system some 60 years later. With the benefit of hindsight it is now obvious that it was the catalyst around which camera design and usage was to develop. From the simplest of box cameras to the most sophisticated folding pocket cameras, the roll film was the common factor.

An abbreviated chronology is probably the easiest way of drawing

attention to some of the major
developments:

1888 The first Kodak roll-film box
camera.
1903 Roll film version of the San-
derson 'hand and stand' cam-
era.
1912 The Newman & Guardia
Sybil roll-film camera.
1914 First Kodak Autographic roll-
film camera.
1916 First roll-film camera with
coupled rangefinder. The
Kodak No. 3A Autographic.
1927 Zeiss (Ernemann) Bobette 11
roll-film camera with f/2
Ernostar lens.
Zeiss Tengor box camera.
1928 First Rolleiflex twin lens roll-
film reflex camera.
1932 Voigtlander Prominent cam-
era having rangefinder and
exposure meter.
1933 Exacta vest pocket roll-film
single lens reflex.
First Zeiss Ikon Super Ikonta,
with coupled rangefinder.
1937 Zeiss Ikon Super Ikonta with
f/2.8 lens, coupled rangefinder
and exposure meter.

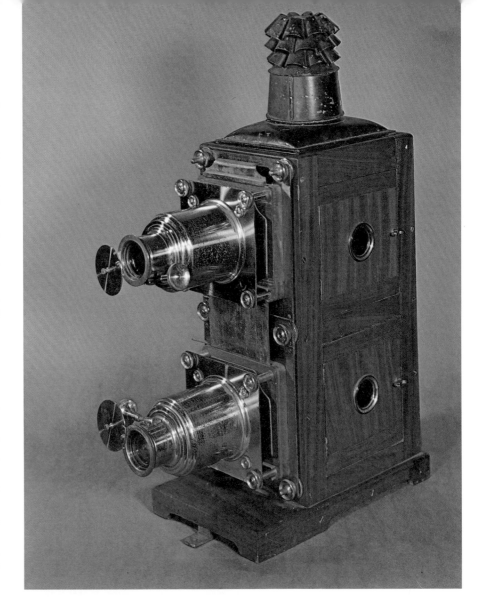

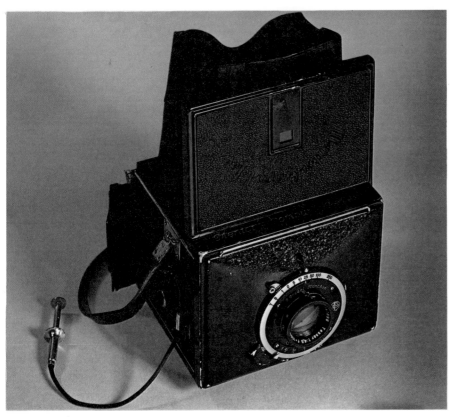

Opposite A single projection lantern
for $3\frac{1}{4}$ inch square slides produced at
about the beginning of the twentieth
century.

Above A double or bi-unial lantern
(*c.* 1890s) made by Newton & Co.
They were the forerunners of the
modern multi-projector presentations.

Left The Mentor compur reflex
camera introduced in 1928.

1945 Ensign Commando (focussing by movement of the film plane). Coupled rangefinder.
1948 Hasselblad 1600F, single lens reflex.
1957 Hasselblad 500C.

The view that the miniature camera is a product of the modern era is a widely held misconception. Some of the earliest of all cameras used by Fox Talbot produced negatives about 1 inch square. The first all metal bodied camera, made by Voigtlander in 1841, took daguerreotype plates 94 mm in diameter. Very many of the early daguerreotype and collodion positive on glass images were within the modern definition of the miniature format of having a negative area of less than 6 square inches. Whilst it is true that many of these were produced in cameras designed to accommodate larger-sized negatives, this was not invariably the case. In the early period there was no facility for making enlarged or reduced pictures from the original image. If a small daguerreotype was required for a locket or brooch it had to be taken at the required degree of reduction. However, such small images were soon in a minority. On the supposition that 'a good, big image is always better than a good, little image' photographers vied with one another to produce bigger and better photographs, and camera makers produced larger cameras.

During the last 20 years of the nineteenth century there was a move towards the so-called 'detective' camera; cameras designed to be unobtrusive because of their size, shape or style. Some, like the Stirn, were designed to be worn under a waist coat, the Photo-Cravat was disguised as a cravat, others were hidden in top-hats or built into a case made to resemble a book. Generally such cameras were looked upon as novelties rather than serious photographic instruments.

The first of the miniature cameras designed to use roll film was the Kombi. Introduced in 1893 this all metal bodied camera took 25 pictures, each 1 inch in diameter, on a roll of film.

The years before the First World War saw the introduction of a number of small format cameras some of which used 17.5 mm wide roll film. The best known of these was designed by a Swede, Magnus Niell, and sold in America as the Expo. In England it was manufactured and marketed by Houghtons as the Ticka in 1906. A variety of models were produced including one with a Cooke lens and focal plane shutter. The same company produced a series of small folding roll-film cameras under the trade name Ensignette which became very popular.

The growth of the Kinematographic industry had its effect on still photography. An engineering expertise had been established in the manufacture of precision cine cameras using 35 mm perforated film, for which film was available in large quantities. It was natural that still cameras using the perforated film should be manufactured. The stan-

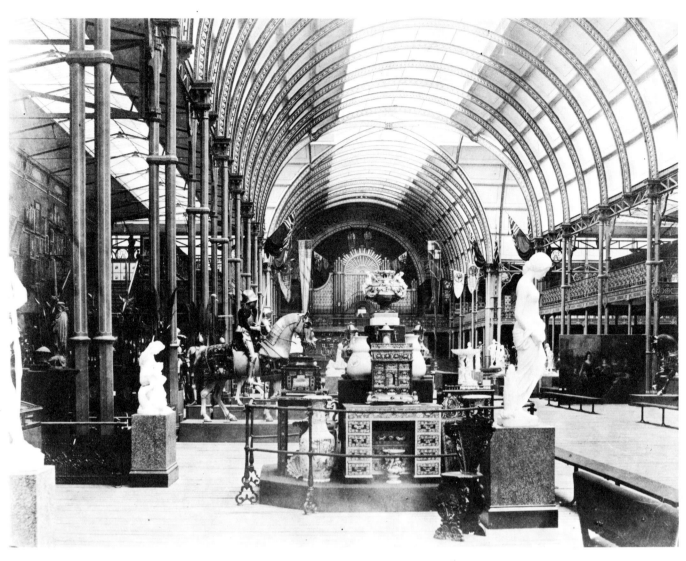

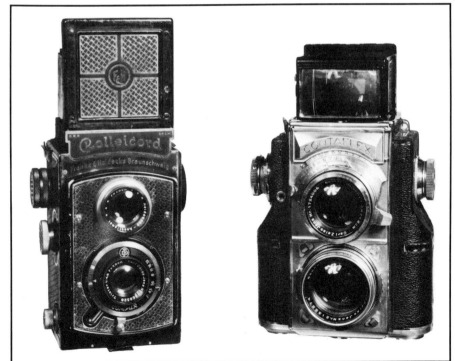

Above The south aisle at the Manchester Art Treasures Exhibition of 1857 taken by Philip H. de la Motte.

Left Two twin lens reflex cameras. On the left a $2\frac{1}{4}$ inch square format 1934 Rolleicord by Franke & Heidecke. On the right the Carl Zeiss 35 mm Contaflex.

Opposite bottom On the left is a Kodak Premoette Junior No. 1 film pack camera (*c.* 1915). On the right is a Kodak No. 2 Hawkeye folding film pack camera.

Opposite top The Contessa Nettel 'Ergo' 4.5 × 6 cm format plate camera having a Zeiss Tessar f/4.5 lens and compur shutter. This was a late (1924) Detective type camera made in the style of a monocular.

The Stirn patent 'concealed vest camera'. Designed to be worn beneath a waistcoat with the lens and the winding button appearing through button holes it took six pictures each 40 mm in diameter on a single circular glass plate. It was in production between 1888 and 1892. A larger model taking four pictures was also available.

dard cine frame size was nominally 1 × ¾ inches, the first dimension being the available width of the film between the perforations. In general, still camera manufacturers took advantage of the possibility, not available to the maker of cine cameras or projectors, of using a double frame format 1 × 1½ inches.

The first two cameras to be commercially produced using 35 mm perforated film were the Homéos and the Tourist Multiple. The former was patented in September 1913 and the latter in March 1914, although it had been on sale since early in the previous year. Shortly afterwards the first of the 'double frame' format 35 mm cameras so familiar today appeared under the name of the Simplex.

The Homéos was the most important of the three. Of those cameras which used 35 mm perforated film it was the first stereoscopic camera, the first commercially produced camera to be patented and the second to be marketed. The first production batch came on the market late in 1913 and those bearing serial numbers below 30 are much esteemed by collectors. It was

designed by Louis Joseph Colardeau and Jules Richard and manufactured by the firm of Jules Richard of Paris, who were already well known for their range of stereoscopic cameras and viewers. When production ceased soon after the end of the First World War about 1,500 had been manufactured and of these only 100 or so were produced before the outbreak of the war in 1914. It incorporated a number of advanced features including an automatic exposure counter and built in close-up lenses.

The Tourist Multiple, of American design and manufacture, took 750 exposures of the standard cine frame size (24 mm × 18 mm) on 50 ft spools of film, and was available with either f/3.5 or f/2.5 lenses. It had been on sale for about one year before the patent was granted on 31 March 1914.

The Simplex, another American camera, could be used to make exposures of the standard cine frame size or of twice that size—the double frame, 24 mm × 36 mm format—and was the first camera to be marketed which utilized this double frame format which is the standard

35 mm still frame size of today. It took either 400 or 800 negatives on a single loading of film depending on which frame size was selected. Other cameras which used 35 mm perforated film included the German made Minigraph introduced in 1915 and the Sept, manufactured by Debrie in Paris. The Sept appeared in 1922 and was a combined still and cine camera which could also be used to make and project contact diapositives, or to produce enlargements from the original negatives.

The early 1920s witnessed the appearance of a number of miniature cameras using 35 mm film, in some instances unperforated, before the appearance at the Leipzig Trade Fair in 1925 of the Leica camera made by the renowned German firm of microscope and instrument makers Ernst Leitz. The designer was Oskar Barnack, an employee of the company who was a keen mountain walker and climber. Influenced by the introduction of the Homéos and Tourist Multiple cameras he made himself a 'one off' 35 mm camera in 1913. This was to become known as the 'UR' Leica, and from time to time the firm has

Top On the left a Hasselblad 500C single lens reflex with f/2.8 lens for 12 exposures on 120 roll film. On the right is a 35 mm Praktica Super TL camera with its wide angle and telephoto lenses in the centre of the illustration.

Above A Leica model M.2 35 mm camera together with a 90 mm Elmar lens. This model with self-timer was available from 1959.

Right The Carpentier Photo Jumelle, a 6.5 × 9 cm format plate camera with internal magazine loading (*c.* 1893). This camera was sold by The London Stereoscopic Company to Miss Marie Corelli, the novelist.

Opposite top Meaghers stereoscopic camera—folded and extended and Dallmeyer's camera for stereoscopic and cabinet pictures.

Opposite bottom The Glyphoscope stereoscopic camera made by Jules Richard on the right with the shutter panel removed so that it could be used as a viewer.

produced a number of replicas for display purposes. The obvious distinguishing feature is a swing-in metal lens cap needed to avoid fogging the film when rewinding the focal plane shutter which was not self capping. In the autumn of 1923 a short production run was made (serial numbers 100-130) of a modified version of the 'UR'. These cameras, known as the 'O' series had a focal plane non self-capping shutter, a plug type lens cap attached to the camera by a short length of string and a direct vision optical viewfinder. They were not sold but were issued for market evaluation purposes only. The camera was introduced to the general public at the Leipzig Trade Fair of 1925. Known as the Model A it had a self-capping focal plane shutter, f/3.5 lens and a direct vision tubular viewfinder. The Model A with various modifications continued in production until 1930. Meanwhile Leitz introduced the Model B in 1926 with a dial set compur shutter in response to a demand for the provision of slow shutter speeds. In 1929 the dial set shutter was replaced with the rim set version. The Model C with interchangeable lens

facility appeared in 1930 and the Model D with coupled rangefinder in 1932.

In 1932 the first model of the Zeiss Ikon Contax camera was marketed and then in 1934 they introduced the Super Nettel, a folding 35 mm camera. In 1934 Kodak introduced their Retina, and the first motorized 35 mm camera with a negative format 24 mm square appeared under the name Robot. The first 35 mm single lens reflex was the Kine Exacta of 1936. The outbreak of the Second World War and the subsequent unavailability of German cameras was met by the introduction in 1941 of Kodak's advanced design cameras—the 35 mm Ektra and the roll film Medalist.

From amongst the large number of miniature cameras produced during the 1920s and 1930s which have not been detailed the following are felt to be worthy of note:

1924 The Ermanox vest pocket format plate camera with focal plane shutter and f/2 Ernostar lens. Manufactured by Ernemann-Werke in Germany.

1927 The Zeiss Ikon (Ernemann)

Bobette Model 11 folding roll-film camera. Fitted with an f/2 Ernostar lens it used daylight loading spools of unperforated 35 mm film to produce a negative $1\frac{1}{4} \times \frac{7}{8}$ inches.

1930 The Zeiss Ikon Kolibri, a 30 mm × 40 mm picture format took 16 pictures on 127 size roll film.

1932 The first sub-miniature camera—the Miniflex—was marketed using unperforated 16 mm film. Originally fitted with an f/3.5 lens a version having an f/0.95 lens was introduced a year later.

1934 The sub-miniature roll-film Coronet camera, with a moulded plastic body in a variety of colours, was marketed.

1936 The Ensign Multex taking 14 pictures on 127 roll film was introduced with an advanced specification including focal plane shutter, coupled range-finder and f/3.5 lens.

1937 The Purma camera took 12 $1\frac{1}{2}$ inch square negatives on 127 roll film and was unusual in that the focal plane shutter was gravity controlled by a

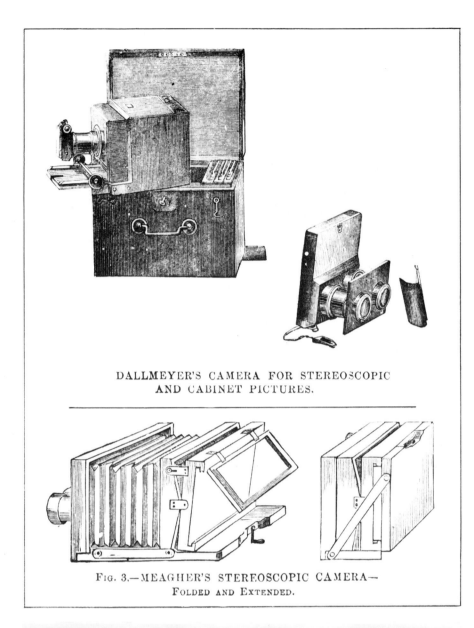

DALLMEYER'S CAMERA FOR STEREOSCOPIC
AND CABINET PICTURES.

FIG. 3.—MEAGHER'S STEREOSCOPIC CAMERA—
FOLDED AND EXTENDED.

small weight which was used to vary the slit width depending upon the angle at which the camera was held.

1937 The first model of the now famous Minox sub-miniature was introduced. Made in Latvia it had a focal plane shutter and f/3.5 lens.

1937 The Compass camera, the most sophisticated sub-miniature camera ever marketed appeared. Designed by an Englishman and manufactured in Switzerland it had a shutter with a range of exposure times between $4\frac{1}{2}$ seconds and 1/500th of a second, a built-in exposure meter, built-in filters, f/3.5 lens and was truly a precision made piece of equipment.

Special purpose cameras

Stereoscopy became very popular during the 1850s and a collection of stereograms and a stereoscope for viewing them were considered to be as essential to the middle- and upper-class Victorian drawing room as the pianoforte. At first the two images forming a stereoscopic pair were produced by making two independent exposures, moving the camera about $2\frac{1}{2}$ inches (the normal separation between the pupils of the eyes) between each exposure. This was only practical for inanimate subject matter, so instruments which were in effect two identical camera bodies side by side were manufactured. By this means the pair of pictures could be taken simultaneously.

The number and variety of such cameras is so large that it is debatable whether they can be properly described as special purpose cameras. An excellent check list of them was prepared by K. M. C. Symons and issued by The Stereoscopic Society in 1978. John Benjamin Dancer, a Manchester optician and photographer, made a number of early stereoscopic cameras including a very fine magazine plate model

57

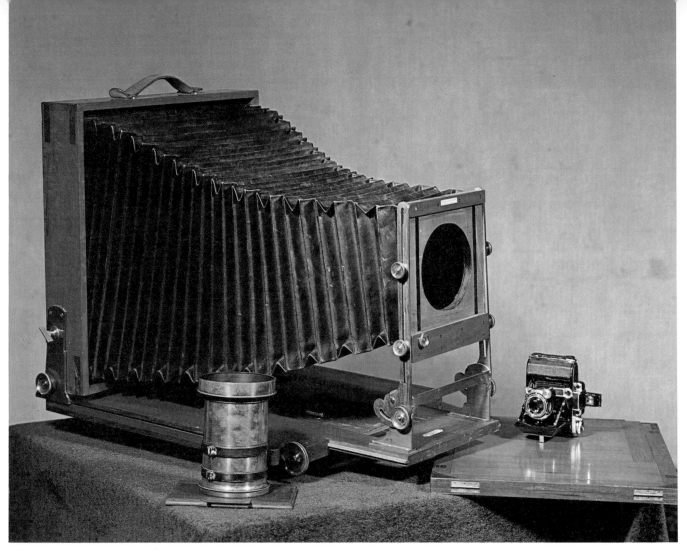

which was dated 1856. Within the next decade a number of examples were being offered for sale by most of the leading camera makers including Dallmeyer, Meagher and Rouch.

There was a decline in interest in stereoscopy during the 1880s and 1890s but the cult was revived at the beginning of the twentieth century. The firm of Jules Richard of Paris manufactured a wide range of cameras, pioneering the all metal-bodied style of construction until the late 1930s. They also produced a wide range of auxiliary equipment, including a number of excellent table stereoscopes, hand viewers and transposing frames. Their Glyphoscope camera of 1905 had a removable shutter panel which enabled it to be used as a viewer as well as a camera. One of their most important stereoscopic cameras was the Homéos.

Some instruments, such as the Le Stereo-Panoramique Leroy of 1906 and the Goerz Anschutz of 1902,

had a provision for the removal or displacement of the central divider or septum and for repositioning one of the two lenses into a central position so that it could be used as a wide-angle panoramic camera.

Stereoscopic reflex cameras in the larger formats were heavy and cumbersome but nonetheless some very compact examples appeared on the market. The Curt Bentzin reflex was a particularly fine instrument, having a focal plane shutter, Zeiss Tessar lenses, with variable separation and adjustable septum. Of smaller size the Voigtlander Stereoflektoscop was a finely designed and constructed three lens stereoscopic reflex introduced in its original form in 1913 and with a stereo compur shutter in 1923. It was normally used in conjunction with an automatic plate magazine.

Another decline in interest occurred in the late 1930s and was followed by another revival immediately after the Second World War, when a number of miniature

Above A 1902 brass and mahogany triple extension field camera to take 15 × 12 inch glass plates by James Lancaster & Son of Birmingham compared with a 1937 Super Ikonta roll-film camera taking 16 exposures on 120 roll film by Zeiss Ikon of Dresden.

Opposite top A 1913 model of the Jules Richard 35 mm stereoscopic camera.

Opposite bottom On the left an example of the Kodak 'Vanity' VPK Model 111, and on the right a 1930 Zeiss Kolibri camera.

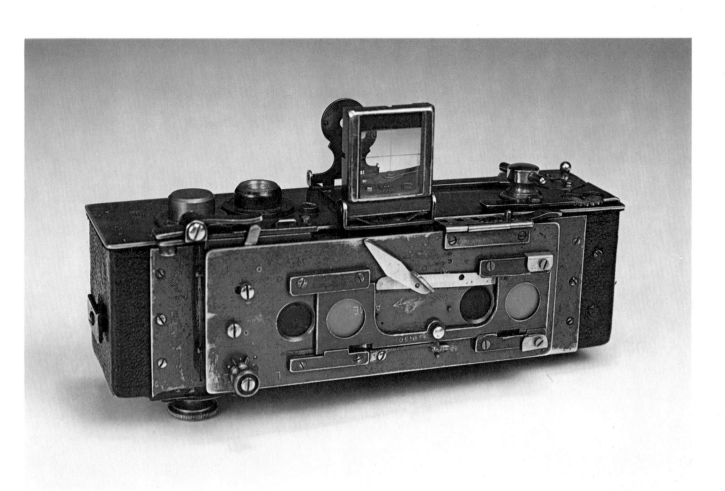

Below On the left a Voigtlander Stereoflectoscop with a spare plate magazine for it in the centre. On the right is an ICA Polyskop camera. These were amongst the most popular of stereoscopic cameras during the 1920s.

Bottom A Thornton Pickard Police fingerprint camera.

Opposite top The Holborn 'Postage Stamp' camera.

Opposite bottom The 35 mm Stereo Graphic camera introduced in 1955.

cameras using 35 mm perforated film were marketed. Prominent amongst them were the following:

The Stereo-Realist. 1946 onwards.
The Verascope F.40. 1946.
The Iloca. *c.* 1950.
The Edixa. 1954.
The Kodak. 1954.
The Stereo Graphic. 1955.

Another form of specialist camera design dating from the early days of photography was the 'panoramic camera'. One of the earliest was a design by Frederic Martens for a daguerreotype camera in which the lens was swung in an arc across an 18 × 5 inch curved plate. The British Phantoscopic, invented by Johnson & Harrison and patented in 1862, rotated through 110 degrees control-

Right to left: Holmes-type hand stereoscope, table stereoscope and Brewster-type stereoscope—the Heidoplast.

camera body moved independently but in synchronous phase.

A specialized novelty type was the so-called 'postage stamp' camera, which was designed to produce a number of images of small size rather than a single larger one. Butcher's Royal Mail camera, introduced in 1906, produced 15 individual stamp-sized negative images on a single plate with a single exposure. It used 15 separate lenses and was really 15 separate cameras built into one box. The Holborn stamp camera produced nine images in the same manner, but was a fixed focus copying camera. An original print of the subject had to be placed in the holder with a decorative mask in front of it. It was marketed by Houghtons of London in 1901 and produced the nine images on a quarter plate negative.

A number of highly specialized cameras have been manufactured for specialist applications and a detailed coverage of them is beyond the scope of a general work but perhaps a few of them should be mentioned briefly.

Special cameras were manufactured for police forces which embodied their own lighting system, usually 2.5 volt bulbs supplied from a dry battery, for the photography of fingerprints. Such cameras were not normally available to the general public and in consequence are not often encountered in collections.

When it is desired to make a set of blocks for conventional colour printing using an ink process for a book or magazine a set of three or more negatives is required, each of which is a record of one of the component colours of the subject. These are usually blue, green and red. Such a set, known as a three colour separation set, is produced by making separate exposures through filters of the appropriate colours. There are technical difficulties as the images must be of similar contrast, have the same depth of field and be of exactly the same size. If the subject is inanimate the problems are less as there is no possibility of movement

led by a clockwork mechanism, whereas The Ross Panoramic Camera of 1859 covered a field of 120 degrees on a curved glass plate using a Sutton panoramic water lens. The concept of the swinging lens was embodied in a number of cameras in later years. The Kodak range of panoramic cameras introduced in various sizes from 1899 employed roll film across a curved focal plane and a swinging lens, as did the Al Vista, an American camera dating from 1900. A number of modern 35 mm cameras based on the same principle have been developed since the Second World War by Russian and Japanese manufacturers.

The most familiar of these panoramic cameras was probably the Cirkut which was used extensively for schools and group photography. It was originally patented in America in 1904 by William Johnston and was eventually manufactured by one of the divisions of the Kodak organization. Both the film and the

between the successive exposures.

The introduction of large format integral tripack reversal colour transparency materials such as Kodak's Ektachrome was the technologist's answer to this problem as the separation set could then be made under controlled studio conditions by copying the colour transparency. Before this, manufacturers devised cameras which took the three negatives with a single exposure through one lens. After passing through the lens the optical image was split into three by a prism or by semi-silvered mirrors and then passed through three filters before reaching one of the three negatives situated at the back or side of the camera. Cameras of this type are known as 'one-shot colour cameras'. Well known examples of these cameras used professionally were: the Bermpohl made in Berlin from 1925 onwards, the British made Hilger dating from about 1930, the American National of the same period and the Jos-Pe which was patented in 1924. A miniature version of the latter was produced for amateurs which used vest pocket sized glass plates. The only other miniature one-shot camera was the Mikut, introduced in 1936, which used a prism system for positioning the three images side by side on a single glass plate. The camera had a number of unusual features for an instrument of its type including a coupled rangefinder.

Lenses, Shutters and Accessories

The faults or aberrations of most concern to the first photographers were those which affected the visual sharpness of the image rather than those which merely affected its shape. The two most important were those known as chromatic and spherical. In the former light rays of different wavelengths are brought to focus in different planes. The shorter

wavelengths of the visible spectrum, the rays of blue light, are refracted to a greater degree than the longer green and red rays as they pass through a simple positive lens and in consequence come to a point of focus nearer to the lens than the longer wavelengths. The effect is more pronounced for light rays passing through the peripheral areas of the lens than it is for those adjacent to the axis.

In the case of spherical aberration the peripheral rays are more strongly refracted as they pass through the lens than those adjacent to the axis and consequently come to focus at a point nearer to the lens than the axial rays. Since both these aberrations are most severe for rays of light remote from the lens axis the use of a small stop will minimise their effect at the expense of a reduction in the quantity of light passed and consequently an increase in the length of time of exposure.

In 1812 an Englishman, W. H.

The Corfield 35 mm Model 1 (1953) complete with long focus lens and clip-on eye level reflex viewer in place of periscopic focus device.

Wollaston, suggested a design for a positive lens consisting of a biconvex crown glass element cemented to a biconcave flint glass element. This combination reduced the degree of chromatic aberration and so the lens became known as an achromatic lens. It was a lens of this type combined with a small stop to reduce the spherical aberration that was used on most of the early cameras.

The first compound doublet lens to be used as a photographic objective was that computed by the Hungarian Josef Petzval, which was fitted by Voigtlander to their all metal daguerreotype camera. Its advantage was that it worked at a relative aperture of f/3.6 so that it effectively passed about twenty times more light than an achromat of f/16. There was some lack of definition outside of the central field brought about by the astigmatism and curvature of field. In practise this was not important as the lens was used primarily for portraiture where a fall off of definition towards the edges of the plate was often an aesthetic advantage.

In 1857 an Irishman, Thomas Grubb, patented a modified form of the Wollaston meniscus lens in which he reversed the order of the elements; there was a noticeable improvement in the correction of the spherical aberration and the lens became known as the Aplanatic. Reference has been made earlier to the panoramic water lens designed by Thomas Sutton in 1859 and fitted to the Ross Panoramic camera. Because of the severe curvature over a field of 120 degrees it had to be used in conjunction with a curved plate.

In 1866 John Henry Dallmeyer introduced his rapid rectilinear lens, so called because it worked at the rapid aperture, for those times, of f/8 and because it reproduced a rectangle as a rectangle, not shaped like a pin cushion or barrel. The lens consisted of a pair of identical achromatized elements with a diaphragm or stop located centrally between them. The field was reasonably flat over a normal working angle of about 50 degrees but if stopped down it could cover up to about 85 degrees.

The next major breakthrough was the introduction in 1888 of a new range of glasses of low dispersion and high refractive indices. Produced by Abbé and Schott in Germany they enabled lens designers to satisfy the conditions for the correction of astigmatism. The first design for an anastigmatic lens was registered in the same year by Ross of London as the Concentric but it did not appear on the market until some four years later.

The Concentric was not commercially successful because its maximum aperture was limited to f/16 on account of severe residual spherical aberration. In 1890 Dr Paul Rudolf designed for Carl Zeiss at Jena an unsymmetrical anastigmat which did not suffer from the disadvantages of the Ross Concentric. Known as the Zeiss Protar it was the basis of future lens design, together with the symmetrical anastigmat designed by Erich von Hoegh for Goerz in 1892 known as the Dagor, and the Triplet designed by the Englishman H. D. Taylor of Taylor, Taylor & Hobson. Almost all modern lenses are derived from one or

other of those three classical optical designs.

Telephoto lenses are long focus lenses with short back foci; the first design was registered by T. R. Dallmeyer, the son of the designer of the rapid rectilinear lens in 1891. In 1899 he introduced a lens of variable focal length using a telephoto construction which was called the Adon. Fifteen years later the same firm was to produce the first anastigmat telephoto lens.

The technical improvements in the resolution capability of photographic lenses from 1890 onwards was a source of dismay to some of the pictorial photographers for whom a sharp clearly defined picture was an artistic disaster. In consequence a number of manufacturers produced lenses with a degree of residual spherical aberration for portraiture or general pictorial photography. In some instances the degree of 'soft focus' was controllable.

Amongst those in general use were the following:

Dallmeyer portrait lenses.	Series A f/4.
	Series B f/3.16.
	Series D f/6.
Dallmeyer-Bergheim.	Aperture varies between f/9 and f/15 according to focal length.
Taylor, Taylor & Hobson Cooke portrait lenses.	Series II 10½ inch f/4.5.
	Series II 13 inch f/4.5.
	Series VI 13-18 inch f/5.6.

Some of the more unusual designs for lenses were associated with those for wide-angle work. There has always been a demand for lenses capable of recording a greater than normal angle of view, and those with angular fields in excess of about 65 degrees are generally considered to be wide-angle lenses. One of the earliest of all was the one designed by Thomas Sutton, patented in 1859, which was used on the Ross Panoramic camera. It was unusual in that the space between the two elements had to be filled with water before use! Used in this manner it was reputed to cover an angular field of about 120 degrees.

The Harrison Globe lens of 1862 consisted essentially of a glass sphere divided into identical elements and covered a field of 90 degrees. It was this design that was developed by the German optical and camera manufacturing firm of Goerz who obtained an English patent in 1900 for their Hypergon wide-angle lens. It had two apertures, f/22 and f/32, but was best used at f/32. Because of the fall off of the intensity of illumination towards the edges of the angular field the lens was provided with a star-shaped diaphragm which had a number of small vanes on its edge. A stream of air was directed onto the vanes from a small tube causing the star to rotate. In this way the star diaphragm, which was mounted in front of the lens limited the amount of light passing through the axial and near axial field of the lens and so evened the intensity of the illumination over the entire field. The angular field covered was 135 degrees, equivalent to a 3 inch lens on a 10 × 8 inch with a little to spare for camera movements!

A number of extreme wide-angle lenses have been designed in recent years, notably by the Japanese optical industry, having angular fields up to 180 degrees. These are popularly known as Fisheye lenses.

Lenses of variable focal length, or zoom lenses as they are called, can be considered to be a logical development of the Dallmeyer Adon telephoto lens. At first they were used for cine or television cameras where any slight lack of optical resolution was offset by the viewing conditions. However, the combination of the application of computer facilities to design computations and improved lens coating technology—which in itself was a very important consideration as lenses of zoom construction often contain as many

Right The Newman pneumatic
shutter of 1886 had a steel plate which
moved up and down within a slot cut
in the barrel of the lens. Shown beside
a modern miniature enlarging lens.

Below Exposure meters: *top* (left to
right) a Turl spot photometer; a
Heyde's 1905 Aktinophotometer; the
Watkin's standard meter made by
Field of Birmingham (1890); and a
Weston Euromaster. *Bottom:*
a Watkin's Bee meter with colour plate
dial; a Wynne 'infallible hunter' meter
(1914); an original Wynne 'infallible'
(1893); and a Decoudun optical
exposure meter of 1888.

Opposite top Two models of the
Sanger Shepherd visual densitometer
introduced in 1911.

Opposite bottom A group of three
roller blind shutters and a Stanley 'go
and return' shutter based on Sargeant's
patent of 1885.

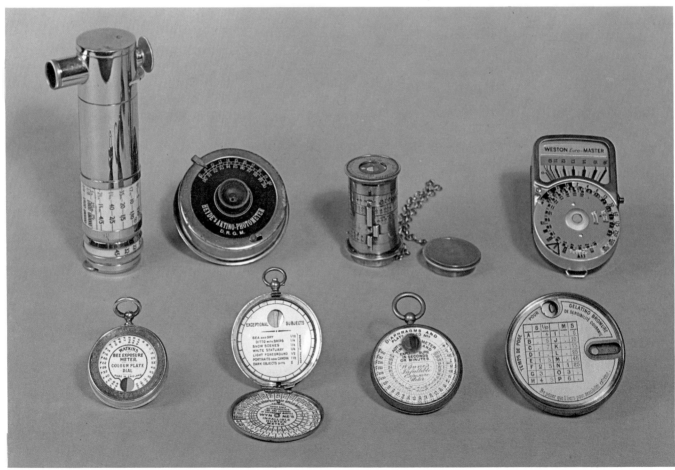

as 12 or more individual elements—enabled designers to produce lenses suitable for still cameras. The first of these was the Voigtlander 36—82 mm f/2.8 Zoomar designed to cover a format of 24 × 36 mm—which was introduced in 1959.

The determination of the 'correct' exposure depends upon many factors: the intensity of the illumination reflected from the subject; the speed of the emulsion in use; the relative aperture of the lens; and, indirectly, by other considerations which may effect only one element of the exposure equation, such as subject movement or depth of field requirements.

Because of its adaptability the eye is a very unreliable assessor of the intensity of illumination reflected from a scene. However, when the emulsion manufacturers had achieved a consistency of film speed from batch to batch combined with a speed which required a mechanic-

ally operated shutter, inventors applied themselves to the problem. Exposure meters in one form or another have been available for about 100 years. The earliest were tint meters known as actinometers. They incorporated a piece of light-sensitive print out paper and the length of time that was required for this to darken so that it matched a neutral blue/grey tone in the meter provided a measurement of the intensity of the light. Various sliding scales similar to the slide rule enabled the other fixed factors to be taken into consideration. The most popular of these meters were the series designed by Alfred Watkins of Hereford from 1890 onwards, and the Wynne and Imperial meters.

An alternative method which relied on observance by the eye was employed in those which became known as 'extinction meters'. They incorporated some form of optical

wedge, clear at one end becoming progressively dark or opaque towards the other. Sometimes this was in the form of regular steps or sometimes it was continuous. The subject was viewed through the wedge and a note made of the wedge density through which some particular aspect of the subject could be discerned. This provided a measurement of the brightness of it. Examples of this type of meter were Decoudun's Photometre-Photographique of 1888, and the Zeiss Diaphot and Justaphot of the mid-1920s.

Hardly describable as a meter but very widely used were the tables like those included in cartons of plates or films. Some of them such as the Burroughes Welcome exposure calculator were particularly sophisticated. Another elaborate calculator based on the same principle was 'Le Posograph'. Both were in use from

the 1920s onwards.

Photoelectric exposure meters as used today came into use in the early 1930s. They employed a selenium cell which generated current in proportion to the amount of light incident on the surface of the cell. This was measured by a simple meter and provided an accurate measurement of the intensity of the reflected light. One of the most popular is the Weston meter, the first model of which, the 617, was marketed in 1932. There is a tendency today to use cadmium sulphide cells whose resistance characteristics to current vary according to the intensity of the light. A specialized form of photoelectric/extinction meters known as 'spot photometers' were developed from original designs by Turl in the 1930s. The first successful version was the S.E.I. meter designed by an Englishman, J.F. Dunn, and placed on the market soon after the end of the Second World War.

It was the introduction of the dry collodion and dry gelatino-bromide negative emulsions with their increased speed that was to create the need for mechanical shutters capable of regulating the length of the exposures to fractions of a second. At first, during the 1870s, most of the shutters were operated either by gravity or else by the tension of an elastic band. They usually consisted of a small frame of wood with a plate sliding within the frame. This plate had an aperture in it, sometimes adjustable in area, and the length of time of the exposure was determined by the size of aperture in use and the tension of an elastic band or the length of the drop as the plate was allowed to pass in front of the lens. Amongst those that were commercially available were the Rouch flap shutter, the Watson drop shutter and the Skaife.

During the 1880s as emulsions became more sensitive and consequently faster a demand for more reliable shutters was created. A large number of designs appeared, notably: the Newman pneumatic shut-

Opposite An original Goerz Hypergon wide angle lens showing the star shaped fan and a later version without fan which was manufactured by Carl Zeiss.

Above A range of interchangeable lenses, from a 35 mm wide-angle to a 500 mm telephoto, which will fit most modern single lens reflex cameras.

ter of 1886, the Cadett pneumatic shutter of 1878, the Lancaster 'see-saw' shutter of 1890 and the Sarjeant shutter of 1885.

The shutters that we have mentioned so far have in general been designed to fit in front of the lens although the Newman was usually fitted into a slot in the barrel of the lens. They were therefore interchangeable from one lens to another. From 1900 onwards the diaphragm type of shutter became very popular. It was usually fitted permanently to the lens and the most reliable and popular form of it was the 'compur', which is still in use today, first introduced in Germany around 1912. It was a development of the earlier compound shutter designed by the same inventor, Friedrich Deckel of Munich. Another prolific designer of shutter mechanisms during the first half of this century was Julius Springer. An ingenious adaptation of these diaphragm shutters was to make the shutter blades perform the dual purpose of iris diaphragm and shutter, the mechanism being so arranged that it only allowed the shutter leaves to open to the diameter that represented the relative aperture required for the exposure. The two examples marketed with success were the Bausch & Lomb Volute of 1902 and the Goerz sector shutter of 1904.

Another form of shutter first suggested by the well-known English topographical photographer, William England, in the early 1860s, took the form of a roller blind with an horizontal slit which was positioned immediately in front of the negative or focal plane. This form of shutter became known as the focal plane shutter for this reason. The range of exposure times obtainable could be varied either by variation of the width of the slit, by regulating the speed of the blind as it traversed the negative or by a combination of both. It was possible to attain exposure times as short as 1/1000th of a second in later versions. It became the most popular shutter for press

cameras and was used for the early Goerz strut type press cameras introduced around the beginning of the present century.

Many of the miniature cameras of the modern era, particularly those having interchangeable lenses, were fitted with focal plane shutters, notable examples being Leitz's Leica and the Zeiss Contax. Because of difficulties of synchronization when using flash bulbs or electronic flash guns, some manufacturers, like Hasselblad, preferred the between-lens compur type shutter which needed a separate shutter for each lens.

Technical Photographic Literature

Since its advent photography has been one of the few human activities that is both a major profession and a major hobby and consequently the literature relating to it has been particularly extensive. In its earliest days the only avenues of learning open to aspiring photographers were either the classes conducted by some of the professional photographers or else 'do it yourself/trial and error' experimentation. Both of these created a need for technical information, which was immediately filled by enterprising publishers and authors.

The speed with which instruction manuals for the daguerreotype process were produced could hardly be matched even today. Within 24 hours of Arago's announcement of the details of the process the first printing of *Historique et description des Procédés du Daguerreotype et du Diorama*, published by Alphonse Giroux et Cie and written by Daguerre himself, was on sale. It is a remarkably scarce book. Beaumont Newhall, writing in a Winter House (New York publisher) publication on Daguerre refers to three known

copies, two of which are in the collection at George Eastman House at Rochester, New York.

Before the end of the year foreign language editions had been published in English, German, Swedish and Spanish, followed shortly by printings in Italian, Hungarian and Polish. In all 32 manuals were published during 1839 and 1840.

The first English language edition was a translation by J. S. Memes, published by Smith Elder of London and Adam Black of Edinburgh. The preface is dated 13 September 1839 and it was reviewed in *The Literary Gazette* on 20 September. It was almost immediately reprinted with a small alteration to the title page and further printings, imprinted *Second Edition* and *Third Edition*, were issued during October.

A list of all the known printings together with reprints of some of them was published in *Daguerre—An Historical and Descriptive Account of the Various Processes of the Daguerreotype and The Diorama*. Published by Winter House Ltd., New York in 1971, it contained an introduction by Beaumont Newhall.

The first American printing was edited by Professor J. J. Mapes and published by J. R. Chilton of New York in 1840. Most of the scientific and art journals of the day printed accounts of the process some of which were condensed versions of the manuals.

The first account of the development of the photographic process to be published in book form was by the well known scientific writer of the day, Robert Hunt. His *Popular Treatise on the Art of Photography* was first published by R. Griffin & Company of Glasgow in 1841 and was followed by *Researches on Light in its Chemical Relations* in 1844, which included a chapter devoted to the events leading up to the announcement of the discovery of the process. The third edition of his *Manual of Photography*, published in 1853, was a concise account of the technical state of the process at the time and contained 112 pages summarising

the historical background from the beginning of the eighteenth century.

In 1855 the first edition of *A Manual of Photographic Chemistry* by Thomas Frederick Hardwich was published and rapidly accepted as the standard technical manual in the English language. Nine editions were published, the last in 1883.

In America *The History and Practice of the Art of Photography* by Henry H. Snelling was published by G. P. Putnam of New York in 1849. During 1864 two other important works appeared. The first of these was *The Silver Sunbeam* a technical manual written by John Towler and published by Joseph Ladd of New York. It became the standard technical treatise in America and was issued in nine editions, the last being published in 1879. A revised edition by H. T. Anthony was issued in Spanish in 1876. The second was *The Camera and The Pencil; or the Heliographic Art* written by Marcus Aurelius Root and published in Philadelphia. In 1887 Edward L. Wilson wrote and published *Wilson's Quarter Century in Photography, a Collection of Hints on Practical Photography*. This 528 page encyclopaedic book was profusely illustrated.

On the continent a number of general textbooks were published of which the following are a selection.
German:
Martin, Anton Georg.
Reportorium der Photographie. Two volumes, 1846.
Martin was librarian of the Vienna Polytechnic. The second edition was issued in 1851 and the sixth in 1865.
Schnauss, Julius. (Edit.)
Photographisches Lexicon. 1860.
This was the first photographic dictionary to be published in the German language and by 1868 had reached its third edition.
Zuchold, Ernst Amandus.
Bibliotheca Photographica. 1860.
Although important as one of the first attempts to produce a bibliography of photographic literature it is in no way a complete one as it lists only about 200 references.
French:
Lerebours, Noël-Marie Paymal.
Traité de Photographie. 1842. Three editions were published within six months.
Gaudin, Marc Antoine.
Traité pratique de Photographie. 1844.
Monckhoven, Desire Charles Emanuel van.
Traité Général de Photographie. 1852.
Traité d'Optique Photographique. 1866.
Monckhoven was born at Ghent in Belgium of German parents and was one of the most influential photographic scientists of the nineteenth century.
La Blanchère, Henri Moulin de.
Réportorie Encyclopédique de Photographie.
Published in six volumes 1862-1866.

Periodicals

The first photographic magazine, edited and published by S. D. Humphrey in New York, made its appearance in November 1850, under the title of *The Daguerreian Journal devoted to the Daguerreian and Photogenic Arts.* Printed every two weeks, it survived a three-month gap in publication during 1852, and several name changes, before its last issue in July 1870 when it was using the title *Humphrey's Journal of Photography.* *The Photographic Art Journal*, edited by H. H. Snelling of New York, commenced publication in 1851, amalgamated with *The American Journal of Photography*, which had itself begun publication in 1852, in 1861 and was eventually taken over by Humphrey's Journal in 1867.

In England, the forbear of *The British Journal of Photography, The Liverpool Photographic Journal*, first appeared on 14 January 1854 published by Henry Greenwood who still issue the Journal and its associated annual, which was first printed in December 1859 as a wall calendar for the year 1860. G. Warton Simpson's *Photographic News Almanac* was first issued in 1859, became *The Year Book of Photography* in 1864 and continued publication until 1907. The first issue of the *Journal of the Photographic Society of London* appeared in March 1853, was renamed *The Photographic Journal* in 1859 and is still published today as the house *Journal of The Royal Photographic Society.*

The interest in both the art and technique of photography became widespread during the decade commencing in 1855 and a large number of periodicals appeared of which the following are some of the more important, together with their original date of publication:
Austria
Photographisches Album. Vienna, 1857.
Zeitschrift für Fotografie und Stereoskopie. Vienna, 1860.
Photographische Korrespondenz. Vienna, 1864.
Belgium
Bulletin Belge de la Photographie. 1861.
France
Bulletin de la Société Francaise de Photographie. Paris, 1855.
Revue Photographique. Paris, 1855.
Le Moniteur de la Photographie. Paris, 1861.
Germany
Photographisches Journal. Leipzig, 1854.
Photographisches Archiv. Elberfeld, 1860.
Photographische Mitteilungen. Berlin, 1864.
Holland
Tijdschrift voor Photographie. 1864.
India
Journal of The Photographic Society of Bombay. 1855.
Italy
La Camera Obscura. 1863.
Spain
El Propagador de la Fotografia. 1863.
So many books, pamphlets and manufacturers' instruction leaflets have been written on the various aspects of photography, many of which are now of considerable his-

torical significance, that it would be impossible to present even a representative survey of them. For those who are interested in the literature of photography reference should be made to *Photographic Literature—An International Bibliographic Guide* edited by Albert Boni and published by Morgan & Morgan of New York. The first volume was published in December 1962 and included references to some 12,000 publications arranged under about 1,200 subject headings with admirable cross referencing. Originally it was hoped to produce volumes every decade. The second volume was published as planned in 1972.

Early photographic education

Reference has already been made to the lectures which were conducted by some of the professional photographers for amateurs and novices. The first systematic courses were established by various governmental organizations, notably the military. A School of Military Photography was created at Chatham in 1856 and, in 1871, it became a part of the training programme for all officers at the Ecole Militaire in Paris. The first correspondence course in photography appears to have been offered by Julius Kruger, a text book writer of Stralsund in Germany, in 1863. Formal courses in all aspects of photography were commenced in 1855 at the Photographic and Chemical Institute at Jena in eastern Germany. In the following year Thomas Malone, who had been a member of the staff of Fox Talbot's printing establishment at Reading under Nicholaas Henneman, lectured on all aspects of photography at The Royal Institution.

In 1857 King's College, University of London introduced the teaching of photography into its curricula; the announcement was made in the annual report for that year. The first lecturer to be appointed was Thomas Frederick Hardwich, a demonstrator in chemistry in the College who was described by the College authorities as 'one of the most distinguished photographers of the day'. He was succeeded for a short time in 1860 by Thomas Sutton, the editor of *Photographic Notes*. In 1861 George Dawson took over the responsibility for all teaching of photography. The original syllabus of 1857 was as follows:

'The ART and SCIENTIFIC PRINCIPLES of PHOTO-GRAPHY.
Hour: 10.30-12.30 Friday.

These Lessons are specially intended to give instruction in the Principles and Art of Photography, to Students who have completed six Terms in this Department.

Besides the regular Course, other classes are formed, consisting each of about six gentlemen, who meet twice a week. Eight Lessons, of one hour and a half each, are given. Fee, £31. 3s.

The hours and days of Lecture for these extra Classes are:-
Monday and Thursday at 9; Tuesday and Friday at 11; Wednesday and Saturday at 1; but the Lecturer will make arrangements for private instruction at more convenient hours.

On Monday and Thursday, from 11 to 1, gentlemen are allowed the use of the Glass House and Developing Room for the purpose of practice and experiments.

Mr. HARDWICH is happy to assist gentlemen joining these classes in the choice of Photographic apparatus, and specimens by the best makers are kept on view.'

Several members of the academic staff at King's College were involved in photography in one aspect or another. Amongst them were Sir Charles Wheatstone, Professor of Experimental Philosophy and Vice-President of the Photographic Society (later The Royal Photographic Society), and P.H. de la Motte, who had given private lessons in photography to Queen Victoria and Prince Albert, lectured in fine art and landscape drawing.

The City and Guilds of London Institutes founded in 1878 included photography amongst its subjects from that date. Their first public examination was conducted in 1880. Prior to that date examinations were conducted by The Royal Society of Arts.

In 1881, Mr W. J. Wilson, F.C.S., M.S.T.E., conducted a course of lectures in photography at the Birkbeck Institution in Chancery Lane, London, and also gave private tuition.

Classes were conducted at The Regent Street Polytechnic in London during the latter half of the nineteenth century, and in an advertisement in the *British Journal of Photography Almanac* for 1899, the lecturer in charge is stated to be Mr Howard Farmer assisted by 16 other teachers. Unfortunately the present staff have been unable to provide any further information relating to the introduction of photographic courses.

Opposite A calotype of Lacock Abbey by W. H. Fox Talbot (*c.* 1844).

The Aesthetic Evolution

Photography and the Conventional Arts

'In this volume the Publisher has availed himself of the accuracy of Photography to present to the reader the precise aspect of the places which, at the same time, are commended to his notice by the pen. ... The reader is no longer left to suppose himself at the mercy of the imaginations, the caprices, or the deficiencies of artists, but to have the genuine presentment of the object under consideration.'

> A. W. Bennett writing in the Preface to *Ruined Abbeys & Castles of Great Britain* by William & Mary Howitt which he published in 1862.

'Painting, drawing and engraving are non-mechanical processes of artistic distortion. Photography is the artistic reproduction of truth.'

In 1840, Queen Victoria had been on the throne for three years, the London and Birmingham railway line had been open for two years and a domestic servant would have expected to earn a wage of about £10 per year. It was against such a background that the photographic process was evolving, but not even the contemporary science fiction writers could have imagined the sociological impact that it was to have.

It is salutary to remember that few people, apart from the upper classes, possessed a portrait of even the closest of their ancestors. Such portraits as did exist were, in the main, idealized ones, executed by artists of varying degrees of ability, who were influenced more by the necessity of pleasing their patrons than they were of producing an accurate likeness.

Similarly, illustrations in books and other printed matter were entirely dependent upon the skills not only of the original artist but also of the engraver of the blocks, the author and the publisher.

The invention of photography brought to those living in the Victorian Era the possibility of having 'factual pictures' depicting not only relatives and friends but also their homes, social activities, environment and their travels abroad, in a quantity and at a cost previously impossible. Those who were unable to travel could gaze with wonder at the photographs of people and places which hitherto they had only been able to visualize through the written or spoken word.

Fox Talbot's pictures of his fam-

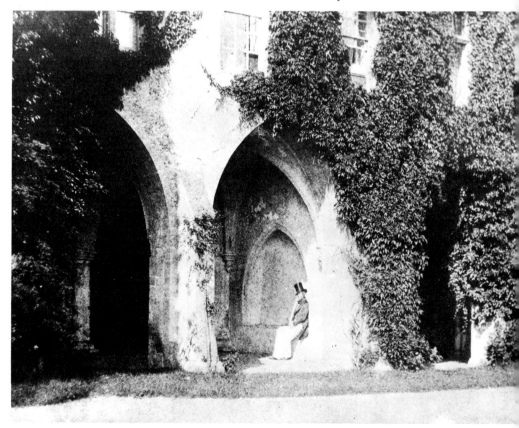

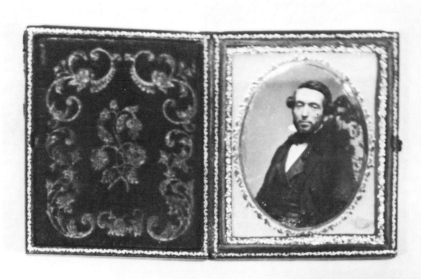

Above and Below The decorated frontispiece and title page of *The Pencil of Nature* by William Henry Fox Talbot which was issued in six parts between 1844 and 1846. Illustrated with original salt paper prints made by N. Henneman and the staff at Fox Talbot's printing establishment at Reading, from Fox Talbot's calotype negatives, it was the first publication illustrated with original photographs to be available to the general public. *The Kodak Museum, Harrow, Middlesex.*

Opposite Various daguerreotype portraits ranging in size from a one-ninth plate to a 5 × 4 inch plate (*c.* 1850).

ily, the employees on his estate at Lacock, his architectural studies of the Abbey and Oxford's Colleges and his Scottish landscapes all evidenced his desire to show how his new process could be used to provide truthful pictures of people and places for those who were unable to see the original subjects at first hand.

The fidelity and sharpness of Daguerre's process led engravers to use daguerreotype images rather than drawings or paintings as their source material. In France a Parisian manufacturer of lenses and scientific equipment, Noël-Marie Paymal Lerebours, made a number of daguerreotype cameras and commissioned travellers and artists to take photographs of places that they visited. It is said that he received several thousand daguerreotype images of places as far apart and as diverse as Jerusalem and Rome, Moscow and Niagara Falls, Córdoba and Edinburgh. He made a selection of the more interesting of them and had plates engraved from them with the addition, where he thought desirable, of figures or animals. Prints from these were published between 1840 and 1842 under the title *Excursions Daguerriennes* and were a success both commercially and artistically. The technique was taken up by other publishers, a notable example being the engravings derived from daguerreotypes taken by Beard, Mayall and others. These were used to illustrate *The History and Description of the Great Exhibition at the Crystal Palace in 1851*, published by The London Printing and Publishing Company.

Many artists looked askance at the new medium and openly criticized it as not allowing them their traditional 'artistic licence' in dealing with the arrangement, composition and content of the picture. However, many took a broader outlook and adopted the new process. Amongst these were David Octavius Hill, then Secretary of the Royal Scottish Society of Artists; Roger Fenton, a good amateur sculptor who became the first Sec-

Opposite Salt paper print by R. Fenton (1850s).

Above and Left *Holland House* by Princess Marie Liechtenstein, published by MacMillan & Co. in 1874, was illustrated with a large number of steel engravings, lithographs and woodburytypes. It is thought that many of the drawings for the two former were the work of Philip de la Motte and it is probable that he also took the photographs from which the woodburytypes were made. It is interesting to compare the photograph and an artists impression of the same view of the house from across the Dutch garden.

retary of The Photographic Society (later to become The Royal Photographic Society); Phillip de la Motte, a member of the Water Colour Society, who in the 1850s conducted classes in photography at King's College, London and ultimately became Professor of Drawing there; and Frederick Scott Archer, another sculptor, who was later to invent the wet collodion process.

Others like Jean Auguste Dominique Ingres and William Etty, the English painter of portraits and nude studies, used daguerreotypes or calotypes as the basis of their paintings rather than holding extended sittings. The best known example is the use of photography by D. O. Hill for his painting *The Disruption of the Church of Scotland* which involved painting over 400 likenesses of those who attended the first General Assembly of The Free Church for the signing of the Act of Separation and the Deed of Demission.

Hill was concerned with the time that would be required to paint a likeness of every man present and so turned to the new technique of photography. Sir David Brewster, the well known scientist and a friend of Fox Talbot, introduced Hill to Robert Adamson during the summer of 1843. Adamson had been experimenting with the calotype process in conjunction with his brother Dr John Adamson, who was a colleague of Brewster. Working as a team Hill and Adamson photographed groups of those who were present at the Assembly with the intention of painting them in on the canvas at a later date. They became so interested in the possibilities afforded by the new medium that they accepted it as a new art form in its own right.

The original intent became secondary. They photographed the 'town and gown' of Edinburgh as well as making a remarkable series of documentary records of the inhabitants of the fishing village of Newhaven, situated on the Firth of Forth three miles north of Edinburgh. Their partnership came to an end in 1848 with the death of Adamson but in the four years that they worked together until the onset of Adamson's fatal illness in the autumn of 1847 they had produced about 2,500 calotype negatives.

The high technical ability of Adamson and the artistic sensitivity

of Hill combined to produce pictures of great quality, which are recognized today as being the finest produced in that first decade of photography.

Hill did not complete the painting until 1866 when it was put on public display. Curiously enough instead of making the reproductions for general sale in the usual form of steel engravings, Hill arranged for the Glaswegian photographer, Thomas Annan to photograph it and produce a number of prints in the new permanent carbon print process developed by J. W. Swan.

The impact of the new process was felt most by the miniature painters and there was a sharp decrease in the number of such paintings exhibited at art exhibitions in the years which followed the invention of photography. Many of them became freelance retouchers and colourists working for the major portrait studios in Berlin, Paris, New York and London.

After the announcement of Scott Archer's wet collodion process, a new technique was evolved which was essentially a marriage of the two arts. The *cliché verre*, as it was known, was adapted to photography by exposing a sensitized collodion plate to light and processing it so that the collodion plate was uniformly opaque. The emulsion was then scratched with a knife or an engraver's tool by the artist, creating a picture as areas of clear glass against a black background (like a scraper board drawing). The plate was then used as a conventional negative which was printed onto photographically sensitized paper to produce a positive image.

In Europe this technique was much used by Jean Baptiste Camille Corot and other members of the Barbizon School. It was introduced into America by John Whetten Ehninger, a New York artist who had studied in Paris between 1848 and 1850.

It was photography's ability to record fine detail, in particular textures, that was to have the greatest effect on the art world. Just as photographers attempted to adapt the process to conventional artistic methods of presentation so artists incorporated into their pictures the realism that was a characteristic of photography.

The Pre-Raphaelite school of painting with its emphasis on detail and truthfulness of the component elements of its pictures was the artists' attempt to show that they too could record as accurately as the photographer. Although many of their subjects were allegorical, they paid particular attention to the veracity of the details of their pictures. The most extreme example was the painter William Holman Hunt who in 1854 was quoted as saying that a particular model was 'as ugly as a daguerreotype' while, in the same year the photographer James Graham accompanied his tour of the Dead Sea area, during which he painted *The Scapegoat*.

After the picture had been exhibited in London it was criticized as being a photographic study. Graham produced a large number of photographic studies for members of the Pre-Raphaelite Brotherhood, which they may have used as the basis of some of their paintings.

Although John Ruskin attempted to defend the Brotherhood against the numerous allegations that their pictures were too photographic in character there is ample evidence that many of its members not only used photography but had been influenced by it during their training. It is known that Ford Madox Brown worked in his early years as a retoucher and colourist of photographs. C. R. Leslie, R.A., a biographer of John Constable; chose to use an original photograph rather than any other method of reproduction to illustrate his book *A Hand-Book for Young Painters* published in 1855 by John Murray.

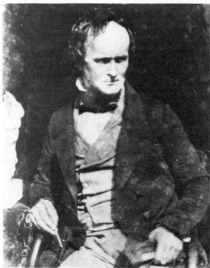

Left *The Disruption of the Church of Scotland. The Signing of The Act of Separation and the Deed of Demission.* Reproduced from one of the Annan carbon prints. *J. Anderson.*

Top *The Scapegoat* by William Holman Hunt. The Pre-Raphaelites not only used photographs but were much influenced by photography during their training. *The Trustees of the Lady Lever Art Gallery, Port Sunlight.*

Above *Alexander Ritchie, the sculptor,* a calotype by D.O. Hill and Robert Adamson (*c.* 1844).

Above The west wing of the Ducal Palace at Venice by Carlo Ponti. Ponti was an eminent photographer during the period 1860 to 1870. This is an albumen print of probably about 1865.

Top A stereogram on glass purporting to show two ghosts playing billiards (*c.* 1900).

One of the greatest of all early portrait photographers and arguably the greatest of all women photographers, Julia Margaret Cameron based much of her work on the allegorical concepts of the Pre-Raphaelites. Her personal friends included G. F. Watts and Alfred Lord Tennyson, for whom she made a series of illustrations for his *Idylls of the King*. But just as the weakness of the Brotherhood may be ascribed to their flirtation with the photographic process and their strength to their imaginative treatment of allegorical subject matter, in her case exactly the reverse applied. Her allegorical pictures lack conviction and imagination whilst her portraits of Watts, Tennyson, Herschel, Browning, Trollope, Palgrave, Carlyle, Mary Hillier, Ellen Terry, Mrs Herbert Duckworth and Katie Koewen all display a serenity of concept only to be associated with true genius.

The tide was to turn. Photographers soon tired of their ability to record in a factual style and the era of 'high art' photography was ushered in with the work of, amongst others, William Lake Price, Oscar Gustave Rejlander and Henry Peach Robinson. They used the process to make numbers of photo-

graphs which were then combined to produce at the printing stage a single composite print.

It was Rejlander who produced the technical tour de force in the photograph *The Two Ways of Life*. Following his compositions based on combination prints made from three or more individual negatives, he was elected to membership of The Photographic Society in 1856. In the following spring he conceived the idea for the *Two Ways of Life* as his contribution to The Manchester Art Treasures Exhibition taking place later in the year.

Rejlander had settled in Wolverhampton in about 1846 and remained there until he moved to London in 1862. It was whilst at Wolverhampton that he developed the techniques for the making of combination prints. Originally a conventional artist, he had exhibited at The Royal Academy in 1848. It is probable that he moved to Wolverhampton from Lincoln in order to obtain work as a freelance artist decorating papier-mâché ware; at the time many of the finest manufacturers of this ware had their factories in the Black Country. He became friendly with many of the members of the acting community in the town, particularly John Coleman who was the manager of the Theatre Royal there, and these two interests undoubtedly combined to influence his style of photography. It is said that many of the models that he employed for his genre and nude compositions were members of touring companies appearing at the theatre.

Few copies of *The Two Ways of Life* were produced and none of the original prints were identical, as against those taken from copy negatives. His growing reputation was considerably enhanced when he was granted an audience at Buckingham Palace by Queen Victoria who bought the original copy of the print after its exhibition at Manchester.

The move to London did not, as he had hoped, increase his personal wealth and he resumed his painting,

exhibiting at The Royal Academy in 1873. Some three years earlier he had put forward a theory that criminals could be identified by the configuration of their ears. It was this that led to him being approached by Charles Darwin who required photographs depicting emotions to illustrate his forthcoming book *The Expression of the Emotions in Man and Animals*. Rejlander took the photographs and also acted as the model for some of the illustrations. The book, published in 1872, was the first to be illustrated by the heliotype process invented by Ernest Edwards. One of these pictures depicting a baby crying received considerable publicity and it is said that Rejlander sold more than 300,000 copies of it.

Robinson, born at Ludlow in Shropshire, was employed as an assistant by a bookseller at Leamington Spa. Like Rejlander he was a talented painter and had a picture accepted by The Royal Academy in 1852 when only 22. Soon afterwards he became interested in photography and opened a studio at Leamington in 1857. Apart from the conventional commercial studio portraits, he embarked on a series of combination prints which were exhibited at many international

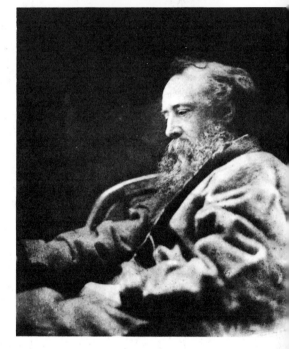

Top *The Belfry at Bruges* by S. Thompson. Thompson was an outstanding topographical photographer during the period 1860-70.

Above G. F. Watts by Julia Margaret Cameron.

exhibitions until the end of the century. *Fading Away*, a sentimental composition depicting an ill, young girl near to death, made in 1858, established his reputation virtually overnight.

He lectured and wrote a number of books on the artistic aspects of photography. *Pictorial Effect in Photography*, the first edition of which appeared in 1869, was one of the earliest books to be illustrated with a woodburytype print. This book together with *Picture Making by Photography*, published in 1884, did much to establish his reputation as the most influential 'high art' photographic artist of the period. In 1868 he opened a studio in Tunbridge Wells and was elected a vice-president of the Photographic

Society in 1887. He retired from business in the following year and became a founder member of the Linked Ring in 1892.

Working in the United States during the early 1870s Eadweard Muybridge, born Edward James Muggeridge at Kingston-on-Thames, commenced the series of experiments on the analysis of human and animal movement which culminated in the publication in 1887 of *Animal Locomotion; an electro-photographic investigation of consecutive phases of animal movement*. These series of sequential photographs of animal and human movement were to have a considerable impact on artists.

Hilaire-Germain Edgar Degas, the French painter, had been in-

fluenced by photographic images from his earliest years as an artist. This was apparent in the use by him of true photographic perspective rather than the traditional styles adopted by artists; in his use of truncated figures on the edges of his pictures as in *Place de la Concorde* (a group comprising the Vicomte Ludovic Lepic and his children painted in the 1870s); and in the extensive use that he made of Muybridge's work for the realistic positioning of arms and legs in his ballet paintings. From the mid-1880s Degas was sufficiently interested to acquire a camera for himself and it is likely that a number of his later landscapes were painted from his own photographs rather than from preliminary sketches.

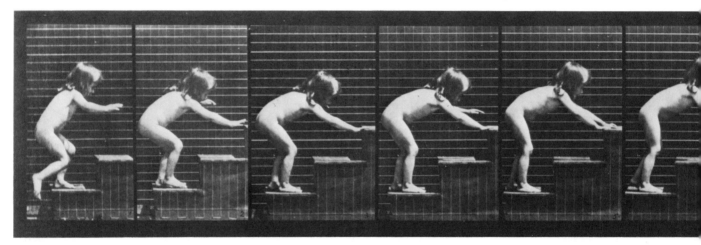

Above A plate from the original 1901 edition of *The Human Figure in Motion* by Eadweard Muybridge.

Right One of the plates from the first edition of *The Expression of the Emotions in Man and Animals* by Charles Darwin.

Opposite *The Lull before the Storm* by W. Mayland. The original of this measures 24 × 18 inches and is a good example of the work of this landscape photographer who was active during the 1850s and 1860s.

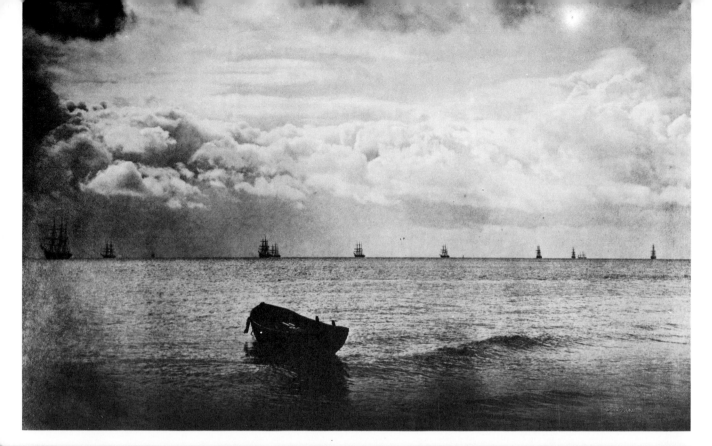

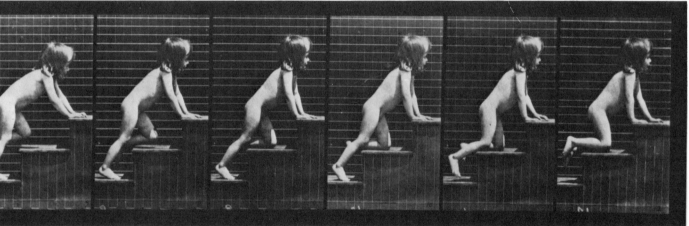

The Naturalistic School

Understandably there was a re-action by some photographers against the 'high art' school, some of whom, like Frank Meadow Sutcliffe, developed their own style and repu-tation whilst others, like Peter Henry Emerson, attempted, by pen and photograph, to ridicule the elaborate combination prints of Robinson and his followers.

Emerson, the son of an American doctor, was born in Cuba and, shortly after the death of his father, his mother, an Englishwoman, returned to England and settled at Southwold in Suffolk. He was edu-cated at Cambridge where he stu-died medicine, obtaining his degree in 1885. In the following year he abandoned all thought of a medical career and turned to writing and photography in which he had be-come interested in 1882. The impact that he was to have was out of all proportion to his experience and ability as a photographer. At first he produced a number of illustrated books on the life and topography of East Anglia. The most important of these was *Life and Landscape of The Norfolk Broads* which like some of his other works was produced in colla-boration with T. F. Goodall. Pub-lished in 1886 it was illustrated with 40 original platinotype prints.

Another, *Wild Life on a Tidal Water* published in 1890, was stated to be illustrated with 'photo-etchings' which appear to be photogravures.

In 1889 Emerson's book *Naturalis-tic Photography for Students of the Art* was published to be followed two years later by a pamphlet *Death of Naturalistic Photography* in which he renounced the concepts embodied in the original work. His attack on the 'high art' form of photographic expression led by H. P. Robinson caused a sensation and although the subsequent pamphlet was con-sidered by many as a public apo-logy, it appeared to make no differ-ence to the style of his photography. Some of his followers, notably George Davison, who in 1912 had to

Right *Quo Vadis* by Frank Meadow Sutcliffe.

Opposite *An Eel Catcher's Home* by P. H. Emerson from *Life and Landscape on the Norfolk Broads*.

Below *Great Yarmouth Harbour* by P. H. Emerson. Frontispiece to his book *Wild Life on a Tidal Water*.

resign as Managing Director of Kodak Limited, because of his anarchist associations, Lyddell Sawyer, who had a portrait studio in Sunderland and a studio in Regent Street, London, together with the independent Frank Meadow Sutcliffe and, surprisingly, H. P. Robinson, formed the group known as The Linked Ring, later to become The London Salon, in 1892.

Sutcliffe, a professional photographer with a studio at Whitby, was one of the finest pictorialists of the first 100 years of photography. The superb skill shown in the handling of the composition of the group of children in his picture *The Water Rats* taken in 1886—surely one of the half-dozen greatest pictorial photographs of all time—the stark simpli-

city of *Quo Vadis*, a signpost on a moor, and his documentary pictures of the local fisherfolk and their countryside seem to be a world apart from the conventional portraits taken at his studio.

The invention and development, during the early years of the twentieth century, of the so-called control processes gave to a new generation of high-art photographers the means to express their artistic thoughts free from the inhibitions imposed by the technical limitations of combination printing, on the one hand, and the aftermath of the naturalistic/high art/Linked Ring controversies on the other. With each process there arose a small circle of dedicated practitioners and it is with them we are now concerned.

The Application of the Control Processes

The gum bichromate process

Of those photographers who practiced this process Robert Demachy, born in Paris and christened Leon-Robert, was undoubtedly the finest exponent. Numbered amongst the greatest of all pictorial photographers, an accomplished writer and speaker, he became the undisputed leader of the French pictorialists. His interest in photography dated from the early 1880s and he was elected to membership of the Société

Français de Photographie in 1882. Between 1893 and 1894 he commenced experimenting with the gum process and in 1895 held an exhibition of his prints in Paris followed two years later by the publication in London of a text book on the process. He had strong links with Britain, holding one-man shows at The Royal Photographic Society, and was elected an Honorary member in 1905. In the same year he was invited and accepted an invitation to join the Linked Ring. Soon after G. E. H. Rawlins introduced his oil process in 1904 Demachy was attracted to it on account of the additional degree of control of the final image that it provided, and two years later abandoned the gum-bi-chromate process in its favour. The exhibition of his prints at The Royal Photographic Society in London in 1907 received ecstatic reviews in most of the newspapers and periodicals of the day as well as in the photographic press. The general reaction was probably best expressed by the very distinguished writer and photographic art critic A. J. Anderson, author of *The Artistic Side of Photography* (London, 1910) who said '... of a truth, Robert Demachy is not a man, he is a miracle'. Demachy abandoned photography completely and inexplicably in 1914 just as Fenton had done in 1862.

Other notable exponents of the gum process included: J. C. Batkin who was a prominent member of the Birmingham Photographic Society; J. Dudley Johnson one of the stalwarts of the Royal Photographic Society, he had twice been President; Edward J. Steichen one of the finest of all American pictorialists; and the Viennese Triforlium of Hans Watzek, Hugo Henneberg and Heinrich Kühn whose work was much admired by Steichen.

The carbon and carbro processes

Swan's carbon process, marketed by The Autotype Company from 1868, and Manly's modification of it,

introduced in 1905 under the name 'ozobrome' and marketed by them as Carbro, did not offer the same opportunities to photographers for extensive manipulation as the other control processes. It was one of the prestige printing processes used by pictorialists of both the high art and naturalistic schools. Alexander Keighley was the last of the great British pictorialists from the era of Robinson and Alfred Horsley Hinton to practise the carbon process. Much addicted to extensive retouching and handwork on both negatives and prints, many of his pictures exhibited a similarity of lighting. The dominant feature of the composition was often presented in a pool of sunlight isolated from a gloomy middle to low key background.

Because it was both a permanent and a control process, with a tonal range similar to conventional printing methods, it was often selected by some of the outstanding pictorialists for the printing of their most famous works. Colonel Joseph Gale and J. B. B. Wellington, both prominently associated with the Naturalistic School, used it for their landscapes during the 1880s and 1890s. J. Craig Annan, the distinguished son of an equally distinguished Glaswegian photographer Thomas Annan, shared his father's enthusiasm for the process. During the period between the two World Wars, one of the most celebrated of all photographers, Pirie MacDonald of New York, as well as the landscapist James McKissack, employed it.

The oil and bromoil processes

The first of the established pictorial photographers to adopt Rawlin's process was Robert Demachy. His reputation and influence was sufficient to encourage others to follow his lead, amongst them C. F. Instone, James McKissack and Bertram Cox, all of whom were exhibiting regularly at International Exhibitions at the turn of the century. However, it was the period between 1920 and 1940 that was to become the golden age of bromoil and bromoil transfer prints. Now that modern printing paper technology has made such prints difficult to produce more than it was in those days when non-supercoated bromide paper could be obtained in a wide variety of surfaces, it seems unlikely that their equal will ever be encountered. Amongst the elite of its practitioners were: the Belgian Leonard Misonne; the American A. D. Chaffee; and the Englishmen, Fred Judge, Chris J. Symes, Bertram

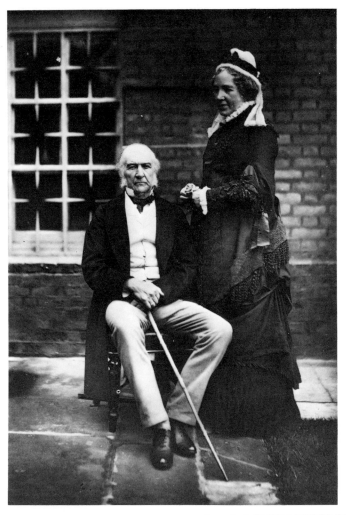

Opposite top *High Conquest*, a bromoil print by C. H. Wills (1950).

Opposite bottom *The Storm Lifting* by C. F. Instone, F.R.P.S. A platinum print, which received medals at the Dublin and Exeter Exhibitions and was reproduced in *Photograms* of 1898.

Left Mr & Mrs Gladstone, a carbon print by J. & A. McLeod of London and Newark.

Below An oil process print by C. F. Instone, F.R.P.S., a prominent pictorial photographer during the early part of the twentieth century.

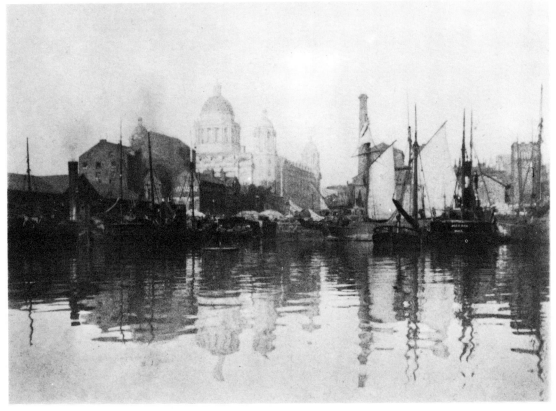

Cox, W. J. Roberts, G. L. Hawkins and the last of the great bromoilists, Arnold E. Brookes who was still producing masterpieces until a week or so before his death in 1977.

The platinum and gum-platinum processes

Although the platinum process was not in any sense one of the control processes it is convenient to refer to it here together with its derived control process—the gum platinum.

Renowned for the delicacy and subtlety of its tonal rendition it was the favoured medium of a number of outstanding creative photographers in the years prior to 1914. The Americans Edward J. Steichen, Fred Holland Day and Gertrude Käsebier all used the process as did the German Baron A. de Meyer and that superb English architectural photographer F. H. Evans, as well as the Cuban-born founder of the naturalistic school of photography P. H. Emerson.

The gum-platinum process was a development of straight platinum printing augmented by applying to the surface of a finished platinum print a gum-bichromate solution incorporating a coloured pigment and then making another exposure behind the original negative. It appears to have been invented by the American Alvin Langdon Coburn, a cousin of F. Holland Day, and was practised by Coburn and by the eminent English pictorialist J. Dudley Johnston. Johnston, who died in 1955 aged 87, served the Royal Photographic Society in a number of capacities and was elected President in 1923 and again in 1929. From 1923 until his death he was Curator of the Society's Print Collection.

The Fresson process and José Ortiz Echagüe

Without doubt the greatest Spanish pictorial photographer, Echagüe was born in 1886 and his superb warm toned prints, mainly of tradi-tional Spanish religious and other events, have graced the walls of International Exhibitions for over half a century. He was one of the very few practitioners of the Fresson process which was a variant of the Artique process. It employed a combination of the carbon and gum-bichromate processes and the image was 'developed' by friction in a solution of sawdust and water which had the consistency of thick soup. The colour of the image could be varied according to the pigment used and the texture of the final print was controlled by the sawdust 'soup'. Most of Echagüe's prints, usually about 20 × 16 inches in size, were a warm sepia colour and always attracted great attention wherever they were exhibited.

Modern Pictorial Photography

From 1930 onwards advances in manufacturing technology contributed to a new approach towards pictorial photography. Small format, precision made cameras, emulsions of greater sensitivity with a finer grain structure, lenses of wider aperture and better resolution capability, together with reliable exposure meters and rangefinders, combined to make the technique of photography easier for the pictorial workers. In general, they were more concerned with the pictures than they were with the means by which the negatives and prints were produced.

The decline in the popularity of many of the control processes, which required a negative of the same size as the finished print, was a direct consequence of the trend towards the miniature camera. Combination printing, apart from the printing in of clouds, became a technique of the past, practised only by a few die-hards. The mystique of the dark-room was dying.

At first the miniaturists as they

Laycock Church, a bromoil by Arnold E. Brookes, F.R.P.S.

Above *Winter Splendour* by J. T. Suffield, A.R.P.S. A chlorobromide print from a negative made in 1947.

Right Interior of a home at Madura, Madras, an archaeological survey photograph by Captain E. D. Lyon. *Collection of the India Office Library, London.*

Opposite Yosemite, California, (1938) by Edward Weston.

were known could not compete with those photographers who continued to use large format cameras. These latter derided the prints of the miniaturists as being unsharp, woolly and grainy. But, as the manufacturers produced smaller and better cameras and faster, finer grained emulsions the gap narrowed.

The new generation of pictorialists divided itself into two schools, the traditionalists who adapted the modern technology to establish forms of artistic expression and those who turned to abstract and surrealistic concepts of picture making.

Some of the traditionalists accepted the slight 'softness' associated with the large exhibition type prints. In fact, not only did they defend them as being more artistic than

technically sharp prints but actually diffused the images during the making of their enlargements. Others, eschewing the techniques of differential focussing and chiaroscura, joined the 'f/64' school and set out to produce pictures having extreme depth of field and critical definition.

The doyens of the 'f/64' school were two Americans—Ansel Easton Adams and Edward Weston. Ansel Adams became the successor to the great photographers of the American West, Carleton E. Watkins and William Henry Jackson. His photographs taken in Sierra Nevada, in the National Parks of Yosemite and Yellowstone, in Arizona, New Mexico and in the Hawaiian Islands have sometimes been described as merely record photographs. Records they may be but Adams'

artistic perception displayed in his choice of viewpoint, of the right moment for the exposure, and, probably most importantly, of the appropriate printing paper has surely produced at the least some of the most aesthetically satisfying photographs of the American National Parks ever taken.

Edward Weston's work was characterized by a simplicity of approach which often produced a feeling that here was a lucky snapshot, taken by a photographer endowed with superb technical skills, rather than a planned or carefully considered composition. His choice of subject matter was more varied than that of Adams but his artistic sense was so sound and sure that it would be a brave critic who attempted to suggest what was the strongest

Above Workers houses in a northern city by Bill Brandt. Note that the houses have no windows facing the street.

Opposite The entrance route to the ancient city of Petra in Jordan by George Rodger; a good example of modern naturalistic photography.

or most satisfying of the subject areas within which he worked.

The middle-of-the-road pictorialists of the period produced work which will eventually bear comparison with that produced in other eras. Just as Julia Margaret Cameron was the finest woman portrait photographer of the nineteenth century so Katherine M. Parsons was the finest woman landscape photographer of the first half of the twentieth century. They had much in common: both took up photography during middle age, both were amateurs, both had an interest in poetry and literature and both used photography to express their literary interests. The technical aspects of photography had no appeal for Mrs Parsons; she did what so many of us should do but do not—she read the manufacturers leaflets and instruction pamphlets and followed their directions! Her glorious pictures of the West Coast of

Scotland did not suffer by this simple approach to the technology of picture making.

A distinguished professional portraitist Bertram Sinkinson of Stafford produced for many years a succession of very fine landscapes as a relaxation from his professional work and he and Mrs Parsons did much to re-establish the traditional English landscape as a photographic art form. Other outstanding landscape artists of the period included: M. O. Dell, renowned for the delicate atmospheric effects that he achieved in his mountain scenes; Bill Brandt, whose provocative style of low key dramatic lighting is so suited to his desolate subject matter; and those superb bromoilists G. L. Hawkins and Arnold Brookes.

In the associated field of the seascape F. J. Mortimer, sometime President of The Royal Photographic Society and Editor of The Amateur Photographer, reigned

supreme until his untimely death during the Second World War.

Outside the British Isles, which has always been the traditional centre of pictorial landscape photography, a number of individuals have made outstanding contributions. Will Till established a school of romantic style landscape photography in South Africa. In America in addition to the work of Ansel Adams, Andreas Feiniger and Frank R. Fraprie with, from a slightly earlier period, the landscapes of Edward Steichen (better known for his portraits), Alfred Stieglitz, Clarence White and Alvin Langdon Coburn were prominent. In the Far East a very characteristic style of photography was created by Francis Wu of Hong Kong and his followers utilizing the local misty atmospheric effects to produce numbers of outstanding high-key seascapes and landscapes.

Much of the outstanding portraiture and figure work was produced in the United States and Canada. Pirie MacDonald of New York was succeeded by Karsh of Ottawa as the outstanding photographer of men. Max Thorek and William Mortensen specialized in interpretive portraiture whilst Shirley M. Hall and P. H. Oelman produced immaculate figure studies. One of the most versatile photographers was Philippe Halsman who produced over 100 front cover pictures for *Life* magazine and who, working under the influence of Salvador Dali, created some astounding surrealistic pictures. Great as they all were, they were forever in the shadow of Edward Steichen.

In Britain, the late Sir Cecil Beaton was creating his own particular style embodying elaborately ornate settings which were in direct contrast to the documentary work that he undertook for the Ministry of Information during the Second World War. Houston Rogers, Peggy Delius and Merlyn Severn were outstanding in their interpretation of the ballet. Angus McBean, one of the most imaginative theatrical

Left Solarized portrait of Marina by Blumenfeld (Paris, 1937).

Below *Les Sylphides* by Peggy Delius, F.I.B.P., F.R.P.S. Exhibited at The London Salon, 1944.

Opposite *Two boys at a shop window* by Frank Mullineux, J.P., F.S.A. (Scot.) (*c.* 1905).

photographers of all time, was to experiment most successfully in the production of surrealistic images. Rosaline Maingot, Joan Craven and G. Newby of Halifax were the finest of the photographers of the female form. The reputation of Marcus Adams as a photographer of children was established beyond doubt, reinforced by Royal patronage.

Julian Smith of Melbourne, Australia was the outstanding portraitist in the Antipodes whilst from India J. C. Patel's work was rapidly establishing an international reputation. In Europe Rolf Windquist and Wilma Björling of Sweden, Jacques Moutet and André Thevenet of France and W. Luthy of Switzerland were all making individual contributions of the highest calibre.

In the fantasy work of the table top Londoner E. Heimann had few competitors and examples of his work appeared in international exhibitions and annual publications throughout the world.

In the immediate pre-war years a number of photographers were tentatively entering the field of 'experimental' photography. Abstract and surrealistic imagery, reinforced with the techniques of solarization, the Sabattier and Mackie line effects, negative prints and photograms and screened prints was limited only by the imagination of the artist. In the hands of masters such as Man Ray, an American who lived in Paris, and Laszlo Moholy Nagy, the Hungarian who had taught at the Bauhaus in Germany during the 1920s and was later to become Director of The New Bauhaus in Chicago, the results were valid expressions of aesthetic thought. Unfortunately the techniques were used by many who lacked the instinctive ability to distinguish the barriers between an art form and a technique. In the post-war years some interesting work has been produced by Jerry N. Uelsmann in the United States.

The influence of magazines such as *Life* in America and *Picture Post* in Britain was largely responsible for

The Manhattan skyline from Brooklyn Bridge in New York City taken with a fish-eye lens. *Bruce Coleman, Uxbridge/ David Overcash.*

Above An immigrant mother and her children at Ellis Island (*c.* 1910), after a long and uncomfortable journey across the Atlantic, awaiting strict immigration checks before being allowed to enter America.

Right A new town in Oklahoma (*c.* 1890) showing some of the thousands of immigrants who sought adventure and escape from the overcrowding of the cities in the east.

Opposite A rear tenement bedroom in New York's Eastside by Lewis W. Hine (1910). *International Museum of Photography at George Eastman House.*

An architectural photograph of the interior of Laon Cathedral, France.

the present day emphasis on documentary photography. Although practised by many distinguished photographers dating back to the last century it was not until the late 1930s that it received the recognition it was due. The work of John Thompson published as woodbury-types between 1877 and 1881 under the titles of *Street Life in London* and *Street Incidents* is now highly regarded. Eugene Atget's Parisian street scenes taken mainly during the first 20 years of the twentieth century, received little attention until some time after his death in 1927. In the United States Lewis W. Hine, Jacob A. Riis and Arnold Genthe were the trendsetters. Their approach was to be continued by a group of photographers who became known as photo-journalists. Many of them were basically press photographers who combined their technical skills and news sense with an instinctive appreciation of the difference between a picture and a record. Their doyen was undoubtedly Henri Cartier-Bresson, a Frenchman who became a founder member of Magnum in which he was joined by Robert Capa, Willy Bischoff and George Rodger. In Britain Humphrey Spender, Bert Hardy, Bill Brandt, E. O. Hoppe and James Jarché were all outstanding.

The Application of Photography

Professional Portraiture

The invention of photography had an enormous impact on social life in general terms but it was portraiture that provided the original commercial application of the process. The calotype process could not compete with the daguerreotype whose clarity of detail and fine tonal rendition made an instant appeal to the general public. The first portrait studio in London was opened by Richard Beard in March 1841 at The Royal Polytechnic Institution in Regent Street. He employed James Goddard, a science lecturer, to manage the establishment and subsequently opened other studios in Parliament Street and King William Street during the following year. Although technically competent the portraits were with few exceptions merely factual likenesses lacking artistic merit.

In June 1841, Antoine Francois Jean Claudet opened a studio at The Adelaide Gallery just off the Strand. In 1844 he took over the top floor of an adjoining house, 18 King William Street. He opened another studio in Regent's Park at the Colosseum in 1847 and finally established his

Left to right: stereoscopic daguerreotype by A. F. J. Claudet contained within a viewing case of his design (1850s); stereoscopic collodion positive on glass (ambrotype) of a military gentleman in a viewing case (1850s); paper stereogram in a Kilburn viewer; and a Beck mirror stereoscope No. 373.

Right and Below A group of four Union cases.

Bottom right An unusual daguerreotype group by Ross & Thompson, the first holders of a Royal Warrant issued on 14 June 1849, as 'photographers at Edinburgh' to Queen Victoria.

Opposite top *Carte-de-visite* portrait by Napoleon Sarony.

Opposite bottom A daguerreotype by R. Beard in a Wharton case.

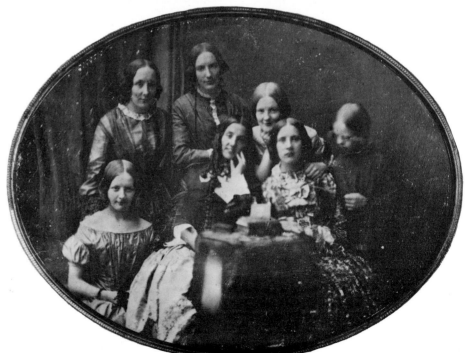

SARONY, 680 BROADWAY.

LESTER WALLACK.

Temple of Photography at 107 Regent Street in 1851.

Claudet was the fashionable society photographer of the day. His sitters included Daguerre, Fox Talbot, Charles Babbage the mathematician, Queen Adelaide, King Louis-Philippe of France and in 1845 he took the only known photograph of The Duke of Wellington. At first his work exhibited a slight lack of technical expertise but this was soon remedied. It was his artistic ability which made his work stand apart from that of his competitors. He had obtained his licence directly from Daguerre, before Miles Berry had been granted a British patent for the daguerreotype process, and claimed to be not only the first daguerreotypist in Britain but also the last to operate the process on a commercial basis. He produced large numbers of very fine hand tinted portraits and during the 1850s specialized in the making of stereoscopic portraits. He was commanded by Queen Victoria to attend Buckingham Palace in 1853 and take stereoscopic portraits of herself and other members' of the Royal family. In the same year he was elected a Fellow of The Royal Society and in 1855 received a Royal Warrant as Stereoscopic Photographist to Her Majesty.

John Jabez Edwin Mayall who had been associated with Marcus Root in Philadelphia and employed by Claudet for a short time opened a studio at 433 West Strand, London in 1847. His hand tinted portraits were the only ones to approach those of Claudet for artistic merit. He produced some of the largest daguerreotypes of the time measuring up to 24 × 15 inches.

Two other outstanding daguerreotypists in London were William Edward Kilburn and T. R. Williams, both of whom had studios in Regent Street. Williams who had at one time worked for Claudet produced a number of very fine daguerreotypes of the Great Exhibition of 1851.

Elsewhere in Britain James Ross

LABOUR IN VAIN, OR THE LOST AIR.

Registered.

MEASURING FOR THE WEDDING RING.

Copyright.

CRINOLINE DIFFICULTIES.

Registered.

THE TRAVELLER'S BLUNDER.

Copyright.

THE PLEASURES OF MATRIMONY;
OR
TWELVE MONTHS AFTER MARRIAGE.

Copyright.

and John Thompson of Edinburgh were granted the first Royal Warrant as Photographers to Queen Victoria on 14 June 1849; Joseph Whitlock opened a studio in Birmingham in 1842 at 120 New Street and R. Lowe established a studio in The Promenade at Cheltenham in 1845.

Daguerreotypes were usually sold in small leather cases, sometimes embossed with the name of the photographer, but a new type of case was introduced around 1852. An American, Samuel Peck of New Haven, Connecticut and an Englishman, Alfred P. Critchlow, a button maker from Birmingham who had emigrated to Haydenville, Massachusetts in 1843, both experimented with various materials with the aim of mass producing cases by thermo-moulding techniques. These Union cases, as they became known, were the first decorative plastic products to be mass produced. Some of the finest die engravers in the United States produced designs for the cases. Because the material is very brittle few have survived without at least some minor chipping on the edges so that examples in pristine

Above Two late-Victorian albums opened to display Royal Portraits. The picture of The Princess of Wales (bottom left) is by Downey.

Opposite top Hand-coloured *cartes-de-visite* from Naples produced during the latter period of the nineteenth century.

Opposite bottom Victorian hand-coloured *carte-de-visite* pictures.

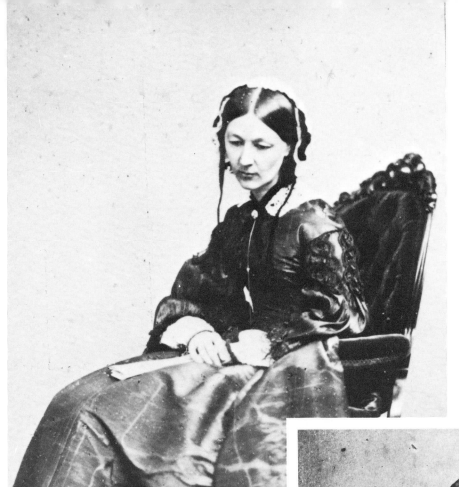

Two *carte-de-visite* portraits of Florence
Nightingale: *below* by W. E. Kilburn
and *left* by H. Lenthall of Regent
Street (*c.* 1854). *The George Parker
History of Photography Collection.*

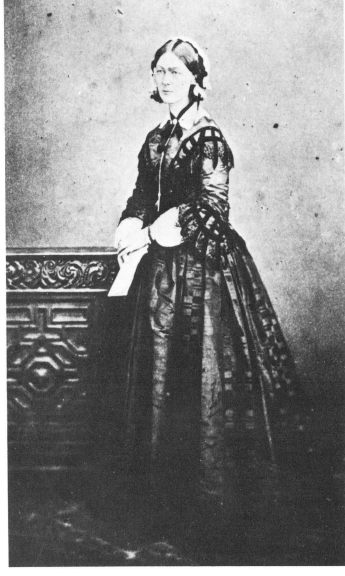

Opposite top A group of *cartes-de-visite*
commencing in the 1860s showing the
changes in title of the firms who ran
the photographic business which was
established by Napoleon Sarony at
66 New Street, Birmingham.

Opposite bottom Deathbed
daguerreotype portrait of a child by
Alphonse Plumier who had studios in
Liège, Brussels and Paris. He
advertised as his speciality 'portraits
après décès à domicile'.

condition are highly sought after by collectors.

In 1854 Andre Adolphe Disderi, a Parisian portrait photographer, obtained a patent for a method of making a number of exposures on a single plate each of which measured about $3\frac{1}{2} \times 2\frac{1}{4}$ inches. They were then printed, trimmed and mounted onto cards about $4\frac{1}{4} \times 2\frac{1}{2}$ inches and became universally known as *cartes-de-visite*. After a visit to his studio by Napoleon III in 1859 when he ordered a number of them they became very popular not least on account of their small size and low cost.

Introduced into Britain by Dr Hugh Diamond, one of the original members of the Calotype Club, and T. Bullock, who had established a portrait studio at Macclesfield, the *carte*'s popularity was to grow rapidly, particularly after the issue by J. E. Mayall of his album of Royal portraits taken in 1860 in *carte* form. Contrary to popular opinion most of these portraits of Royalty and other prominent personalities of the day now have very little commercial value. They were published in large numbers and sold by most stationers and in consequence are

Opposite top A child's adjustable posing seat made by the Porle Werner Manufacturing Company of New York. *Mr M. Dyche*.

Opposite bottom Woodburytype portraits of prominent people issued as *cartes-de-visite* by John C. Murdock of London, Edinburgh and Glasgow. On the left is Alfred Tennyson and on the right Robert Browning.

Above A Japanese embroidered silk surround for a *carte-de-visite* portrait.

fairly common. It is said that the portrait taken by Downey in 1867 of The Princess of Wales carrying her baby, Princess Louise, on her back was so popular that 300,000 copies were printed within a year or so.

Although some of the better class of photographers declined at first to enter into what they considered to be the 'cheap end' of the market, the popularity of the *carte* and the profits to be made from it eventually outweighed all other considerations. In England such well-known photographers as Beard, Claudet, Mayall, Silvy and Williams all issued *cartes*. The French photographers Nadar and Pierre Petit, as well as Disderi, and the Americans Brady and Napoleon Sarony all produced large numbers of them. The latter, who on his return to the United States from England in the late 1860s opened a studio in New York, was an extrovert eccentric who became the most highly regarded theatrical photographer in America. *Cartes* issued by him from his studio in England at 66 New Street, Birmingham during the short time that he was there are now much sought after by collectors.

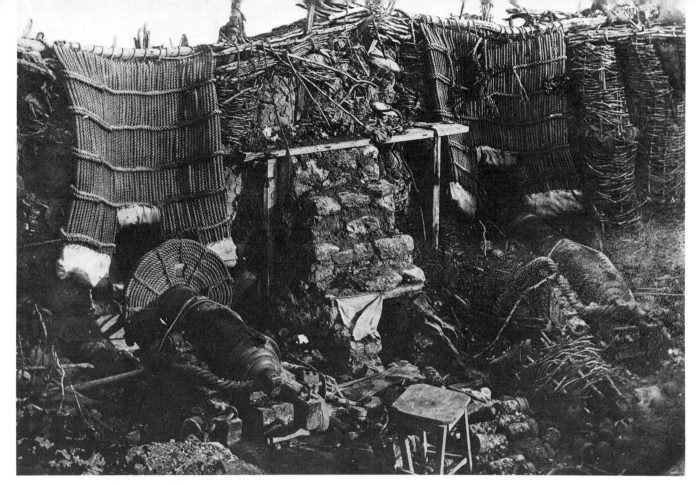

In England F. R. Window of London introduced the variant of the *carte* known as the 'cabinet' portrait in 1866. The size of the print was about $5\frac{1}{2} \times 4$ inches mounted on a card $6\frac{1}{2} \times 4\frac{1}{4}$ inches. During the period 1860 to 1890 *carte* and cabinet portraits were the financial backbone of the photographic industry.

A somewhat macabre application of photography which was for a time popular in France and the United States was the deathbed portrait. Originating as daguerreotypes and ambrotypes often presented in specially designed Union 'mourning' cases decorated with angels they later took the form of *cartes* and cabinets but were seldom displayed in the portrait albums of the period.

Some of the earliest examples of wedding photographs, school groups and the like appeared as *cartes-de-visite*. Well known topographical photographers such as Frith, G. W. Wilson, James Valentine and Francis Bedford all issued *cartes* depicting well known buildings and places. These were the forerunners of today's picture postcard.

It was the introduction of the simple-to-operate box camera by George Eastman, which enabled the general public to produce their own snapshots, that led to the demise of the *carte-de-visite* and photographers turned to the production of larger portraits.

Opposite top A fine example of photography by magnesium flash powder taken by Robert Slingsby (*c*. 1889).

Opposite bottom A platinum print of Aubrey Beardsley (1872-98) by Frederick H. Evans (1895). *National Portrait Gallery*.

Above *The Barracks Battery* by James Robertson.

The Camera at War

Although daguerreotypes had been taken during the Mexican War (1846-48) and calotypes had been made by John MacCosh, a surgeon in the East Indian Company's Army, during the 2nd Sikh War (1848-49) and the 2nd Burma War (1852-53), these appear to have been confined to portraits or groups of the officers and men and of captured arms.

When the Russo-Turkish War (1853-56) broke out in the Crimea the first photographer on the scene

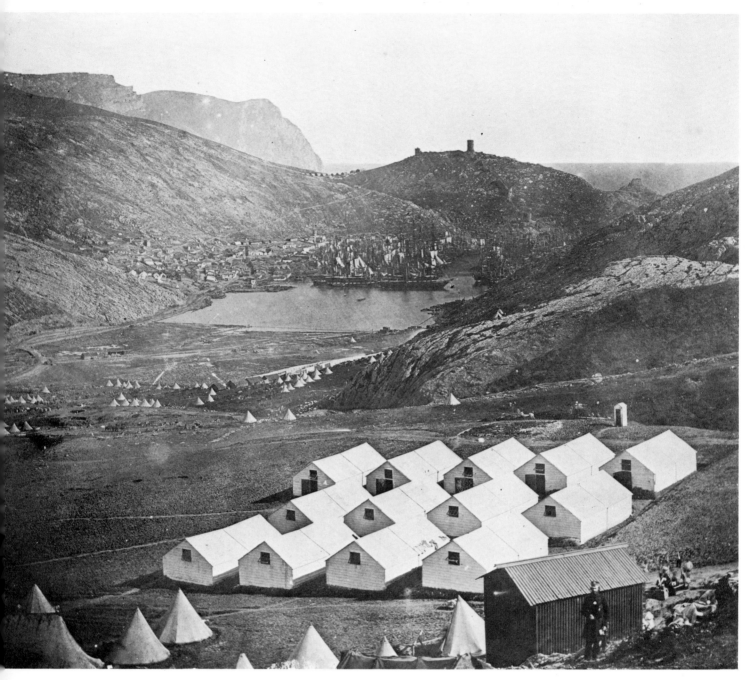

was a Rumanian De Szathmari, who was an artist and amateur photographer living in Bucharest. From April 1854 he took pictures of both the Russian and Turkish combatants, eventually compiling a series of albums one of which was exhibited at the Universal Exhibition in Paris in 1855. Following the involvement of the British and French Governments, who had sent some 60,000 troops to the peninsula in September 1854, Roger Fenton undertook an expedition there in February 1855 under the auspices of the Manchester publisher Thomas Agnew. Prior to his departure the war office had made arrangements for an official photographer to be attached to the troops, but the boat on which he and his assistants sailed was lost at sea in a hurricane. Two young soldiers were then given a short course in photography by J. E. Mayall and sent out as replacements. However, it appears that they were unsuccessful and no record of their work is known. Fenton's expedition was probably inspired by the dramatic accounts of the war published by *The Times* and other newspapers. He arrived at Balaclava in March 1855. Although he was present when the battle was in progress, his pictures did not portray the true horrors of the war. It has been said that he was too much of a gentleman to photograph the dead and injured on the battlefield. His own health deteriorated and he returned home in June 1855. Later in the year his pictures were published in a series of portfolios by Agnew.

Three months later James Rob-

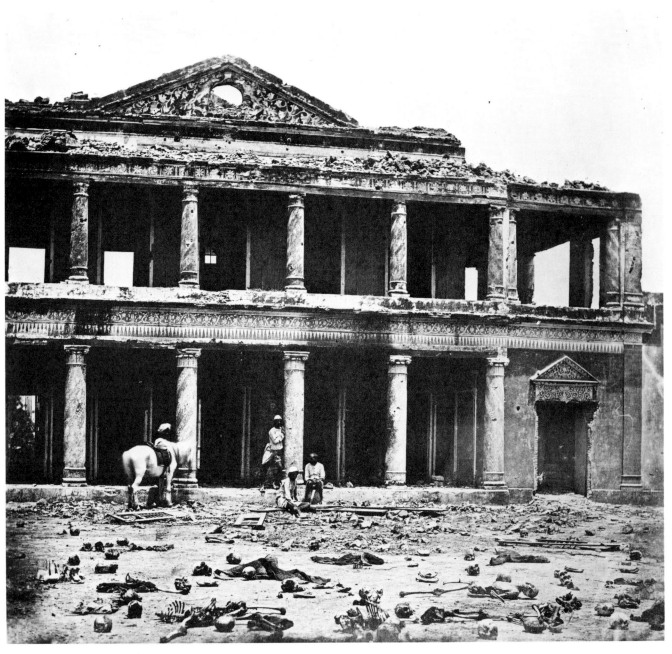

Opposite General view of Balaclava, with Genoese fort, from the Guards' camp by James Robertson.

Left *Awaiting the Arrival of Sir Charles Napier* a salt paper print by R. Fenton. Sir Charles succeeded Lord Gough as Commander of the British Forces in the Second Sikh War in 1849.

Above A scene of devastation from the 2nd China War (1856-60) by Felice Beato (1860) who was considered to be the first photographic war correspondent.

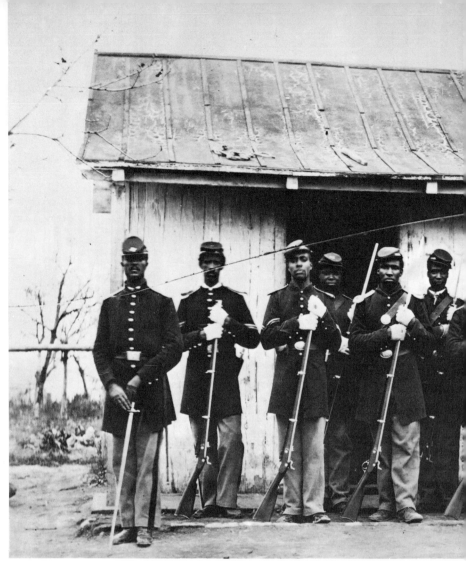

Right The Guardhouse and guards of the 107th Colored Infantry at Corcoram, Virginia issued by Matthew Brady during the American Civil War (1861-65).

Far right Abraham Lincoln, taken in 1865 by Alexander Gardner.

Below *Battlefield of Gettysburg* by Matthew Brady.

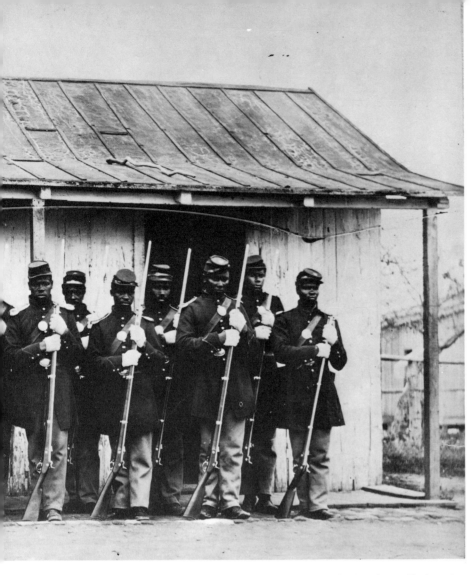

ertson, the Superintendent of the Imperial Mint at Constantinople, accompanied by his colleague Felice Beato arrived at Balaclava and photographed the aftermath of the war. His photographs depicted the devastation that Fenton had avoided and have not been accorded the degree of importance that they merit.

George Shaw Lefevre, later to become Baron Eversley, was also active during the Crimean war and an album of 12 of his photographs taken at Sebastopol on 8 September 1855 was published in London in 1856.

In the same year Robertson and Beato resumed their photography of the ruins and antiquities of Greece, Malta and Palestine which they had commenced in 1850. In the following year they journeyed to Palestine en route to the Indian Mutiny. Although Beato is well known for his general topographical views of the Near and Far East he must be

accorded the distinction of being the first photographic war correspondent. He subsequently joined the Anglo-French contingent in the Opium War in China and in 1884 recorded General Wolseley's campaign to relieve General Gordon at Khartoum.

In the United States Mathew B. Brady, a well established portrait photographer with studios in New York and Washington, decided to undertake a photographic survey of the American Civil War (1861-65) as a commercial venture.

Brady recruited a team of photographers amongst whom were: Alexander Gardner, Timothy H. O'Sullivan and Louis H. Landy. Gardner, a Scotsman, who had been trained in the use of the wet collodion process and the albumen print, was in charge of Brady's Washington Studio when it was opened in 1858. O'Sullivan, who worked on the Government Surveys of Arizona and Colorado after the cessation of

the fighting, took particularly fine landscape pictures. Landy was personal assistant to Brady and because of Brady's policy of publishing all pictures taken by the team under his own name and never giving any credit to individuals, his work is little known. Such of his work that has been identified shows him to be a sensitive photographer possessed of high technical skills.

Gardner parted company with Brady during 1862, irritated by the latter's attitude of claiming credit for the pictures taken by his staff, and opened his own studio over Shephard & Riley's Bookshop in Washington. He recruited his own team to continue photographing the war and one of its earliest members was O'Sullivan who had left Brady for the same reason as Gardner.

In 1866 Philip & Solomons of Washington published *Gardner's Photographic Sketch Book of The War*. This comprised two albums with a total of 100 albumen prints each of

nominal size 10 × 8 inches. Although all the prints were made in Gardner's studio, Gardner was very careful to credit the pictures to the member of his team who took the negative. However, of the pictures in the sketch book 71 were taken either by Gardner, his son James or by O'Sullivan.

George N. Barnard, a one-time assistant to Brady, was a member of Gardner's team who is now best known for his pictures of General Sherman's campaign in the South. A selection of these were published in 1866 in an album titled *Photographic Views of the Sherman Campaign*.

During the Franco-Prussian War, the Prussian Army had established an Army photographic unit which was directed by W. G. Schwier. Intended as a survey unit, they nonetheless produced many pictures of the military operations.

As early as 1856 a school of military photography had been established at Chatham in England and by 1881 every Army Corps was provided with a photographic unit including a wagon adapted as a portable darkroom. In France, from 1861, selected officers received photographic instruction from André Disderi. Ten years later the subject was a part of the training course at the École Militaire in Paris.

Although the introduction of faster films, wider aperture lenses and more portable equipment in the first

Opposite Federal Artillery of 1862 attributed to Matthew Brady's assistant Timothy O'Sullivan.

Above The northwest corner of the British Redoubt at Sherpur, Dacca by John Burke (1879).

Above The trench of the bayonets, showing the graves of unknown French soldiers, 1917.

Opposite top British troops marching to relieve French and American troops in the Villers-Cotterets Forest, 1918.

Opposite bottom A German corpse at Verdun.

decade of the twentieth century should have resulted in the First World War being particularly well recorded by photography this was not the case. Some official photography was undertaken—mainly of a survey nature—both from the ground and from the air, but the very nature of trench warfare made photography in the battlefields virtually impossible. Some photographs were taken unofficially by combatants on both sides but this was certainly not encouraged. Some of the pictures, both stereoscopic and other, which were issued after the war are now known to have been specially staged.

The introduction of the sophisticated miniature camera in the 1930s enabled war correspondents to record the realities of fighting. The Spanish Civil War of 1936 was to provide the battlefield, Hungary was to provide the photographer in the person of Robert Capa, born André Friedmann.

At the age of 22 Capa was in Paris, an unknown photographer with no money and little prospect of any success. Within a few months he was on his way to Spain armed with one 35 mm camera. From then on until 1954, when he was killed by a landmine in Vietnam, he was seldom far away from one of the major theatres of war.

It was in Spain that Capa was to produce the photograph that was to fashion his future and which has often been described as the greatest war picture of all time. Capa's *Moment of Death* was a lucky snapshot, but that in no way detracts from its qualities as a dramatic composition symbolic of warfare.

From Spain he went to Hankow in 1938 to photograph the war between the Chinese and their Japanese invaders. With the outbreak of the Second World War, Capa went with his Contax cameras to London, North Africa, Sicily, Salerno and Anzio with E Company and then to St Laurent-sur-Mer, the Normandy beaches on D-Day and across France with Patton to Berlin.

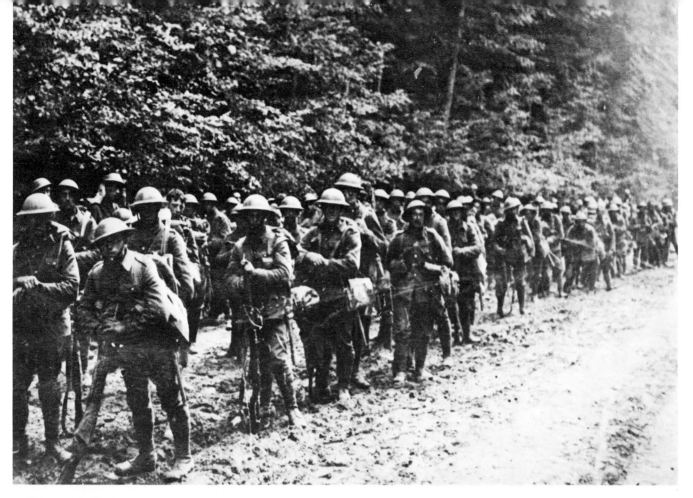

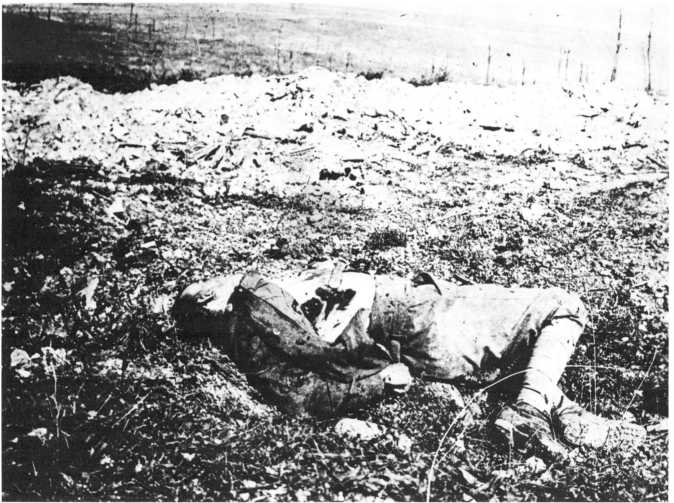

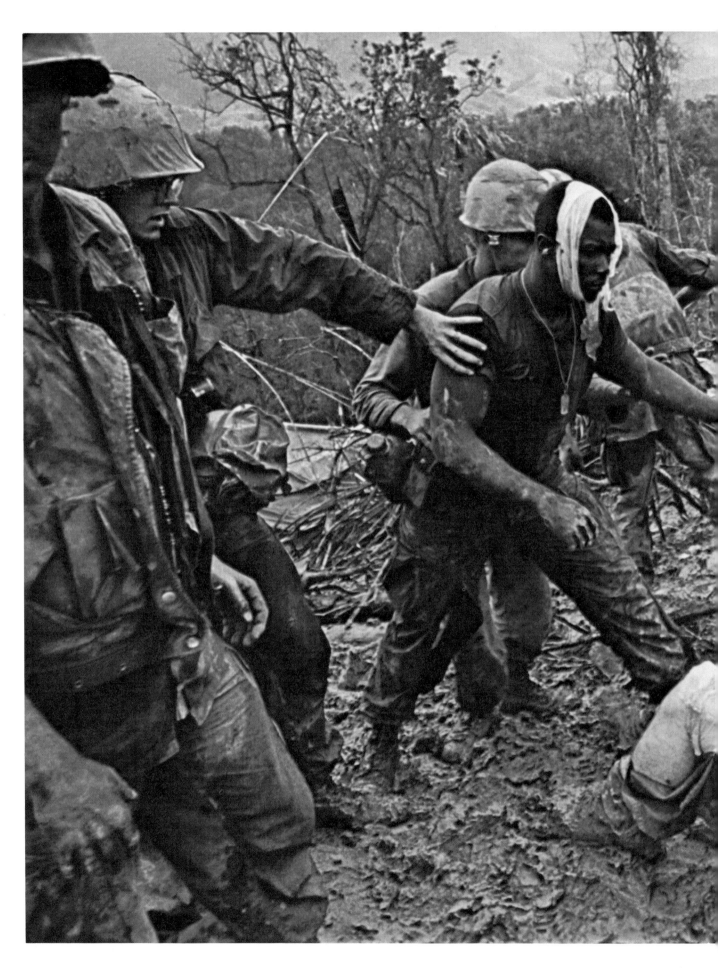

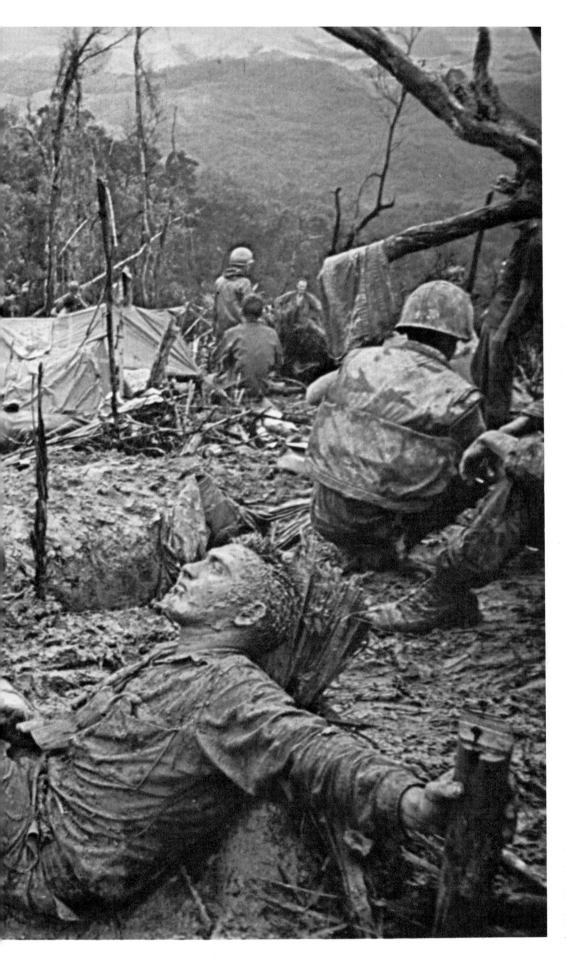

First-aid centre during Operation Prairie, Vietnam, (1971) by Larry Burrows. Burrows was one of many photographers to cover the war in Vietnam for *Time/Life*. One article in *Life* magazine advertised his work on the cover: 'In Color: Ugly War in Vietnam'. *Colorific, London/Larry Burrows.*

Above Robert Capa's famous photograph *Moment of Death*, taken during the Spanish Civil War of 1936. *Magnum, London/Robert Capa.*

Opposite top *Cairo from the Citadel* by Francis Frith (1858). This is reproduced from an original 20 × 16 inch contact gold-toned albumen print. The quality of the definition and the extreme depth of field is remarkable for so early a photograph.

Opposite bottom 'The explorer furnished with his photographic apparatus, which is now constructed in such a manner that it can be used with ease in any part of the world, brings back with him from his travels documents invaluable, because no one can deny their accuracy.' Gaston Tissandier writing in *A History and Handbook of Photography* (1876).

In 1946 he was a founder member together with David Seymour, George Rodger and Henri Cartier-Bresson of the photo-journalistic group Magnum.

In 1948 Capa covered the first Arab-Israeli War. This was followed by an assignment in Vietnam which ended abruptly with the explosion of a landmine on 25 May 1954.

Capa, the complete photographer of war, had the eye of an artist and could see a picture even in a death.

The Second World War and its aftermath produced a small band of outstanding war photographers some of whose pictures may possibly influence the attitude of future generations towards war.

Amongst them were Capa, Larry Burrows, Eliot Elisofan, David Duncan and Horst Faas. Faas spent eight years between 1962 and 1970 working for Associated Press in Vietnam and was to receive in 1965 both the Pulitzer Prize for Photography and the Capa Memorial Award.

The Camera and the Explorer

The realization that photography was capable of providing a record of the journeys of explorers and travellers occurred soon after its invention. The practical difficulties were the cumbersome nature of the equipment and its transportation. In France, in 1849, the Ministry of Education had commissioned an archaeological expedition to Egypt and the Near East. Maxime du Camp, an author, accompanied his friend Gustave Flaubert on the expedition between 1849 and 1851 and took some 200 calotype negatives of monuments and general views. After his return to Paris a selection of 125 were printed at Blanquart-Evrard's works in Lille to illustrate a book *Egypte, Nubie, Palestine et Syrie* (Paris, 1852).

Throughout the 1850s there was a

Below *The Great Pyramid and the Great Sphinx* (1858) by Francis Frith. One of the 20 × 16 inch prints from *Egypt, Sinai and Jerusalem* published by W. MacKenzie.

Right *The Ramesum of El-Kurneh* (1858) by Francis Frith, a 20 × 16 inch gold-toned albumen contact print.

Opposite The title page of the volume of 20 × 16 inch prints of Frith's *Egypt, Sinai and Jerusalem*. Note the 2 inch square Kodachrome mount bottom left.

considerable interest in the people and topography of the Near East. Francis Frith, an English Quaker, undertook a number of journeys there. The photographs which he took established his reputation as an outstanding topographical photographer and were to be the foundation upon which the firm of Francis Frith & Co., of Reigate was built. In September 1856 Frith started his first journey along the course of the Nile from Cairo to Abu Simbel. He returned to England in July 1857 but set out on his second journey in November of the same year to Egypt and Palestine. Following his return in May 1858 he established the firm

at Reigate. Soon afterwards, in 1859, Frith departed for Egypt once again. It was this expedition which took him over 1,500 miles up the Nile to beyond the Sixth Cataract through country which no photographer had previously visited.

Frith used the wet collodion process and experienced great difficulty because the heat often caused the collodion to bubble. The majority of his pictures were taken using a 10 × 8 inch camera but he also had with him a stereoscopic camera and a larger one taking plates of 20 × 16 inches which he used to photograph the most important and interesting scenes. On his return a selection of

the prints was published in a series of volumes which are now recognized as being amongst the most significant of all travel books illustrated with original photographs.

The most important of these was *Egypt, Sinai and Jerusalem* which was illustrated with 20 albumen prints each of a nominal size of 20 × 16 inches with a descriptive text written by Mr & Mrs R. S. Poole. The page size was 30 × 21 inches and this is undoubtedly one of the reasons why so few copies of it have survived in good condition. The quality of the photography, the large size of the prints and the interesting subject matter combine to make it a work

which is generally considered to be one of the 12 great books of photography. It was published by William Mackenzie of Glasgow and most of the prints are signed and dated 1858.

A number of volumes of the 10 × 8 inch photographs were published by Mackenzie in various forms, the most usual of which consisted of four volumes each containing 36 photographs and a frontispiece. A two volume edition with 78 prints and a text written by Frith was published by James S. Virtue in London. A selection of the stereograms was issued in book form with a commentary written by Joseph Bonomi. Copies of all the photographs taken

127

on these expeditions were available from the Reigate establishment.

Between 1863 and 1866 Samuel Bourne, the son of a Staffordshire farmer, undertook three expeditions into northern India and the Himalayas. During the last he took a number of photographs from a height of 18,600 ft on the Manirung Pass. This was the greatest height at which photographs had been taken at that time, exceeding by nearly 3,000 ft those taken by Auguste Bisson from the summit of Mont Blanc in July 1861.

Like Frith, Bourne used the wet collodion process and had to employ a large number of porters to carry the cases of 12 × 10 inch glass plates, chemicals and equipment as well as the food and other necessities of a large scale expedition into the foothills. He kept a diary of his travels and wrote a number of articles based on his expeditions which were published in The British Journal of Photography between 1864 and 1870. In 1864 Bourne entered into partnership with Charles Shepherd of Simla who was the proprietor of one of the earliest Indian photographic studios. Bourne returned to England in 1870 and was followed in 1885 by Shepherd. The firm continued to trade under the name of Bourne & Shepherd and is still in existence today at Calcutta. It was this firm who marketed Bourne's prints from their studios in Simla, Calcutta and Bombay. Until recently his pictures have not been accorded the recognition that without doubt they deserve. Technically they bear comparison with the very best of the period and his pictorial sense was sure. Undoubtedly they will attract greater attention in the future.

Walter Bentley Woodbury, who was later to invent the woodbury-type process, met James Page in 1851 on his journey from Manchester to join the Australian gold rush there. Together they decided to seek their fortunes but when their prospecting proved to be unsuccessful they purchased some photo-

Opposite top *Mount Aboo-Jain Temples* (interior) by Samuel Bourne.

Opposite bottom *Darjeeling—Kanchanjanga from Birch Hill* by Samuel Bourne.

Left *Futtehpore Sikri—Palace of Akbar's Wife* by Samuel Bourne.

Above *Secundra—Entrance Gate to Akbar's Tomb* by Samuel Bourne.

Right *Colossal Figure at Singa Sarie, Java* by Walter Bentley Woodbury.

Above *River Scene—Java* by Walter Bentley Woodbury.

Opposite *The Freezing of the Sea* by Herbert G. Ponting.

Above *Captain Scott's Birthday Party*, by H. G. Ponting.

Opposite *Captain Oates with Ponies and Dogs at Sea*, by H. G. Ponting.

graphic equipment and moved on to Batavia in Java in 1852. On arrival they found that they were to be the first photographers to settle there. The local people greeted them with enthusiasm and they soon established a very profitable portrait studio under the name of Woodbury & Page.

Woodbury undertook a number of trips into the interior of the country and obtained some very interesting topographical photographs of the jungle, using both stereoscopic and conventional plate cameras. When he returned to England to obtain further supplies of materials he took some of these views

with him and arranged for them to be marketed by Negretti & Zambra of London.

The importance of the part that photography could play in the scientific investigations and explorations undertaken by expeditions grew from its use by Professor Piazzi Smyth, the Astronomer-Royal for Scotland. During his investigation of the Great Pyramids of Egypt in the early 1860s he pioneered the use of magnesium for lighting their interior passages and rooms.

When Captain Scott's ill-fated Second British Antarctic Expedition of 1910 set out they had with them Herbert G. Ponting, a well-known

photographer and writer, whose job it was to record the complete activities of the expedition, the conditions under which they lived and the topography and animal life of the Antarctic. The book that he wrote and illustrated, *The Great White South*, records the magnificence of his achievement. The best of his photographs were printed in various sizes up to 30 × 20 inches after the return of the expedition and are currently much sought after by collectors.

In the United States Carleton E. Watkins made a series of 20 × 16 inch prints from negatives that he had taken in the Yosemite Valley which were one of the outstanding exhibits at The Universal Exhibition in Paris held in 1867. His work, produced under great difficulty, often in sparsely populated areas, did much to publicize the Yosemite Valley which had been declared a National pleasure area in 1864.

During the 1870s William Henry Jackson, the grand old man of American photography, most of whose negatives have survived, was official photographer to a number of Government geological surveys having made his reputation photographing the Indian settlements around Omaha. He travelled around the west with a wagon set up as a darkroom and his pictures taken in the vicinity of Yellowstone were influential in the negotiations that resulted in the formation of the National Park there in 1872.

The building of the American Railways, particularly the Central Pacific Railroad which crossed the Sierra Nevada, attracted the attention of a number of American photographers including Jackson, Eadweard Muybridge—whose work with his tutor and partner Watkins, led to his appointment in 1868 as Government Director of Photographic Surveys—together with the American Civil War photographers

Opposite top *Penguins in the Pack-Ice* by Herbert G. Ponting.

Opposite bottom A double page in a Japanese topographical album (*c.* 1900).

Above *The Terra Nova at the Ice-Foot* by Herbert G. Ponting.

On the Merced, Yosemite Valley, California by Houseworth. An outstanding example of American topographical photography reproduced from a woodburytype plate in *Treasure Spots of the World* edited by Walter Bentley Woodbury and published in 1875 by Ward, Lock and Tyler of London.

Alexander Gardner and Timothy H. O'Sullivan. Many of their pictures were in the form of stereograms and were sold in the United States in vast numbers.

In Canada, The Assiniboine and Saskatchewan Exploratory Expedition was established to survey an emigrant route between Lake Superior and the Red River settlement. This 1858 expedition under the leadership of Professor H. Hind was the first official Canadian one to make use of photography. Their photographer was Humphrey Lloyd Hime and his prints of the native inhabitants, their living conditions and environment are certainly amongst the finest of all early Canadian photographs.

In the early 1870s William Bradford, who was himself an artist, undertook an art expedition to Greenland taking with him two Boston photographers, Dunmore and Critcherson, who made a very fine technical but nonetheless sensitive record of the work of the expedition. A large selection of their prints was used to illustrate an account of the journey: *The Arctic Regions Illustrated with Photographs taken on an Art Journey to Greenland* written by Bradford and published in 1873 by Sampson Low, Marston, Low & Searle.

The first recorded efforts at underwater photography took place at Weymouth in England in 1856 when William Thompson, an engineer, attempted to take some photographs of seaweed at a depth of about 18 ft with only partial success. However, it was a Frenchman, Louis Boutan, working in 1893 at the Arago Research Laboratory at Banyuls-sur-mer who established the principles of modern underwater photography. By 1895 he was using a 10 × 8 inch studio portrait camera in a suitable underwater housing. In the same year the first self-contained underwater flash unit was devised by Chaufour.

In recent years photography has become an essential part of all expeditions whether topographical or ethnic. Haas and Cousteau have recorded the wonders of the oceans; Gregory and his colleagues have recorded the activities of mountaineers as they climbed the highest mountains in the world. Armstrong and Aldrin photographed man's first faltering footsteps on the surface of the moon. Photography may yet solve the problem of the existence of the Loch Ness Monster, the Yeti, and the reported sightings of Unidentified Flying Objects.

Photography and Mass Communication

Before the invention of photography the illustrations in books and other printed matter were wood, copper or steel engravings, or less frequently etchings. All of these were dependent upon the ability and the inclination of the block maker to reproduce faithfully the artist's original drawing. However, it was not long before photographs were used as the basic image. The illustrated magazines of the 1850s, such as *L'Illustration* of Paris, *Illustrierte Zeitung* of Leipzig and the *Illustrated London News*, first published in May 1842, all contained occasional illustrations bearing the legend 'from a daguerreotype'. Original photographic prints as a means of illustrating books were admirably suitable on aesthetic grounds; the technical problems were the barrier that prevented their more extensive use, as they were not compatible with conventional printing processes. Photographic prints had to be prepared and then 'laid down', i.e. glued into position, individually within the text. The introduction of the semi-mechanical process of reproduction known as the woodburytype in 1864 was a partial solution to the problem. A number of periodicals and magazines were illustrated by this process including:

The Congregationalist
The Philatelic Record
The Theatre

Right Copies of *Figaro Programme* and *The Saturday Programme and Sketch Book* (1875) which bore a woodburytype portrait on the front page of each issue.

Left Coloured steel engraving from a daguerreotype by J. Watkins.

Below The unveiling of the bronze statue of Captain Cook, R.N., at Whitby by Admiral The Lord Charles Beresford on 2 October 1912. An early example of photography for the press, photographed by Frank Meadow Sutcliffe.

The Saturday Programme and Sketch Book

The introduction of the halftone process was to revolutionize the use of photography for newspaper and magazine illustration. Just as it does today the newspaper industry did not take kindly to technological changes. As early as 1880 *The New York Daily Graphic* produced a special edition showing the various methods of picture reproduction available to the publisher. In 1883 the *Leipziger Illustrierte* used Georg Meisenbach's line screen process for which he had obtained a German patent in 1882 for a feasibility study. Although the halftone process was used by various newspapers occasionally—*The New York Times* issued a weekend photographic illustrated supplement in 1896—it was not until *The Daily Mirror* of London, which had commenced publication in November 1903, became on 7 January 1904 the first newspaper to be illustrated exclusively by photographs reproduced by a halftone process. It was another 15 years before the *Illustrated Daily News* of New York became the first American paper to be able to make a similar claim.

N. S. Amstutz, an American from Ohio, began a series of experiments in the early 1890s with the aim of producing a system for the transmission of a photographic image along a wire system similar to the telephone. Although he announced that he had succeeded in 1905 no practical use of the system was made until a development of it by a German Professor, Alfred Korn, resulted in

the establishment of a link between *The Daily Mirror* in London and *L'Illustration* in Paris in 1907.

The transition from the use of photographic prints to halftone reproduction was more rapid in the field of general book publishing than it was in the newspaper industry. However, it is of interest to recall that the earliest known photographically illustrated book was a memorial book: *Record of the Death-Bed of C.M.W.* This was a privately printed and published account of the short life of Catherine Mary Walter (2 December 1819-16 January 1844). She was the daughter of the then-owner of *The Times* newspaper, the text was written by her brother John Walter and the volume contained a photograph of a bust of the dead girl taken by Nicholaas

Henneman. Henneman had been Fox Talbot's personal servant at Lacock Abbey and at the time was in charge of the Talbotype establishment at Reading.

When Henry W. Taunt, a well-known Oxford photographer, stood as an independent candidate in the Oxford local elections of 1880, he distributed his campaign literature far and wide. It included a photograph of him and undoubtedly served a double purpose as it was also advertisement for his business. Taunt was responsible for the publication of a guide book to the Thames which was illustrated with original photographs taken by him. The first edition of it appeared in 1872 and was rapidly out of print. It was revised and enlarged at regular intervals.

BOUGUEREAU

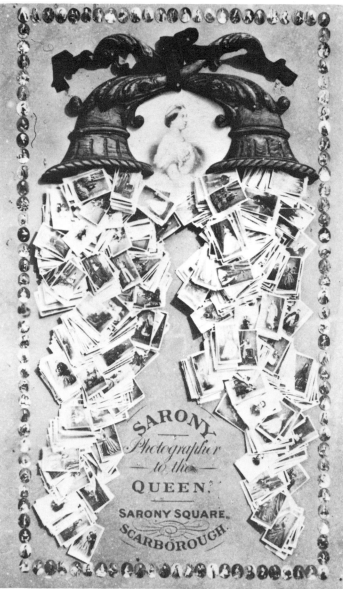

SARONY
Photographer to the
QUEEN.
SARONY SQUARE.
SCARBOROUGH.

THE ART POWER OF PHOTOGRAPHY.

Abridged from the Photographic News. June 26th 1863.

We have a striking illustration before us of the Art Power of Photography. It consists of the
Portrait of a Lady by Mr. Sarony, & one of the same Lady by another person. The latter
presents a somewhat commonplace, coarse, plain looking woman, the former a pleasing
graceful portrait of a Lady. One is angular, hard, and square, the other is soft, delicate,
and pleasing, if not beautiful; The Photography and Artistic taste are in all cases
good, and in some, perfect; The pictures are all exceedingly brilliant, and the majority
exquisitely soft & delicate as well; From the beauty of the model, the sweet expression
& graceful pose, the rich and well arranged accessories & perfect Photography, are amongst
the choicest gems of Photographic Art we have seen; one of the especial features which
strikes us is the easy, graceful, & natural poseing, as well as variety of effects, & absence of the
commonplace and conventional.

PRICES 6 FOR HALF GUINEA. 20 FOR ONE GUINEA. 45 FOR TWO GUINEAS.
Studio open from 10 A.M. to 4 P.M.

N.B. ALL CARTES DE VISITES DELIVERED FOURTH DAY AFTER SITTING.

Currently photography is taken for granted as a means of communication in almost all aspects of modern living. Advertising, television, crime detection and prevention, medical research, business and family records, space research, these are but a few examples of the integration of photography into entertainment, commercial, academic and family life.

The realization that photography was capable of making a significant contribution to the advancement of knowledge in other disciplines came about soon after its invention.

Fox Talbot himself was responsible for some of the earliest applications of photography to science. He included some photomicrographs, taken with a solar microscope at a magnification of about 15 times, amongst the examples of photogenic drawings exhibited in the library of the Royal Society in January 1839. The subjects included botanical sections and the wings of insects. In 1851 he obtained a patent relating to the photography of rapidly moving objects by illuminating them with the spark generated from a battery of Leyden jars which had a duration of about 1/100,000th of a second. In 1887 Professor E. Mach of Prague succeeded in photographing shells travelling at about the speed of sound. His photographs were actually shadowgraphs and showed clearly the wave disturbance as the projectiles passed through the air. Today high speed photography has advanced to the extent that it is possible to take a series of sequential photographs using image converter cameras at rates of about 20 million pictures per second.

Sophisticated cine cameras using conventional 16 mm cine film have been developed for high speed industrial motion analysis filming which operate at framing rates of 8,000 pictures per second, at which speed 100 ft of film passes through the gate of the camera in half a second, travelling at a speed of 200 ft per second (136 miles per hour).

Aerial photography was first accomplished by Gaspard Felix Tournachon, a distinguished French photographer who used the trade name 'Nadar'. In 1858 he succeeded in producing a collodion positive on glass (ambrotype) of the countryside near Paris from a balloon at a height of about 250 ft. Five years later he was taking photographs of the French capital from a height of 1,500 ft.

That prolific inventor Walter Bentley Woodbury was granted a patent in 1877 for a method of aerial photography. He used an unmanned captive balloon to which was attached a camera with a clockwork mechanism operated by an electro-magnet activated by remote control via an electric cable from the ground.

During the First World War some aerial photography took place over the trenches to assist military intelligence but it was in the Second World War that aerial photography 'came of age'. It was one of the most important of all the backroom activities undertaken by the services on both sides. The total number of prints and negatives produced during the war will probably never be known but as an example one reconnaissance unit of The Tactical Air Force produced just over one million negatives and some 20 million prints in the period between D-Day and VE-Day.

Astronomers were amongst the first to realize the potential advantages of photography as a method of

making a faithful record of a transient event. Because of the long exposure times needed by the calotype and daguerreotype processes the results were not entirely satisfactory until precision equatorial mountings were designed and manufactured. Professor Erich Stenger had stated that John W. Draper made a daguerreotype of the moon in 1840 at New York. His son, Dr Henry Draper, continued his work and during the late 1850s and early 1860s produced some very large enlargements, some 4 ft in diameter, from small wet collodion negatives.

The earliest successful daguerreotypes of the moon were taken by John Adams Whipple of Boston and Professor William Cranch Bond using a 15 inch telescope at the Cambridge Observatory, Harvard University. One of the images that they produced was awarded a gold medal at the Crystal Palace Exhibition of 1851. Lewis Rutherford, another American who was associated with Dr Henry Draper, became interested in astronomical photography in about 1858 and

specialized in the subject for the following 20 years. During the 1860s Warren de la Rue published sets of photographs of the moon's surface and exhibited examples of his work at many of the International Expositions held in London, Berlin, Paris and elsewhere.

The Moon considered as a Planet, a World, and a Satellite by James Nasmyth and James Carpenter was published by John Murray of London in 1874. Their book was illustrated with a number of woodbury-types depicting the surface of the moon. These were not produced from photographs of the moon but from photographs of simulated plaster models. Careful examination of the illustrations will reveal cracks in the plaster and the standard of sharpness of the images is better than could normally be expected.

In 1852, the authorities in Switzerland decreed that all beggars and vagrants should be photographed so that they could be easily identified but it was in Britain that this type of photography was developed to a greater extent than

A Victorian stereogram on glass depicting the surface of the Moon.

Above Books illustrated with original
photographs: on the left *Sunshine in the
Country* with 20 albumen prints, text
and prints by William Grundy (1861)
and on the right *Hyperion* by
Longfellow illustrated with 24
albumen prints by Francis Frith,
published by A. W. Bennett, London
(1865).

Left A motorized portable film
processor for all film up to 5 inches
wide as used by mobile photographic
units in the Second World War and
after.

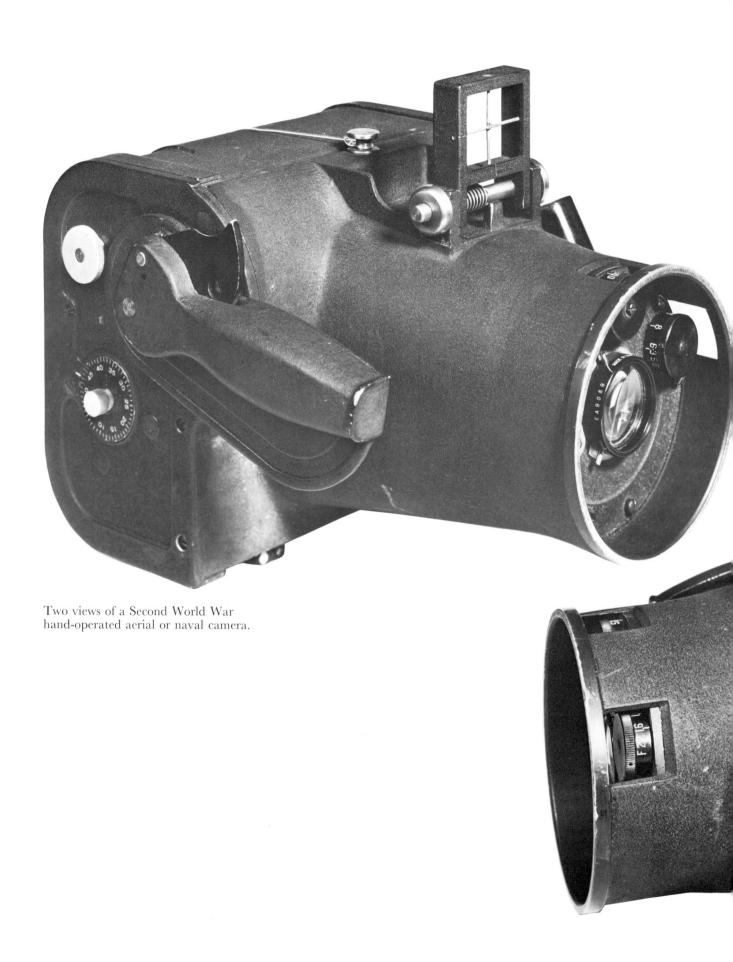

Two views of a Second World War
hand-operated aerial or naval camera.

elsewhere. The British Quarterly Review (Vol. LXXXVIII) published an account of the development of the photographic process in October 1866 which included an account of the early use of photography in prisons.

In 1854 the Governor of Bristol Gaol, James Anthony Gardiner, proposed to photograph all inmates of his gaol in order that they could be formally identified should they return. It appears that he had taken a number of identification photographs, some of which were daguerreotypes and claimed to be the first to do so. Evidence that Mr Gardiner had been taking stereoscopic photographs of some of the prisoners at his gaol was put before a select committee of the House of Lords for a report, which led to the Prison Act of 1865. The governors of the Wakefield and Leeds gaols supported Mr Gardiner's suggestions.

The museum at the Police Training Centre, Birmingham has a most interesting collection of ambrotypes taken during the nineteenth century at the local gaol. In December 1972 a collection of lantern slides and negatives, many of them showing scenes in Gloucester Gaol including prisoners on a treadmill, was sold at a sale of photographica by Christies of London.

The photography of fingerprints at scenes of crime and on articles associated with criminal activities was pioneered by a detective in the Bradford City Force, Oliver Cromwell. Cromwell was a member of the Royal Photographic Society and acted as police photographer in Bradford. He took the photographs of fingerprints on a tumbler which resulted in the first conviction in this country on photographic fingerprint evidence at Bradford in February 1905. Cromwell wrote a book *Fingerprint Photography* which was published by Elliot Stock of London and Henry Casaubon Derwent of Bradford in 1907.

Photography is now an established facet of medical life. Most teaching hospitals have photographic departments producing visual aids for the teaching staffs and for diagnostic purposes. Some of the earliest medical photography was undertaken by Dr Hugh Diamond, the Superintendent of a home for the

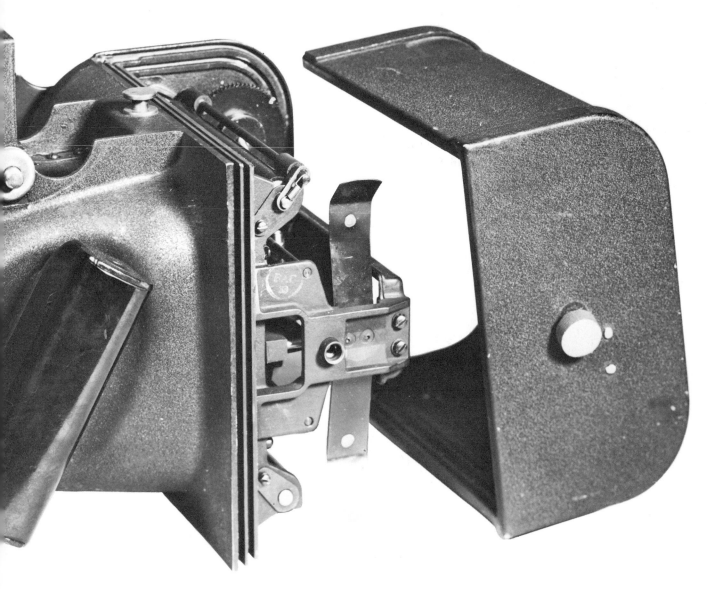

mentally disturbed in Surrey. He photographed many of his patients, hoping to establish common factors in their physiognomy. Very few of his pictures have survived but The Royal Society of Medicine in London have a number of them.

In 1865 an account was published by John Churchill & Sons, London, of an operation performed by J. Sampson Gamgee, a surgeon at The Queen's Hospital in Birmingham, on a miner, Joseph Bramwell. The operation, which took place on 11 September 1862 is fully described in the book entitled *Amputation at the Hip Joint*. The book includes original photographs of Bramwell taken by Napoleon Sarony at his studio at 66 New Street, Birmingham, immediately before the operation and again afterwards, showing the severed limb after healing. The Parisian photographer Pierre Petit took the post-operative photographs of the specimens from a limb which had been prepared by Professor

Houel and Professor Robin for microscopic examination. The book is certainly one of the earliest photographically illustrated accounts of an operation to be published.

The forerunners of the microfilm system for document storage and retrieval used extensively by commercial organizations today and of the microdot images, so beloved of the writers of thrillers, were the microphotographs produced in the 1850s. The leading microphotographers of the day were John Benjamin Dancer, Herbert Watkins and Alfred Rosling, whose daughter married Francis Frith, the topographical photographer.

Their photographs usually on standard 3 × 1 inch microscope slip slides had to be viewed through a compound microscope and usually required a magnification of at least 25 times. They were produced by copying through a microscope the original wet collodion negative, using an objective of about one inch.

Above *A Photograph of Five Notorious Housebreakers and Receivers arrested by Sergeant Rudnick* from an album (*c.* 1900).

Opposite top right Official Police identification photograph (*c.* 1890) showing the use of a conventional mirror to obtain profile view.

Opposite top left An official Police identification photograph (1893). Note the use of a specially shaped mirror to obtain the profile view on the same negative.

Opposite bottom Official Police photograph showing the use of a 'two up' *carte-de-visite* camera to obtain both full face and profile portrait views.

The subjects were often extracts from the Bible, The Lord's Prayer, reproductions of famous paintings or portraits of prominent personalities of the period. Queen Victoria was so intrigued by some examples that she had a signet ring made which contained a microphotographic group portrait of her family.

The 'Dargon pigeongraphs' flown out of Paris during the siege of 1870-71 attached to the wings or legs of homing pigeons were produced in this manner. Another application of the technique was embodied in the 'airgraph' letters of the last war.

Today we are accustomed to the use of photography for illustrations in the commercial field but this was not always so. Industrial photography may be considered to have developed from the photographs taken by T. R. Williams, J. J. E.

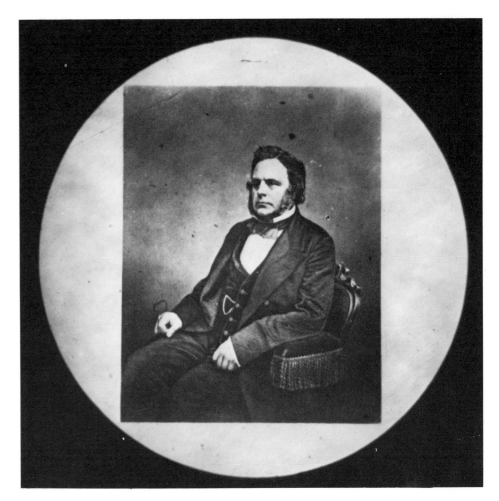

Right A print made at a magnification of 100 times from the microphotograph of John Bright made by Alfred Rosling.

Left Early examples of the use of photography as a visual teaching aid in medical training.

Below A Victorian forensic photograph used to compare the soles of a pair of boots with plaster casts made at the scene of the crime.

Mayall and others at the Crystal Palace International Exhibition of 1851. One of the earliest industrial photographers was James Mudd of Manchester who owned a portrait studio there and made some very fine landscape and industrial photographs in his spare time. Two comparatively little known industrial photographers operated in Preston in Lancashire from the 1880s. Much of their work was related to the photography of factories and products of a number of companies who operated under the 'umbrella' of the Dick Kerr Company of Kilmarnock. These companies were builders of many forms of early electric traction, trams, trolleybuses and some early petrol engine powered trams. Arthur Winter owned a photographic business in the late 1880s and undertook photographic work

Above *The Canterbury Cricket Week.*
A double page from the first book on
cricket to be illustrated with original
photographs. It was printed and
published by William Davey at
Canterbury in 1865 and included
detailed score cards, photographs of
the players and scripts of the plays
performed in the evenings.

Top An example of industrial or
advertising photography from the
Edwardian era.

Opposite bottom *The Byzantine Court,*
number one in the series of stereoscopic
daguerreotypes depicting scenes at the
Crystal Palace Exhibition of 1851.

Opposite top A group of ten
microphotographs including examples
by the three leading micro-
photographers of the 1850s and 1860s:
John Benjamin Dancer, Alfred
Rosling and Herbert Watkins.

Pleurotus Cornucopiae (*opposite*) and
Amanita Rubescens (*above*) by S. C.
Porter, F.R.P.S. Both were exhibited
at the Autumn Exhibition of Nature

Photography held by The Royal
Photographic Society 1958 and
awarded the Society's medal.
Mrs. S. C. Porter.

at the Electric Railway and Tramway Carriage Works Ltd. He died at an early age and was succeeded by his son. His competitor for the business at the works was a local tobacconist and stationer Edward Hoole. Hoole was a most careful, painstaking and competent photographer who produced some of the finest industrial photography of the period that has been seen.

During the 1850s The Rev Theophilus Smith took numbers of photographs including some stereoscopic images in the steel works of Sheffield and Rotherham. Robert Howlett was associated with the engineering work of I.K. Brunel and took the famous photograph of Brunel standing in front of the chains of the Great Eastern, smoking a cigar.

Some excellent woodburytypes of industrial machinery used in the woollen industry are included in *The History and Antiquities of Morley* written by William Smith and published in 1876. Another book containing an early example of industrial photography is John T. Hyde's *Principles of Gunnery*, published in 1862, which includes an albumen print of the Armstrong Gun.

A number of firms produced catalogues of their products during the last century which were illustrated with original photographs, for example:

Mintons Limited. *A Catalogue of Enamelled Tiles*. Published by Mintons. Undated.
Hay. James. *A Description of the Machinery and apparatus for a*

Gunpowder Factory. Published in Birmingham 1877. Contains a number of photographs of industrial machinery manufactured by Taylor & Challen of Birmingham.

The Royal Worcester Porcelain Company produced several commemorative works which included photographs of their products which had received awards at International Exhibitions.

Collections and Collecting

Collecting

Just as the 1840s and 1850s witnessed the establishment of the photographic process, the 1960s and 1970s have seen its artefacts become highly collectable items. Before then antique dealers or auction houses had shown very little interest in photographic images and equipment. The few private collectors were looked upon as idiosyncratic individuals. Because of the unpopularity of the products of the Victorian Era in general their problem was to acquire material before it was thrown away. In the years after the Second World War there was a growing realization that many of the products of the second half of the nineteenth century were worthy of preservation. One consequence was that an interest in the artefacts of photography and photographic history has now been accepted as an academic study.

A picture sale held by Christies of London on 2 July 1971 included a group of portraits taken by Julia Margaret Cameron. This was followed on 13 July 1972 by the first of Christie's sales to be devoted entirely to photographic items. Meanwhile Sothebys were including in their collector's sales similar items. Both these firms now hold regular sales in London and New York. Outside London Biddle & Webb, Birmingham, are holding three or four sales each year whilst in West Germany Augsburger Kunst-Auktionhaus Petzold of Augsburg

hold similar sales.

Specialist dealers and galleries are now well established in many countries and a number of societies devoted to photographic history and collecting have been formed. At a meeting held on 22 March 1972 interested members of The Royal Photographic Society decided to form an historical group within the society. The support was considerable and it rapidly became one of the most active groups in the society. Their first major conference was held on 16 March 1974 and was devoted to a series of papers on 'the recognition of early photographic processes, their care and conservation'.

Above An early gas-heated dry mounting iron by Ensign, adapted for use with natural gas. *M. Dyche.*

Opposite NASA photograph taken by Edwin Aldrin of Neil Armstrong on 21 July 1969 during man's historic flight to the Moon in Apollo XI.

155

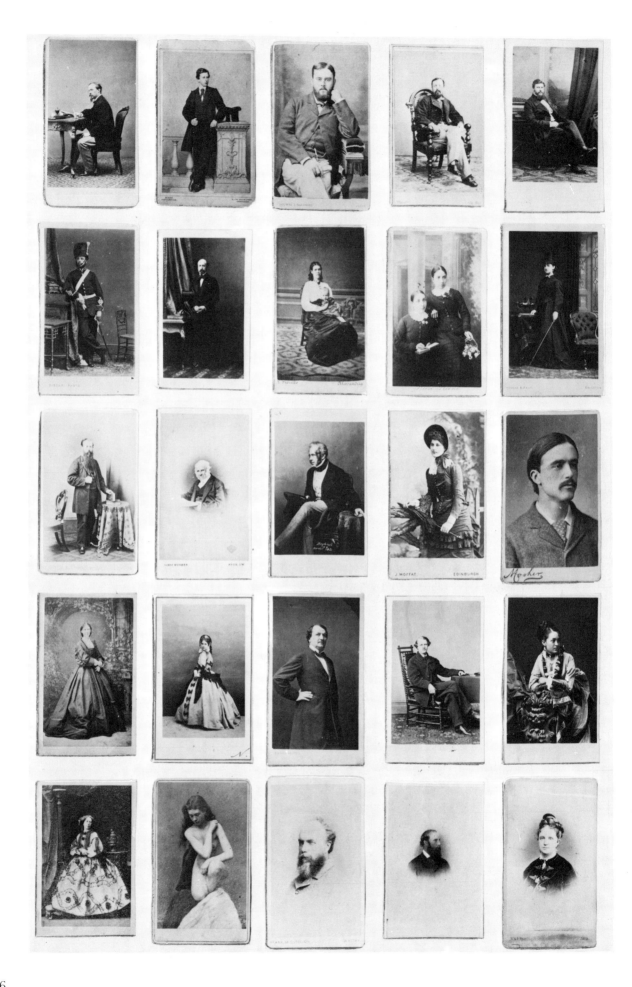

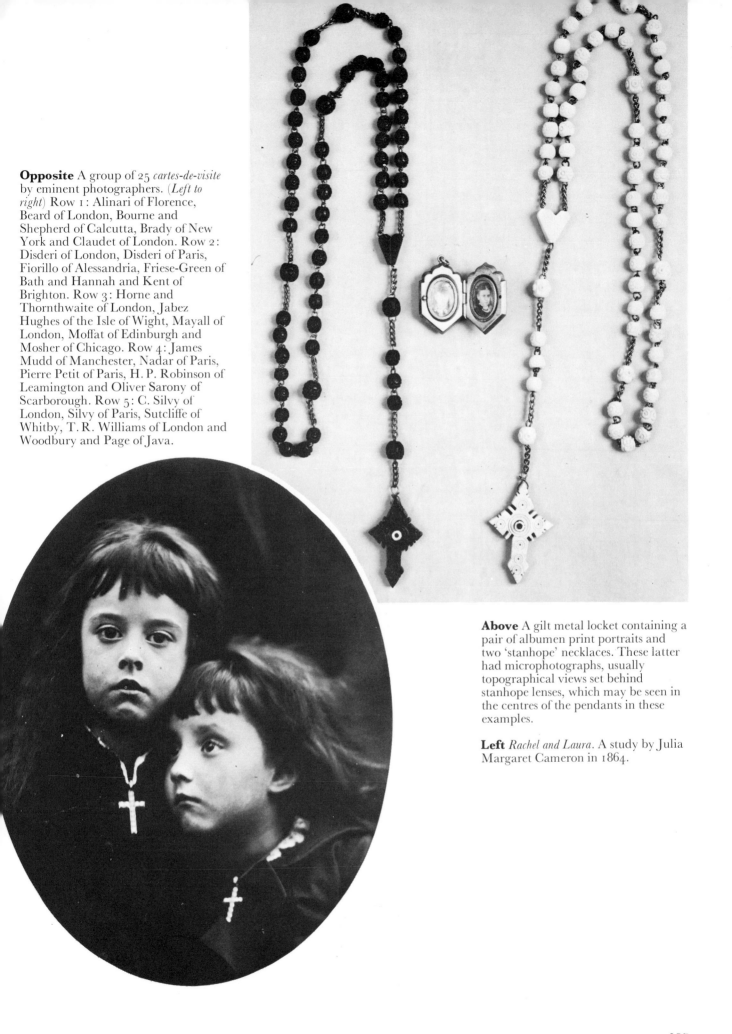

Opposite A group of 25 *cartes-de-visite* by eminent photographers. (*Left to right*) Row 1: Alinari of Florence, Beard of London, Bourne and Shepherd of Calcutta, Brady of New York and Claudet of London. Row 2: Disderi of London, Disderi of Paris, Fiorillo of Alessandria, Friese-Green of Bath and Hannah and Kent of Brighton. Row 3: Horne and Thornthwaite of London, Jabez Hughes of the Isle of Wight, Mayall of London, Moffat of Edinburgh and Mosher of Chicago. Row 4: James Mudd of Manchester, Nadar of Paris, Pierre Petit of Paris, H. P. Robinson of Leamington and Oliver Sarony of Scarborough. Row 5: C. Silvy of London, Silvy of Paris, Sutcliffe of Whitby, T. R. Williams of London and Woodbury and Page of Java.

Above A gilt metal locket containing a pair of albumen print portraits and two 'stanhope' necklaces. These latter had microphotographs, usually topographical views set behind stanhope lenses, which may be seen in the centres of the pendants in these examples.

Left *Rachel and Laura*. A study by Julia Margaret Cameron in 1864.

The first issue of the magazine *The History of Photography: an International Quarterly* was published in January 1977 by the London publishers Taylor & Francis under the editorship of Heinz K. Henisch.

A number of national museums, notably The Science Museum at South Kensington, London, whose collection dates from 1882, possess very important collections of both images and equipment. The Museum of Technology at Prague, the Deutsches Museum at Munich, and The Smithsonian Institution at Washington in America are especially noteworthy.

Many general museums and libraries have important holdings of photographic material, one example being the City of Birmingham Reference Library who, apart from the well-known collection of prints and negatives by Sir J.B. Stone, have a very fine collection of Fenton prints. Some general and specialist museums contain prints, lantern slides and negatives relating to their specialist subject areas which are now of considerable importance in their own right, for example The British Museum, The Victoria & Albert Museum and The National Portrait Gallery.

Some of the learned societies and professional bodies maintain libraries and museums which contain photographic images and equipment. Reference has already been made to The Royal Photographic Society; amongst others are The Royal Microscopical Society, The Royal Geographical Society, The National Buildings Record and The Royal Society of Medicine, who have a number of examples of the work of Hugh Diamond.

In America a large number of societies devoted to the historical aspects of photography have been established: The Photographic Historical Society of New York, P.O. Box 1839, Radio City Station, New York; The Photographic Historical Society of America, P.O. Box 71, Waltham Branch, Boston.

The photographic trade itself has

set up and maintains some outstanding collections, for example the Agfa-Gevaert Foto-Historama at Leverskusen in West Germany, The Kodak Museum at Harrow, Middlesex and the collection at the George Eastman House in Rochester, New York. There are also a number of private collections which are open to the public such as The Barnes Collection of Cinematography at St Ives in Cornwall and The Fox Talbot Museum at Lacock Abbey in Wiltshire which is under the administration of The National Trust.

Very few people make a conscious decision to start collecting anything. Usually the acquisition of some curiously interesting object creates a general interest in the subject which leads to an introduction to an expert or a group of like-minded enthusiasts. In a modest way the new convert acquires a few more examples, meets other collectors and reads about the new hobby. In due course they find that they have a small general collection on which to build.

However, photography is such an

all embracing subject that the need to specialize becomes evident at a very early stage. It comprises three main areas: equipment, images and literature. Within each of these there exists opportunities for further detailed specialization.

Equipment is by far the most popular, particularly amongst novice collectors. However, the establishment of a comprehensive collection under this heading is beyond the resources of most individuals. Just imagine the space that would be required to house a representative collection of enlargers and this would only be a small part of a general collection of equipment.

There are areas of specialization available to suit all tastes and pockets. A collection of exposure meters, calculators and tables would occupy little space and a very representative collection could be assembled for a comparatively modest outlay. One collector might collect only box cameras, another might collect shutters and yet another might collect only Leica equipment.

Images include all forms of photo-

Opposite An example of a ceramic tile portrait based on a photograph. Admiral Sir David Beatty from a photograph by Speaight Ltd. The tile was made by J. H. Barratt & Co. of Stoke on Trent.

Above A pair of Japanese lacquer albums.

Above A collection of exposure meters and calculators.

Right *Champagne Charlie.* An example of a musical score issued with a photographic portrait of the artist mounted on the front page.

Opposite A theatre programme illustrated with an original photograph.

graphic pictures, whether negative or positive, single or stereoscopic, in monochrome or colour. Some collectors will form a general collection containing a few examples of each process whilst others will concentrate on a particular one such as the daguerreotype or on an individual photographer or group of photographers.

Photographic literature comprises two categories: books relating to the technical and aesthetic aspects of photography and books in which the illustrations take the form of original photographs. Until the 1960s and 1970s there was little interest in technical books published during the nineteenth century, whatever the subject. It is now one of the growth areas in book collecting. Early books on the technical

aspects of photography are scarce. Many were used in darkrooms as reference works and consequently deteriorated very quickly, eventually being thrown away. Others were discarded as soon as new processes were introduced. They are now sought after by collectors and historians alike and some command high prices. In the 1970s several publishers issued facsimile reprints of some of the more important works and for research purposes these are quite adequate. However, no dedicated book collector would be satisfied with such a book.

The collection of books illustrated with original photographs requires a degree of patience and dedication beyond that of the general collector. In the main such books are not classified by dealers and since they

occur in all subjects from theology to technology they are to be found only by making a very determined search of a dealer's shelves.

Some books such as the first edition of H. P. Robinson's *Pictorial Effect in Photography* (Piper and Carter, 1869) belong to both categories, the frontispiece is a woodburytype while the illustration facing page 196 is a carbon print. Others such as *Northward Ho! Being a Record of a Three Weeks Tour in Norway* by Richard Waddington, which was published by J. H. Burrows at Southend in 1886, are only of interest to the collector of photographica because of the illustrations.

A very neglected area at present is the miscellaneous ephemera of photography. Instruction leaflets, letter headings, original advertisements, labels, posters and catalogues are all included within this category. Even pre-1939 items are scarce; for who keeps the instruction leaflets packed with every roll of film, or even the box itself?

Whatever is collected must be chosen with discretion. Condition is all important. If you feel that you must acquire an article in poor condition then do so bearing in mind that its value is only some 10 to 20 per cent of its equivalent in first class condition; consider it as merely a 'stop gap' until a good example comes your way. Remember that it will be difficult to sell when you do obtain a replacement. The only justification for retaining items in poor condition is rarity. It would be very silly to reject a daguerreotype taken by Daguerre himself because it was badly scratched! On the other hand it would be unwise to acquire one depicting an unknown sitter by an unknown photographer which was in a similar condition.

There is always a temptation to undertake repair or restoration oneself but this requires specialist knowledge and experience. Many amateur 'do it yourself' restorers have ruined important items by inexpert attention. Even a sable brush can scratch some daguerreotypes whilst

Right A group of photographic medals
and badges including in the centre The
Royal Photographic Society's medal
awarded to the late S. C. Porter,
F.R.P.S., in 1958.

Below A group of books with original
photographs (1860-90).

Opposite top An interesting example
of a Victorian photographic album
having carved wooden boards.

Opposite bottom A group of Union
cases (1850s).

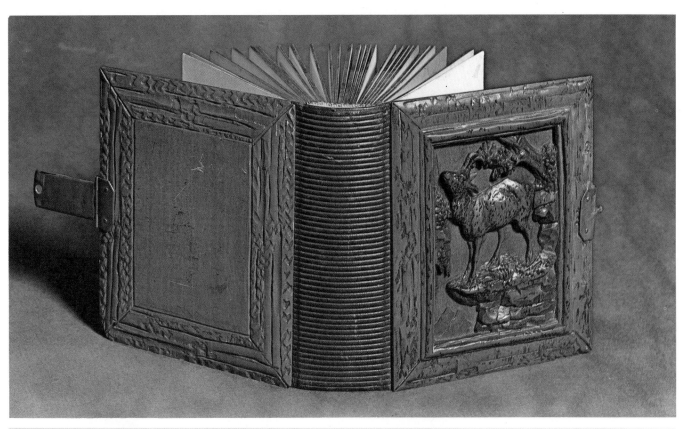

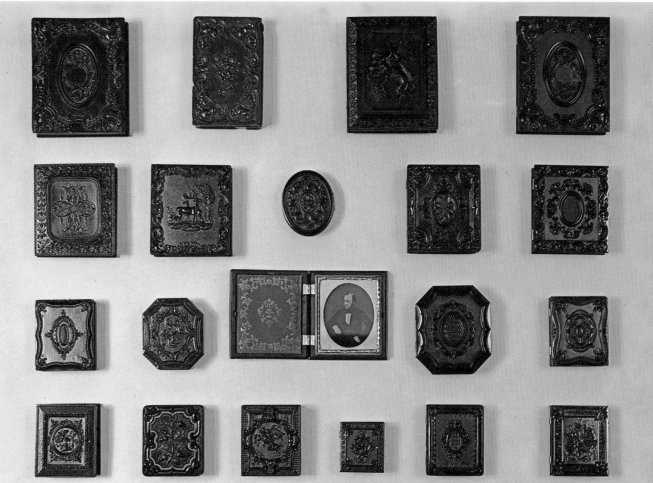

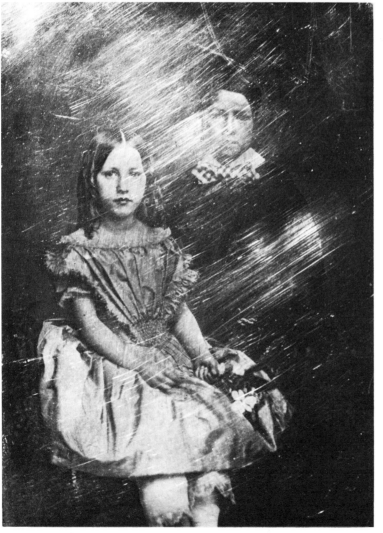

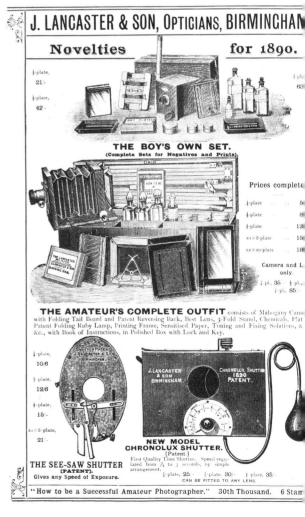

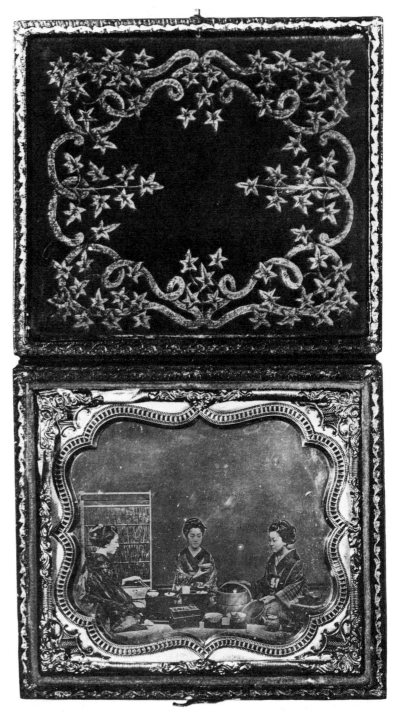

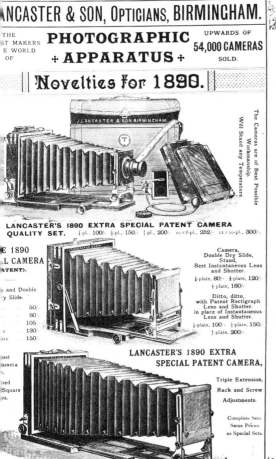

Left J. Lancaster & Son, Opticians, Birmingham. 1890 brochure for photographic apparatus.

Opposite bottom A daguerreotype showing the result of an attempt to clean it using cotton wool and a silver polish.

Opposite top A group of interesting *carte-de-visite* photographs including a deathbed portrait, female coal miners at Wigan, Siamese twins and an advertisement for a washing machine.

Above right The daguerreotype of the Japanese tea ladies which featured in the case Regina v George Bernard Shaw at Manchester Crown Court, June 1979.

Above left The back of a daguerreotype showing the usual method of sealing.

some of the published formulae for cleaning and restoration would not even be considered by experienced craftsmen. Many such concoctions will have only a short term effect whilst jeopardizing the long term life of the article. To those who wish to undertake such work it is best to seek the advice of someone with genuine experience.

Patience is the hallmark of the dedicated collector, for sometimes it is necessary to wait almost a lifetime to obtain a key item. Any collection is more valuable, in both interest and intrinsically, than the total of the individual items that it includes. The more comprehensive it is the greater will be the difference. An excellent example of this is the *carte-de-visite*. Individual *cartes* by unimportant photographers depicting unknown sitters have little interest or value. However, a large collection of such images provides a comprehensive view of the development of photography and social life and costume during the second half of the nineteenth century. Examples of *cartes* by famous photographers such as Beard, Claudet, Mayall, Williams, Silvy, Cameron, Robinson, Sutcliffe and Nadar are found quite frequently and in general at a modest price.

Specialization is possible, for example *cartes* of well-known celebrities, of interesting places or of curious or unusual subjects. A very interesting collection could be made of *cartes* produced by various processes. Albumen prints are most common but examples of woodburytypes, chromotypes, platinotypes, tintypes and even salt paper prints are not particularly scarce.

A collection was started some 25 years ago of *cartes* issued by Birmingham photographers which today comprises some 2,500 *cartes* by about 300 individual photographers and it is still incomplete! It includes variations in the design of the advertisements on the back of the cartes, which are often of greater interest than the photographs; photographs of important local people and

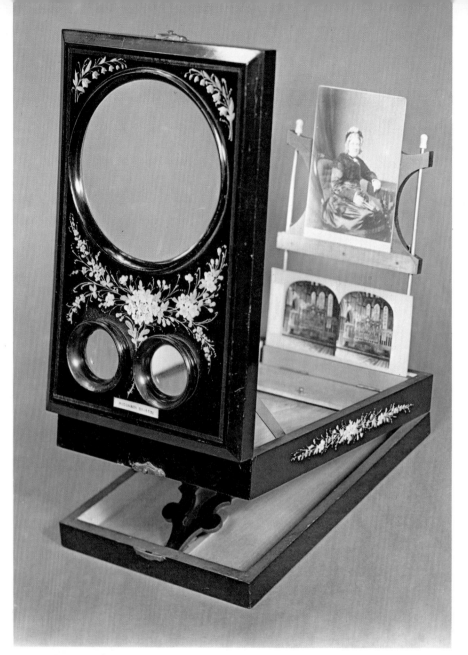

Top A stereographoscope by Husbands of Bristol.

Above An authentic collodion on glass stereogram of the Moon by Warren de la Rue.

Opposite The advertisements on the backs of *cartes-de-visite* were often elaborately printed in one or more colours. These examples are from the author's collection of *cartes* by Birmingham photographers.

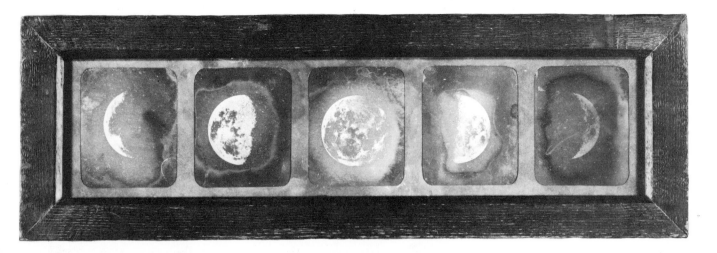

Opposite The backs of some of the *cartes-de-visite* in the author's collection.

Above The group of daguerreotypes of the Moon said to have been taken by Warren de la Rue which were purchased by the North Western Museum of Science and Industry from George Bernard Shaw. *The North Western Museum of Science and Industry, Manchester.*

Left A portrait by Julia Margaret Cameron.

national celebrities; and series of *cartes* showing the progression of a photographer from an obscure back street address in the suburbs to a most prestigious establishment in the centre of the town.

The remarkable prices obtained for some photographs by famous photographers or of unusual subjects has within the last three or four years resulted in a number of forgeries appearing both on the open market and in the sale rooms. The detection of such items is difficult. In the first instance considerable experience over many years and that indefinable talent, instinct, must be the surest guides to their identification. Such suspicions may be followed by scientific examination. There is much doubt amongst various experts concerning the authenticity of some of the exhibits at recent exhibitions, but the only instance of a prosecution took place in the Manchester Crown Court during June 1979. In this case George Bernard Shaw of Oldham was sentenced to one year's imprisonment after being found guilty in a case involving daguerreotype images of the Moon —purchased by The North Western Museum of Science and Industry in Manchester—and two other daguerreotypes, one depicting three Japanese tea ladies and the other, a stereoscopic posterior view of a nude lady at her toilet which had been sold privately.

An unusual feature of these images was that they were on sheets of sterling silver rather than on the conventional silver plated sheets of copper. In the case of the Japanese tea ladies the image had been glued into the usual case in a manner that made its removal for examination difficult and it showed little evidence that it had been originally sealed in the manner associated with most authentic examples.

Most of the modern reproductions or forgeries featured unusual subjects, presumably because there is little point in making conventional portrait reproductions which would sell at little more than the cost of

making them. They include daguerreotypes of ruined abbeys, of a watchmaker's workshop and of nude ladies, all of which appeared to be similar to those which were the subject of the court case.

Collectors should be wary of any daguerreotypes produced on silver plate, lacking evidence of any original seals, bearing little or no tarnish (unless it is known that they have been cleaned recently—in which case the owner should know) and examples in which the image is a copy of another daguerreotype.

A Simple Guide for Collectors

It is hoped that the following information will be of assistance to those who are contemplating starting a collection as well as to those with established collections looking for information outside their own specialization.

The recognition and identification of the dates, the quality, the maker or artist, the rarity and the

value of the photographica is essentially a matter of experience and instinct as it is with all antiques.

It is advisable to study the subject in general, to talk to experienced collectors, to cultivate the friendship of reputable dealers and to visit as many exhibitions and museums featuring displays of the artefacts of photography as possible. Above all else examine and handle as many examples as possible.

Antique collecting, like ladies' clothing, has its fashions! Even the incunabula, so beloved of the book trade, have their 'ups and downs'. Photographica has only recently become collectable in the 1960s and 1970s so the market is a fragile one. In the earliest days of the explosion of interest very high prices were obtained for comparatively common items but fortunately the market is now levelling out. At the bottom end prices have increased very little and in some instances have actually dropped. Quality, condition and true rarity are coming to the fore.

A key to the identification of photographs by the more common processes

Answer question one and proceed to the next question indicated by the number in the right-hand column.

1. Is the image negative? 2
Is the image positive? 9

2. Is it on paper? 3
Is it on glass? 6
Is it on film? 7

3. Is it on plain paper? 4
Is it on translucent paper? 5

4. Is it on uncoated writing or drawing paper? 22
Is it on coated paper or card? 23

5. Is the paper waxed? 24
Is the paper oiled? 25

6. Has the image a creamy or milky appearance when viewed by reflected light, is the coating uneven particularly towards the edges and probably with wire marks across the corners? 26
Is the image dark when viewed by reflected light and does it have an even coating right to the edges? 27

7. Is the film highly inflammable and does it have a pungent smell? 28
Does it burn only with difficulty or has no pungent smell? 8

8. Does the film tear easily? 29
The film will not tear. 30

9. Is the image on paper? 10
Is the image on some other material? 14

10. Is the image on uncoated paper having a matt appearance? 11
Is the image on a coated paper having a lustre or glossy appearance? 13

11. Is the image colour red-brown, possibly faded wholly or in part to pale yellow, especially towards the edges? 31
Is the image colour silvery grey (sometimes it may be a warmer tone) with no fading and a very subtle range of tones? 32
Does the image have a distinct colour (red, green, blue, etc.) or a neutral tone (black or grey) with no evidence of fading and is obviously pigment based? 12

12. Is the print mounted or laid down on card, the image colour usually purple or chocolate brown (sometimes blue or red) and generally with a distinct image relief? 33
Is the image slightly granular in texture and with a very slight lustre? 34
Is the image distinctly granular in texture with a slight lustre? 35

13. Is the coating thin or medium in thickness, with a slight to medium gloss and the image colour red-brown or sepia usually with some fading towards the edges? 36
Is the coating thick, the surface matt to glossy or textured and the image colour black, sepia, or coloured? 37

14. Is the image on metal? 15
Is it on some other material? 17

15. Is the image on a silver surfaced sheet of copper appearing positive when viewed at the correct angle? 38
Is the image on some other metal? 16

16. Is the image on black or brown enamelled tinplate? 39
Is the image on some other metal (aluminium, copper)? 40 or 46

17. Is the image on glass? 18
Is it on some other material? 21

18. Is the image in the form of an opaque glass positive? 19
Is the image a transparent positive? 20

19. Is the image a negative one which appears positive when viewed by reflection against a dark background or is it on a dark coloured piece of glass (black, red, blue)? 41
Is the image on opal glass? 40, 42 or 46
Is the image in the form of a paper print fixed to the back of a convex shaped

Adapted from the original key formulated by Brian Coe, Curator, The Kodak Museum, Harrow, Middlesex.

piece of glass often roughly coloured on the back? 43

20. *Is the image cream in colour when viewed by reflected light and black and white when viewed by transmitted light?* 44

Is the image dark when viewed by reflected light and is the image colour black, sepia or coloured by toning? 45

Is the image dark when viewed by reflected light and the image colour usually chocolate or purple-brown with a high relief? 33

Is the image dark when viewed by reflected light and of almost any colour and with a slight relief? 40

21. *Is the image on wood?* 40 or 46

Is the image on a fabric? 32 or 47

Is the image on china or porcelain which has been fired? 48

Is the image on a form of synthetic ivory? 49

The Processes

22. Photogenic drawings (1834-42). Image colour pink, purple, or red brown usually with pink or lilac tinted highlights caused by fogging of the incompletely stabilized image. Authentic examples are very rare.

OR

Calotypes (1841-*c.* 1860). Image colour red brown often fading to yellow with white or off white highlights. Examples are uncommon.

23. Reflection printing card negatives (1920s and 1930s) usually postcard size or smaller.

24. Calotype (see 22 above) or the waxed paper process (negative) (1851-65).

25. Eastman negative paper (1883-85).

26. Wet collodion negative (1851-*c.* 1885).

27. Gelatine dry plate (*c.* 1880-1970).

28. Cellulose nitrate negative film (1889-*c.* 1939).

29. Safety film (*c.* 1930-).

30. Polyester film (*c.* 1965-).

31. Salt paper print (1839-*c.* 1860).

32. Platinotype or platinum print (*c.* 1880-1914).

33. Woodburytype print (1864-*c.* 1905).

34. Carbon print (1860s-1930s).

35. Bromoil (1907-*c.* 1940s but still practised by a few enthusiasts).

36. Albumen print (1850-*c.* 1890s).

37. Gelatino-silver papers (1880s onwards).

38. Daguerreotype (1839-*c.* 1860s).

39. Ferrotype, tintype, melanotype (1860s-1940s).

40. Carbon transfer print. Actual image identical to 34 but transferred by the use of a temporary support.

41. Collodion positive on glass commonly known as an ambrotype (*c.* 1852-1890).

42. Sensitized opal glass.

43. Crystoleum (*c.* 1880s-1920s).

44. Collodion transparency (1851-*c.* 1900).

45. Gelatino-silver transparency (1880s onwards).

46. Transferotype (1890s-1950s).

47. Sensitized fabrics. (Sold by Platinotype Company 1890s-1920s.)

48. Photoceramics carbon images fired in the glaze (1860 onwards).

49. Eburneum print (1865-80).

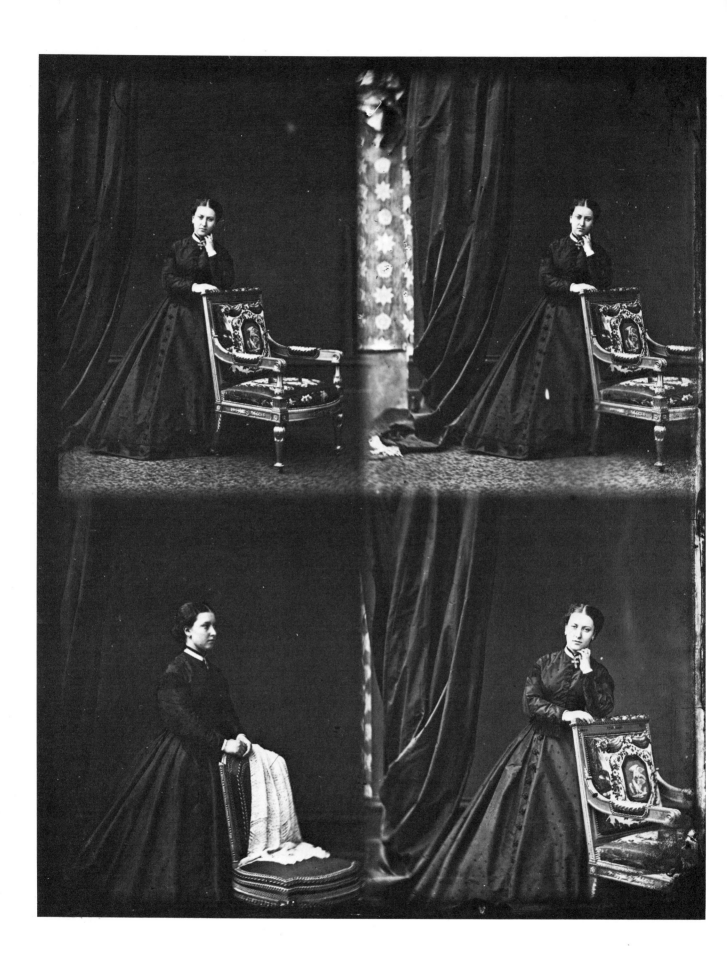

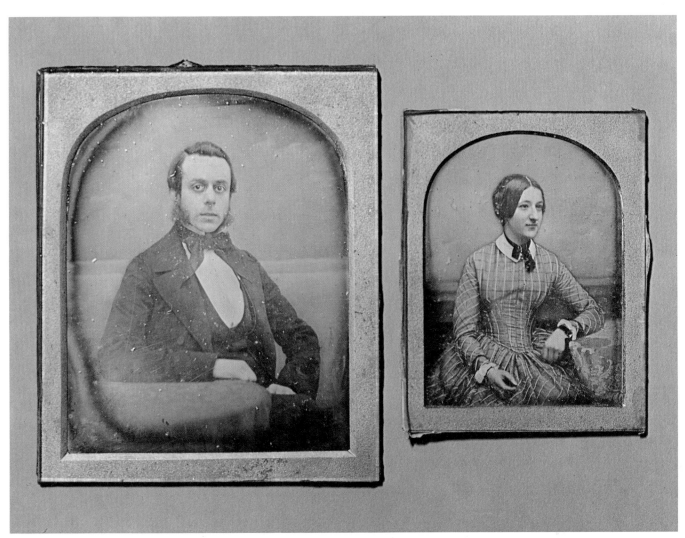

The daguerreotype

1. It is always a negative image which appears as a positive when viewed at the correct angle.
2. It is always on a highly polished mirror-like metallic surface, almost invariably a sheet of silver plated copper with the image often laterally reversed.
3. It was usual for the assemblage of daguerreotype plate, intermediate mask (known as the matt) and the piece of glass used as protective cover to be sealed. This was accomplished by using strips of paper or cloth glued to the back of the plate and to the edges of the glass.
4. The surface of the plate is often tarnished particularly towards the edges. Examples with their original seals intact are less

likely to be severely affected and certainly daguerreotypes in their original condition, i.e. uncleaned and with the original seals intact, are looked upon with greater favour by collectors.

5. In some instances the plates have plate-maker's marks embossed onto their corners but these are, of course, covered by the matt and cannot be examined unless the original seals have been broken.
6. Some examples are to be found in which parts of the image, such as gold rings, jewellery, gilding on the spines or edges of books or brass fittings on furniture, have been heightened by the application of gold leaf or paint to the image. Other examples have been hand coloured but the quality of such work varies to a

Above Two hand-coloured daguerreotypes by A. F. J. Claudet (late 1840s).

Opposite A print from a 'four up' wet collodion *carte-de-visite* negative of Princess Louise, daughter of Queen Victoria taken by Hills & Saunders who received a Royal Warrant as photographers to the Queen on 27 April 1867.

very considerable degree dependent upon the skill of the artist employed by the photographer. Some are remarkably crude. The best may be considered as works of art.

7. The majority of English daguerreotypes are unattributed on account of the patent situation. The usual practice on the part of those photographers who had taken out licences was to have their name and address embossed in gilt on the covers of the cases. Sometimes their name was stamped on the matt or a printed label was affixed to the back. Rarely instructions for colouring, delivery or the name of the sitter and the date have been scratched or written with a pencil or wax crayon on the back of the plate.

8. The process was in commercial use between about 1840 and 1860.

9. The length of time of the exposure, once the process was in commercial use varied between 5 and 60 seconds.

10. Never touch the surface of the plate, even with a sable hair brush or soft cotton wool for both have been known to cause scratches. Never attempt to clean the image except with the assistance of someone who has genuine experience of the problems and the techniques involved. Although various formulae have been published recently in popular magazines do not use them on anything other than scrap material until considerable experience has been acquired. Some of the suggested formulae have only a short term effect and may in fact actually damage the image in the long term. In any case most discerning collectors consider that a cleaned daguerreotype is of lesser interest and certainly of less commercial value than an uncleaned one. Images which have been hand coloured are very difficult if not impossible to clean as almost invariably the colouring will either 'run' or else diminish in intensity if any form of liquid treatment is employed.

11. The nominal sizes of daguerreotypes and their conventional

Above A most unusual photograph of Queen Victoria in a jovial mood.

Right Queen Victoria—an officially posed photograph.

A CROWDED STREET MARKET.
HONG-KONG.

A CROWDED STREET MARKET.
HONG-KONG.

SHOEING A BULLOCK. INDIA.

These cigarette cards in the form of
photographic stereograms were issued
with Army Club cigarettes who would
also supply a viewer on payment of
1/- (5p).

Right The Victor Mount Cutter for cutting both circles and ovals.

Opposite top An example of a hand-coloured stereogram on glass (1870s).

Opposite bottom A group of cigarette cards in the form of original photographs.

names are:

Whole plate	$8\frac{1}{2} \times 6\frac{1}{2}$ inches
Half plate	$5\frac{1}{2} \times 4\frac{1}{4}$ inches
Quarter plate	$4\frac{1}{4} \times 3\frac{1}{4}$ inches
Sixth plate	$3\frac{1}{4} \times 2\frac{3}{4}$ inches
Ninth plate	$2\frac{1}{2} \times 2$ inches
Sixteenth plate	$1\frac{5}{8} \times 1\frac{3}{8}$ inches

The standard size of stereograms was $6\frac{7}{8} \times 3\frac{1}{4}$ inches overall. One notable exception was Kilburn whose standard size for singles was $3\frac{1}{2} \times 3$ inches and $4\frac{1}{2} \times 3\frac{1}{3}$ inches for stereograms. Baird sold a number of single daguerreotypes which measured $7\frac{1}{2} \times 6$ inches.

The auction scene

No serious collector or dealer can ignore the auction scene as it is the foundation of the antique and art market. At present very few firms hold specialist sales devoted entirely to photographica, but it is quite usual for photographic items to be included in general sales.

Most people think of auction sales as opportunities to purchase items to augment their collections, but just as important is their role of providing a market for both collectors and dealers to dispose of surplus or duplicate items. We hope that the following notes will remove some of the mystique that is all too often associated with the saleroom. Some auction houses specializing in photographica:

Augsburger Kunst-Auktionshaus Petzold,
Maximilianstrasse 53,
8900 Augsburg, West Germany.

Biddle & Webb of Birmingham,
Icknield Square Salerooms,
Ladywood Middleway,
Birmingham B16, England.

Christie's South Kensington Limited,
85 Old Brompton Road,
London SW7 3JS, England.

Christie's East, a Division of Christie, Manson and Woods International Inc.,
219, East 67th Street, New York, N.Y., U.S.A.

Sotheby's Belgravia,
19 Motcomb Street,
London W1A 2AA, England.

Sotheby Parke Bernet Inc.,
980, Madison Avenue, New York, N.Y., U.S.A.

Announcements of forthcoming sales are made in local and national newspapers and in specialist periodicals or the firms will arrange to forward to you details in advance if you register with them.

Buying at Auction.

Intending purchasers have the opportunity of examining the items on offer prior to the commencement of the sale and of deciding which, if any, they would like to buy as well as how much they would be prepared to pay for any individual item. Some firms charge a 'buyers commission' usually about 10 per cent of the price realized under the hammer and purchasers should take this into account when making their bids. At the time of writing Biddle & Webb and Christie's of South Kensington do not make such a charge. Prudent purchasers will determine the maximum price that they are prepared to pay before the commencement of the sale and will not exceed it. Some of the firms publish a list of estimated prices and these will provide some indication of the likely 'hammer price'. But they can only be estimates. The staff will often give you an unofficial estimate of what they think is the likely price which in

H.M. QUEEN VICTORIA.
Ogden's Guinea Gold Cigarettes

Admiral Sir Michael Culme Seymour.
Ogden's Guinea Gold Cigarettes

298 WILLIAM WORDSWORTH.
The great Philosophic Poet.
Born 1770. Died 1850.
Ogden's Guinea Gold Cigarettes

MARTIN HARVEY.
Ogden's Guinea Gold Cigarettes
SERIES C 1-100

Vernon Hampson
Ogden's Guinea Gold Cigarettes

G. L. Jessop
Gloucester & Australian Team 19012
Ogden's Cigarettes.

MARGARET OF ANJOU.
QUEEN OF HENRY VI
Ogden's Guinea Gold Cigarettes
New Series I

Miss Wales
Ogden's Guinea Gold Cigarettes

EILEEN CHALMERS.
Ogden's Guinea Gold Cigarettes
SERIES C 1-100

540 MILLIE STOLLER.
Ogden's Guinea Gold Cigarettes

Auriol Lee
Ogden's Guinea Gold Cigarettes

MAXINE ELLIOTT.
Ogden's Guinea Gold Cigarettes
SERIES C 1-100

Ogden's Guinea Gold Cigarettes
New Series
CAMBRIDGE AT FULL SPEED

VESTA TILLEY.
Ogden's Guinea Gold Cigarettes
SERIES C RR-200

QUEENIE LEIGHTON.
Ogden's Guinea Gold Cigarettes
SERIES C 1-100

Gallaher Ltd
IRISH VIEW SCENERY SERIES
BLARNEY CASTLE, CO. CORK
Cigarettes

Ogden's Guinea Gold Cigarettes
G.W.R. 6 ft. 8-in. 4-WHEELED COUPLED ENGINE,
NEW EXPRESS.

general is remarkably accurate.

Some collectors welcome the opportunity a viewing day provides to handle and examine items that they would otherwise not see. Indeed Mr Ernest Biddle, the Birmingham auctioneer, described his salerooms as: 'A museum that changes its exhibits each week.'

When handling items at a view please do so with great care. The owner may be standing next to you! If you are not conversant with the operation of a particular camera, for example, ask the staff to demonstrate it rather than risk damaging it by incorrect or too forceful operation. After all, as a potential customer you are entitled to service and advice.

Remember that the items on sale do not belong to the auctioneer, he is merely the custodian of them until they are sold by him on behalf of the owner. Both he and the owner are entitled to rely on prospective purchasers to handle the items with care. Those firms who hold specialist sales have staff who are very knowledgeable within their specialist fields, and whose advice is available to prospective sellers or purchasers alike. The catalogues themselves should be and often are a source of informed comment. The comment 'circa 1850' applied to a daguerreotype indicates that in the opinion of the cataloguer the image is an original one of that period. The comment 'date of origin uncertain' indicates that there is some doubt in the mind of the cataloguer regarding its authenticity. In the preparation of a catalogue care must be taken to be fair to both vendor and purchaser and the reputation of an auction house is often built on the standard of its catalogues.

If you are unaccustomed to bidding at auction sales the best advice is to attend a number of sales, preferably devoted to items in which you have no interest, and just watch. If you still feel a little unsure or are unable to attend a sale in person, bids may always be registered with the auctioneer who would execute

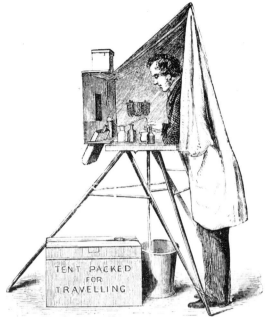

PHOTOGRAPHIC TENT.

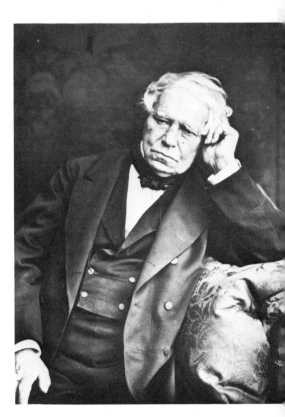

Above A fine woodburytype print by Goupil & Cie of Parie (*c.* 1878) from *Galerie Contemporaine*.

Top A portable photographic tent of the 1850s.

Left These miniature photographs sometimes called 'gems' were often mounted in this form on *cartes-de-visite* or used in lockets.

A modern plastic 35 mm slide viewer on the left compared with a Victorian twin lens viewer for standard 3¼ inch square slides.

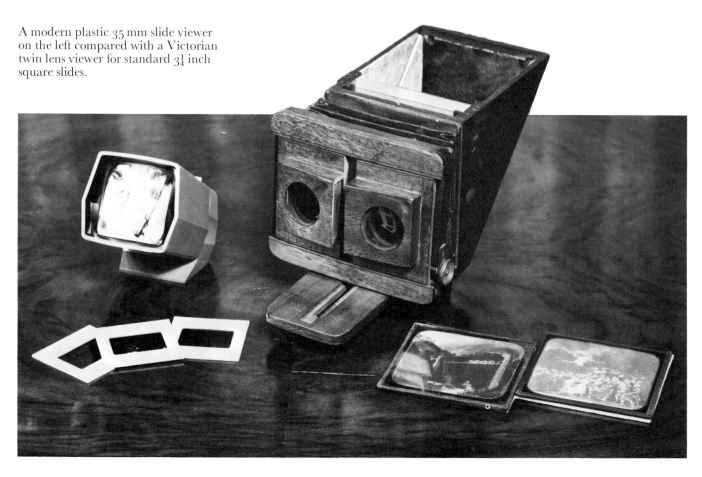

the bid on your behalf, buying the item at the lowest possible price. No charge is made for this service.

If you do decide to make your own bids, and most do eventually, it is most important that you make your intentions quite clear. Until you are experienced it is best to state your bid clearly, loudly and decisively. Any auctioneer will welcome prospective buyers who make their bids in this manner.

If in the very unlikely event of a lot being 'knocked down' to you because the auctioneer thought that you were bidding when you were not, do not panic. Just state loudly and clearly that you were not bidding, and any reputable auctioneer will accept your statement and put the lot on offer again.

The rate at which lots are sold will vary considerably, but as a rough guide a rate of 100 lots per hour is a fair average for sales conducted on the auctioneer's own premises, as are most specialist sales. Much depends upon the individual auctioneer and his staff. The safest procedure is to ask the regular staff.

Some items in sales in Britain may be subject to an additional surcharge over and above the hammer price in respect of Value-Added Tax at the current rate. Elsewhere some form of sales tax may be in operation. In either case this will be indicated in the catalogue or else announced at the time of the sale.

Selling at Auction.

As a method of disposing of surplus or duplicate items selling at auction has much to recommend it.

The vendor does not have to advertise, is assured of some competition for the item that is on offer and that the price is what the collectors and dealers present at the sale consider it to be worth.

In England the usual commission payable to the auctioneer is 15 per cent of the hammer price. Vendors have to pay Value-Added Tax at the current rate on the amount of the commission and both these sums will be deducted by the auctioneer from the total due to them when settlement is made after the sale. If the vendor makes arrangements with the auctioneers prior to the sale they may agree to a reserve price below which the item will not be sold, but it is usual for the vendor to have to pay a commission if the item does not achieve the reserve price.

Acknowledgements

No book of this nature is the unaided work of its authors and so to the many generous individuals and organizations who have been helpful in providing much of the information contained within our files, we are now pleased to take this opportunity of expressing our appreciation.

We are particularly indebted to the following: the late Eric Griffiths, F.I.I.P., F.R.P.S.; the late J.T. Suffield, A.R.P.S.; Peter Barrie; Vincent Bulman; Brian Coe, F.B.K.S., Curator, Kodak Museum, Harrow, Middlesex; B.E.C. Haworth-Loomes; Robert Lassam, F.R.P.S., Curator, Fox Talbot Museum, Lacock; Dr George Parker, Ph.D., A.R.P.S.; Gordon Smith, M.B.K.S.; Dr David Thomas, Ph.D; and John Ward of The Science Museum, London

We are especially grateful to Miss Maria Severynen and Dr George Parker who read much of the original manuscript and made very many helpful suggestions.

Mr and Mrs W.J. Chignell undertook the photography of all but a few of the illustrations and we are most appreciative of their efforts.

Apart from the illustrations whose source has been acknowledged individually the material for the remainder has been provided by: Ernest Biddle, Mrs F. Hill, Miss J. Hodges, Miss Maria Severynen, Célestine Dars and the Wills Collection of Photographica.

The Hamlyn Publishing group would like to thank the Kodak Museum for their co-operation in supplying the subjects for the jacket and to the photographer Michael Plomer.

Photographs American National Archives 100 bottom; Archaeological Survey of India, New Dehli 92 bottom; Arts Council of Great Britain, London 96; Bill Brandt, London 94; Prudence Cuming Associates Ltd., London 82 top, 85; George Eastman House Collection, New York 101; Établissement Cinématographique et Photographique des Armées, Fort D'Ivry 120, 121 top, 121 bottom; Hamlyn Group Picture Library 132, 133; Kodak Museum, Harrow 12, 16 centre right, 16 bottom, 73 79, 157 bottom; National Portrait Gallery, London 112; Victoria and Albert Museum, London – Felice Beato 115; Victoria and Albert Museum – Edward Weston 111.

Bibliography

A considerable number of books on photography and its evolution have been published in recent years. Those that are listed here are publications that we have found to be both informative and interesting.

Technical Works.
Hedgecoe, J., *The Photographer's Handbook*, Ebury Press, London, 1977.
Horder, I., *The Manual of Photography*, Focal Press, London, 1978.
Focal Press, *The Focal Press Encyclopaedia of Photography*, Focal Press, London, 1956 and subsequent editions.

Technical Periodical.
The British Journal of Photography (editor G. Crawley), established in 1854 it is published weekly by Henry Greenwood & Co., Ltd., London.

General Works.
Beaton, Sir C. and Buckland, G., *The Magic Image: The Genius of Photography from 1839 to the Present Day*, Weidenfeld & Nicholson, London, 1975.
Boni, A., *Photographic Literature: An International Bibliographic Guide*, Morgan & Morgan, New York, Vol. 1. 1962, Vol. 2. 1972.
Braive, M., *The Era of the Photograph*, Thames & Hudson, London, 1966.
Buckland, G., *Reality Recorded: Early Documentary Photography*, David & Charles, Newton Abbott and The New York Graphic Society, Boston, 1974.
Ceram, C.J., *Archaeology of the Cinema*, Thames & Hudson, London, 1965
Coe, B., *The Birth of Photography*, Ash & Grant, London, 1976.
Cornwell-Clyne, A., *Colour Cinematography*, Chapman & Hall, London, 1951.
Cook, Olive, *Movement in Two Dimensions*, Hutchinson, London, 1963.
Gernsheim, H., *Creative Photography: aesthetic trends 1839-1960*, Faber & Faber, London, 1962.
Gernsheim, H. & A., *The History of Photography*, Thames & Hudson, London, 1969. *The Concise History of Photography*, Thames & Hudson, London, 1965.

Newhall, B., *The History of Photography*, Secker & Warburg, London and The New York Graphic Society, Greenwich, 1972.
Scharf, A., *Art and Photography*, Allen Lane, London, 1968. *Pioneers of Photography*, British Broadcasting Corporation, London, 1975.
Sipley, L., *Photography's Great Inventors*, American Museum of Photography, Philadelphia, 1965.
Taft, R., *Photography and the American Scene*, MacMillan Co., New York, 1938 and subsequent reprints by Dover.
Thomas, Dr D.B., *The First Negatives*, Her Majesty's Stationery Office, London, 1965.
Time-Life Books, *The Time-Life Series of Books on Photography*, Time Incorporated, New York, 1970.
Wakeman, G., *Victorian Book Illustrations*, David & Charles, Newton Abbott and Gale, Detroit, 1973.

Works on Individuals or Firms.
Arnold, H.J.P., *William Henry Fox Talbot: Pioneer of Photography and Man of Science*, Hutchinson Benham, London, 1977.
Bruce, D., *Sun Pictures: The Hill & Adamson Calotypes*, Studio Vista, London, 1973.
Coe, B., *George Eastman and The Early Photographers*, Priory Press, London, 1973.
Gernsheim, H. & A., *Julia Margaret Cameron*, Fountain Press, London, 1948. *L.J.M. Daguerre*, Secker & Warburg, London, 1956. *Roger Fenton*, Dover Books, New York, 1970.
Hercock, R.J. & Jones, G.A., *Silver by The Ton: A History of Ilford Limited, 1879-1979*, McGraw-Hill, Maidenhead, 1979.
Hiley, M., *Frank Sutcliffe*, Gordon Fraser, London, 1974.
MacDonnell, K., *Eadweard Muybridge*, Weidenfeld & Nicholson, 1972.
Newhall, B., *Frederick H. Evans*, Aperture, New York, 1973. *Daguerre*, (introduction by Beaumont Newhall) Winter House, New York, 1971.
Turner, P. & Wood, R., *P.H. Emerson*, Gordon Fraser, London, 1974.
Woolf, V. & Fry, R., *Victorian Photographs of Famous Men and Fair Women. Photographs by Julia Margaret Cameron*, reprint of 1926 edition with additional notes by Tristam Powell, Hogarth Press, London, 1973.

Bibliography of Specialist Publications for Collectors

Books

Abring, H.D., *Von Daguerre Bis Heute Foto Museum Herne*, West Germany, 1977.

Auer, M., *Collection – Michel Auer*, 1972 & 1977, *Index and Price Guide* published by the author, 1978.

Auer, M., *The Illustrated History of the Camera*, Fountain Press, 1975.

Castle, P., *Collecting and Valuing Old Photographs*, Bell and Hyman, London, 1979.

Coe, B., *Cameras – From Daguerreotypes to Instant Pictures*, Marshall Cavendish Editions, London, 1978.

Coe, B., *Colour Phogoraphy*, Ash & Grant, 1978.

Holmes, E., *An Age of Cameras*, Fountain Press, 1974.

Howarth-Loomes, B.E.C., *Victorian Photography A Collector's Guide*, Ward Lock, 1975.

Klamkin, C. & Isenberg, M., *Photographica*, Funk & Wagnals, New York, 1978.

Lager, J.L., *Leica Illustrated Guide*, Morgan & Morgan, New York, 1975.

Lager, J.L., *Leica Illustrated Guide. Lenses, Accessories & Special Models*, Morgan & Morgan, New York, 1978.

Lothrop, E.S., *A Century of Cameras*, Morgan & Morgan, New York, 1973.

Mathews, O., *The Album of Carte-de-Visite and Cabinet Portrait Photographs 1854-1914*, Reedminster Publications Ltd., 1974.

Nagel, H., *Zauber Der Kamera*, Deutsche Verlags-Anstalt, Stuggart, 1977.

Newhall, B., *The Daguerreotype in America*, Dover Publications, New York, 1975.

Permutt, C., *Collecting Old Cameras*, Angus & Robertson, 1976.

Rinhart, F. & M., *American Miniature Case Art*, Barnes & Co., New York, 1969.

Symons, K.C.M., *Stereoscopic Cameras*, The Stereoscopic Society, 1978.

Tubbs, D.B., *Zeiss Ikon Cameras 1926-39*, Hove Camera Foto Books, Hove, 1977.

Wade, J., *A Short History of the Camera*, Fountain Press, 1979.

Willsberger, J., *The History of Photography*, Doubleday & Co., New York, 1977.

Catalogues

Masterpieces of Victorian Photography, a catalogue of the Arts Council Exhibition held on the occasion of The Festival of Britain, 1951 in conjunction with The Victoria and Albert Museum (out of print but very desirable).

Barnes Museum of Cinematography: catalogue of the Collection. text by John Barnes. Part One – *Precursors of the Cinema*. 1967, Part Two – *Optical Projection*. 1970.

The Science Museum Photography Catalogue, by D.B. Thomas, B.Sc., Ph.D. Her Majesty's Stationery Office, 1969.

David Octavius Hill and Robert Adamson, Catalogue of the Scottish Arts Council Exhibition 1970, by Katherine Michaelson.

From Today Painting is Dead, The Beginnings of Photography catalogue of the Arts Council of Great Britain's Exhibition at The Victoria & Albert Museum 16 March – 14 May 1972, selection of exhibits and text by D.B. Thomas, B.Sc., Ph.D.

The Real Thing. An Anthology of British Photographs 1840-1950, catalogue of an Arts Council of Great Britain Exhibition 1975, text by David Mellor.

Photography: the first eighty years, catalogue of an exhibition organized by P. & D. Colnaghi & Co. Ltd., 27 October to 1 December 1976.

Periodical

History of Photography: An International Quarterly, edited by Heinz K. Henische and published by Taylor & Francis Ltd., 10-14 Macklin Street, London WC2 5NF. Vol. 1 Number 1 January 1977 onwards.

Miscellanea

Camera. William Henry Fox Talbot. A commemorative issue published in connection with the centenary exhibition of Fox Talbot's work staged at Photkina 1976 and subsequently at The Science Museum, South Kensington, London in 1977. A loose insert lists the panels of prints (salt paper prints made from Fox Talbot's original negatives by B.W. Coe, Curator of the Kodak Museum, Harrow, Middlesex and members of the staff of Kodak Limited, in association with The Science Museum and The Fox Talbot Museum).

The Recognition of Early Photographic Processes, Their Care and Conservation. A pre-print of papers presented at a Symposium organized by The Historical Group of The Royal Photographic Society held on 16 March 1974.

Glossary

Actinometer A form of exposure meter (q.v.) based on the use of a piece of light sensitive paper which darkened when exposed to light. The length of time that was needed for the paper to assume a tint, which matched a standard tint, was measured and this when related to other factors such as film speed and lens aperture produced an indication of the exposure time required. Also known as Tintmeters.

Albumen paper prints Invented by Blanquart-Evrard in 1850 it was an improvement on the salt paper printing method used for calotype negatives. Thin paper was coated with a solution of egg-white before being sensitized with silver salts. the result was a smooth surface capable of resolving fine detail and having a fine sheen finish. It was in almost completely universal use until the late 1880s.

Amalgam An admixture formed from two or more substances one of which is usually mercury. The daguerreotype image is an amalgam of mercury and silver.

Ambrotype The American name for the collodion positive on glass (q.v.)

Aperture The actual diameter of the clear area visible for rays of light to pass through a lens. This is usually expressed in a photographic context as the relative aperture or f/no of a lens obtained by dividing the focal length of the lens by the aperture.

Autotype process A trade name for the carbon process (q.v.) derived from its commercial exploration by the Autotype Company.

Bromide print process A black-toned printing paper having sufficient speed for enlarging made by combining silver nitrate and potassium bromide. It succeeded the albumen print process.

Bromoil print An image formed in oil based pigments applied by brush to the surface of a bromide print for which the image had been bleached and the gelatine differentially hardened in proportion to the density of the image.

Calotype process Fox Talbot's own name for his process introduced in 1840 in which a latent image (q.v.) was made visible by the use of a developer.

Camera lucida An aid to drawing first introduced by W.H. Wollaston at the beginning of the nineteenth century; it consisted of a prism mounted on an arm above a sheet of drawing paper. On looking through the prism an image of the scene before the instrument was seen superimposed on the drawing paper which could be drawn in pencil or charcoal.

Camera obscura The latin name for a darkroom. Used at first to denote a room, building or tent within which an image of the scene without was formed by a pinhole or lens. Small portable versions in the style of boxes fitted with a lens, viewing screen and sometimes an internal mirror were much used by artists, and it was from these that the original photographic cameras were derived.

Carbon process Derived from the Pouncy process (1858), which was incapable of rendering halftones, the carbon process was invented by Joseph Wilson Swan and patented by him in 1865. Because the final image consists of a suspension of pigment in gelatine it does not fade with the passage of time and is, therefore, one of the permanent processes.

Carbro process A later development of the carbon process first introduced as the Ozobrome process by Thomas Manly in 1905 it used a bromide print instead of a negative as the original image. Developed commercially as the Carbro (CARBON-BROMIDE) process by the Autotype Company.

Carte-de-visite/cabinet prints The names given to the small photographs usually found in Victorian portrait albums popular during the period 1860-1914. The *carte-de-visite* print was about 9 x 5.5cm mounted on a card 10.5 x 6.25cm and the cabinet print about 14.5 x 10.25cm mounted on a card 16.5 x 10.75cm.

Chloride printing papers Otherwise known as 'gaslight' papers because they could be used in subdued artificial light they were in common use for contact printing between about 1890 and 1950.

Collodion process Introduced by Frederick Scott Archer in 1851 as the wet collodion process, it was the first emulsion on glass negative process to be a commercial success. Because it was cheap and had not been patented it remained in use until late into the nineteenth century.

Collodion positive on glass Derived from the wet collodion process it was a negative which had been treated to give it a light cream-like colour. When viewed against a dark background it appeared as a positive image.

Daguerreotype Introduced in 1839 and named after its inventor, L.J.M. Daguerre it was an image formed on the surface of a silver-plated sheet of copper. It became obsolete during the early 1860s.

Detective cameras Used to identify hand-held cameras made during the period 1875-1900, it was applied mainly to box-type cameras which were often disguised as books or parcels, or were hidden within clothing. Later it denoted any camera which was designed to be used unobtrusively or was made to appear other than what it was.

Development The technical term used to denote a process by which an invisible (latent) image is converted into a visible one by chemical action.

Diapositive The name given to a positive image, usually on glass, for viewing by transmitted light.

Emulsion The term used to denote a suspension of light-sensitive silver salts within a medium such as gelatine or collodion.

Exposure meter A device designed to measure the amount of light reflected from or incident upon a subject to be photographed.

Extinction meter A type of exposure meter (q.v.) which utilized a form of transparent grey scale through which the scene to be photographed was viewed.

Ferrotype The name by which collodion positive images on dark enamelled sheets of tinplate were known. Often referred to as Tintypes, their original name in America was Melainotype. In general use between the 1860s and the 1930s.

Fixation The process by which the unused light sensitive silver salts within exposed emulsions are rendered soluble and thus capable of being removed from the emulsion by diffusion during washing.

Focal length The distance between the rear optical point of a lens and the image formed by it when focussed on an object situated at infinity. In general a lens has a focal length approximately equal to the diagonal of the plate or film format with which it is to be used.

Focal plane shutter A type of shutter which is in the form of a blind having a variable slit which moves in front of the plate or film within the camera. First proposed by William England in 1862.

Heliograph The name given to the images produced by Joseph Nicéphore Niepce during the 1820s on a metal plate coated with bitumen of judea.

Latent image The invisible image produced within a light sensitive emulsion which has to be treated chemically (developed) in order to become visible.

Macrophotography The process of photographing objects (usually very small) in such a manner that the images produced are larger that the original.

Matt In general used as a term denoting a photographic printing paper having a smooth surface and no sheen. It is also the name given to the gilt metal overlay in general use between the image and the glass when mounting daguerreotype and ambrotypes.

Melainotype An American name for the ferrotype (q.v.)

Microphotography A method of making very small (microscopic) images by the photographic process which require to be viewed using a compound microscope. It must not be confused with photomicrography (q.v.)

Negative The name given to the image formed by the camera after it has been developed and fixed. In appearance the tones of the subject have been reversed, dark ones appearing light and vice versa.

Normal lens A lens is described as normal when its focal length is approximately equal to the diagonal of the plate or film format with which it is used.

Photogenic drawing The name given to Fox Talbot's first process in 1834 based upon the light sensitivity of silver salts.

Photomicrography A method of producing enlarged photographs of very small objects by the use of a microscope. Not to be confused with microphotography (q.v.).

Pinchbeck metal An alloy of copper, tin and zinc often used as a cheap imitation of gold for the manufacture of matts (q.v.).

Platinotype or platinum print The name was given to the printing process devised by William Willis and patented in 1873 which utilized platinum salts instead of the conventional silver ones.

Positive A photographic image in which the tones of the subject have not been reversed as they have been in a negative image (q.v.)

Reflex camera A camera which has a mirror incorporated within its body which enables the image to be seen the right way up.

Retrofocus lens A lens of such special construction that the working focus (q.v.) is longer than its focal length. A lens of this type is often needed when wide angle lenses (q.v.) are required for single lens reflex cameras to allow

sufficient space for the mirror to rise.

Sensitometry The study of the manner in which a light sensitive photographic emulsion responds to the action of light and subsequent processing.

Shutter A mechanical device used on a camera to control the length of time of the exposure.

Stabilization A method of rendering inert the light sensitive salts in an emulsion which were not affected by the exposure.

Stereogram A pair of stereoscopic positive images in the form of either paper prints or transparencies mounted for viewing in a stereoscope (q.v.)

Stereoscope A form of optical instrument using lenses, mirrors or prisms to produce a three dimensional image from a stereogram (q.v.)

Sun pictures The name given by Fox Talbot to pictures produced by his calotype process (q.v.).

Telephoto lens A lens of special construction whereby the working focus (q.v.) is much shorter than its focal length thus producing a more compact design.

Tintype See ferrotype.

Union case A case for ambrotypes and daguerreotypes moulded in a thermoplastic material using a steel die as the mould. Introduced in the early 1850s by Samuel Peck of Connecticut and by Alfred Critchlow, many of the dies were produced by the finest die engravers of the period.

Wide angle lens A lens which has a focal point appreciably shorter that the diagonal of the plate or film format on which it is used the consequence of which is that the image embraces a greater angle from the viewpoint than is normal.

Woodburytype A photochemical process in which a relief image in bichromated gelatine is used to make a mould in lead under a pressure of several tons per square inch. This mould is then used to produce images in pigmented gelatine.

Working focus The distance between the back of the lens and the image produced by it of an object at infinity. Also known as back focus.

Eminent Personalities in the History of Photography

Adams, Ansel Easton (1902-)
Adamson, Dr John (1802-1860)
Adamson, Robert (1821-1848)
Alhazen (965-1038)
Annan, Thomas (1829-1887)
Annan, J. Craig (1864-1946)
Archer, Frederick Scott (1813-1857)

Barnard, George N. (1819-1902)
Batkin, J.C., (1867-1936)
Bedford, Francis (1816-1894)
Bennett, Charles (1840-1927)
Bisson, Auguste (1828-)
Blanquart-Everard, Louis-Désiré (1802-1872)
Bolton, W.B. (1848-1899)
Bourne, Samuel (1834-1912)
Brady, Matthew B. (1823-1896)
Brewster, Sir David (1781-1868)

Cameron, Julia Margaret (1815-1879)
Camp, Maxime du (1822-1894)
Capa, Robert (1913-1954)
Claudet, Antoine Francois Jean (1797-1867)
Corot, Jean Baptiste Camille (1796-1875)

Daguerre, Louis Jacques Mandé 1787-1851)
da Vinci, Leonardo (1452-1519)
Davison, George (1856-1930)
Day, Fred Holland (1864-1933)
Degas, Hilaire-Germain Edgar (1834-1917)
de la Motte, Phillip (1820-1889)
della Porta, Giovanni Battista (1535-1615)
Demarchy, Robert (1859-1936)
De Szathmari (1812-1887)
Disderi, Andre Adolpha (1819-1890)
du Hauron, Louis Ducos (1837-1920)

Eastman, George (1854-1932)
Edwards, Ernest (1837-1903)
Emerson, Peter Henry (1856-1936)
Etty, William (1787-1849)
Evans, Frederick H. (1853-1943)

Fenton, Roger (1819-1869)
Fox Talbot, William Henry (1800-1877)

Frith, Francis (1822-1898)

Gardner, Alexander (1821-1882)
Gaudin, Marc Antoine (1804-1880)
Genthe, Arnold (1869-1942)
Godowsky, Leopold (1900-)

Hardwich, T. Frederick (1829-1890)
Herschel, Sir John (1792-1871)
Hill, David Octavius (1802-1870)
Hine, Lewis W. (1874-1940)
Hinton, Alfred Horsely (1830-1908)
Hunt, Robert (1807-1887)

Ingres, Jean Auguste Dominique (1780-1867)
Ives, Frederick Eugene (1856-1937)

Jackson, William Henry (1843-1942)
Johnston, J. Dudley (1868-1955)
Joly, John (1857-1933)

Käsebier, Gertrude (1852-1934)
Keighley, Alexander (1861-1947)
Kennett, Richard (1817-1896)
Klic, Karl (1841-1926)
Kühn, Heinrich (1866-1944)

Lerebours, Noël-Marie Paymal (1807-1873)
Levy, Max (1857-1926)
Lumiere, Auguste (1862-1954)
Lumiere, Louis (1864-1948)

Mach, Professor E. (1838-1916)
MacCosh, John (1805-1885)
Maddox, Dr Richard Leach (1816-1902)
Mannes, Leopold D. (1899-1964)
Martin, Anton Georg (1812-1882)
Martin, Adolphe Alexandre (1824-1896)
Maxwell, James Clerk (1831-1879)
Mayall, John Jabez Edwin (1810-1901)
Meisenbach, Georg (1841-1912)
Monkhoven, Desire Charles Emmanuel van (1834-1882)
Muybridge, Eadweard (1830-1904)

Newton, Sir Isaac (1642-1727)

Niépce, Joseph Nicéphore (1765-1833)
Norris, Dr Hill (1831-1916)

O'Sullivan, Timothy H. (1840-1882)

Parkes, Alexander (1813-1890)
Poitevin, Alphonse Louis (1819-1882)
Ponton, Mongo (1801-1880)
Pouncy, John (1819-1894)
Price, William Lake (1809-1896)

Rejlander, Oscar Gustave (1813-1875)
Riis, Jacob A. (1849-1914)
Robinson, Henry Peach (1830-1901)
Root, Marcus Aurelius (1808-1888)
Russell, Major C. (1820-1887)
Rutherford, Lewis (1816-1892)

St Victor, Niépce (1805-1870)
Sayce, B.J. (1837-1895)
Scheele, Karl Wilhelm (1742-1786)
Schulze, Johann Heinrich (1687-1744)
Schwier, W.G. (1842-1920)
Smyth, Professor Piazzi (1819-1900)
Snelling, Henry H. (1817-1897)
Steichen, E.J. (1879-1973)
Sutcliffe, Frank Meadow (1853-1941)
Sutton, Thomas (1819-1875)
Swan, Joseph Wilson (1828-1914)

Taunt, Henry W. (1842-1922)
Taupenot, J.M. (1824-1856)
Tournachon, Gaspard Felix (1820-1910)
Towler, John (1811-1889)

Vogel, Hermann Wilhelm (1834-1898)

Watkins, Carleton E. (1825-1916)
Watzek, Hans (1848-1903)
Wedgwood, Josiah (1730-1795)
Wedgwood, Thomas (1771-1805)
Weston, Edward (1886-1958)
Williams, T.R. (1825-1871)
Willis, William (1841-1923)
Woodbury, Walter Bentley (1834-1885)

Young, Dr Thomas (1773-1829)

Index